BALI NYONGA
TODAY

Bali Nyonga Today

Roots, Cultural Practices and Future Perspectives

Edited By

Vincent P. K. Titanji

SPEARS MEDIA PRESS
DENVER

SPEARS MEDIA PRESS
Denver
7830 W. Alameda Ave, Suite 103 Denver, CO 80226
First Published 2016 by Spears Media Press
www.spearsmedia.com
info@spearsmedia.com
Information on this title: www.spearsmedia.com/Bali-nyonga-today

Ordering Information:
Special discounts are available on bulk purchases by corporations, associations, and others. For details, contact the publisher at any of the addresses above.

ISBN: 9781942876168 [Paperback]

To the memory of our forebears and the valiant people of Bali Nyonga

Contents

LIST OF FIGURES

Fig 7 Top left, *Myrianthus arboreus* (*Cecropiaceae*) fruits, use to treat sterility; bark of tress are boiled, fruits eaten when ripe; Top right, *Irvingia gabonensis* (*Irvingiaceae*); Bottom left, Bush mango Plant to treat diabetes, Centre: dried fruits of bush mango; Bottom right: *Myrianthus arboreus* plant. 173

Fig 7.1 Top left: *Cissus quadrangularis* (*Vitaceae*) Plant to treat hypertension; Top right: *Lantana camara* (Verbenaceae) For treatment of hypertension; Bottom right : *Vernonia guineensis* (*Asteraceae*). Ginseng for treatment of malaria; Bottom left: *Spathodea campanulata* (*Bignoniaceae*) For malaria treatment 174

Fig 7.2 Top left and bottom; *Albizia adianthifolia* (*Caesalpiniaceae*), for treatment of hypertension; Top right and bottom; *Anacardium occidentale* (*Anacardiaceae*) for treatment of Diabetes. 174

LIST OF TABLES

LIST OF BOXES

LIST OF CONTRIBUTORS

Domatob, Jerry Komia
Dr Domatob is a Mass Communication Professor at Alcorn State University, Lorman-Mississippi. A journalist, photographer, poet and researcher, he is currently working on two book projects. His latest publications are: *Communication, Culture and Human Rights* and *Positive Vibration* – a poetry collection.

Fochang, Babila
Rev. Fochang was born in Bali, Cameroon. He has served the Presbyterian Church as pastor in various capacities and currently serves as Synod Clerk since January 2015. He holds a Master of Theology in African Christianity from the University of Kwazulu Natal (UKZN) and currently completing his doctoral dissertation at the same institution. Fochang has published extensively on Christian and moral issues from an African perspective.

Fokunang, Charles
Prof Fokunang is currently the Director of Students' Affairs at the Central Administration of the University of Bamenda, Head of Preclinical Animal Toxicology laboratory (The Animal House), Coordinator of Pharmacy Programmes in the Faculty of Medicine and Biomedical Sciences, the University of Yaoundé 1. He is a member of the African Administrators of Research Ethics, A Chartered Biologist (CBIOL) and member of the Institute of Biology (MIBIOL), London, an international consultant in clinical trials and drug development. He is a visiting professor in many universities abroad and nationally, and has published a book, many book chapters and over 100 scientific papers in international peer-reviewed journals.

Gwanfogbe, B. Mathew
Professor Gwanfogbe is the current Vice Chancellor of the Bamenda University of Science and Technology (BUST) and former Director of the Higher Teachers Training College, ENS Bambili. He is a member of the Cameroon Historical Society and the editor-in-chief of Pantikar Journal of history and a member of the British History of Education Society. He has published many articles in refereed journals and history

teaching textbooks. He is a Knight of the Cameroon Order of Merit and a long-standing member of the Bali Historical Society.

Langmia, Kehbuma

Dr Langmia is a Fulbright Scholar, Professor and Chair of the Department of Strategic, Legal and Management Communication in the Cathy Hughes School of Communications, Howard University. A graduate from the Mass Communication and Media Studies Program at Howard University in 2006, Dr Langmia has extensive knowledge and expertise in Information Communication Technology (ICT), Intercultural/International Communication and Social Media. Since earning his PhD in 2006, he has well over 23 publications in the form of books, book chapters and peer-reviewed journal articles.

Ndangam, Gwannua

Ba Augustine Ndangam (Ba Nkom Gwannua) served as a high school administrator and principal between 1979 and 1995 in Wum, Kumbo and Bamenda respectively. He taught at the Higher Teacher's College (ENS) Bambili and later at the Bamenda University of Science and Technology. Ba Ndangam has been an active community leader who has consistently championed and enthusiastically supported initiatives aimed at the development of Bali Nyonga and improving the welfare of its people.

Njimanted, Godfrey Forgha

Njimanted Godfrey Forgha (PhD), is an Associate Professor of Economics at the University of Bamenda, Cameroon. He specializes in Quantitative Methods, Monetary, industrial, public sector, Development and Economics planning. Dr. Njimanted currently heads the Division of Tertiary Science and Technology, at the Higher Technical Teachers Training College in Bambili, University of Bamenda. He has taught and consulted with many institutions of Higher Learning in Nigeria, Cameroon and Kenya. Dr Njimanted has published widely in reputable peer-reviewed international journals.

Nyamndi, George

George D. Nyamndi holds a PhD in Literature and a diploma in the teaching of French as a foreign language from the University of Lausanne, Switzerland. He is Associate Professor of Literature and Criticism in the Faculty of Arts, University of Buea, where he was until recently Vice Dean in charge of Studies and Students Affairs. He is a novelist, playwright and essayist. He ran for the presidency of Cameroon in 2004 and 2011.

Sikod, Robert Babila
Mr Sikod holds a BA (Hons) in History, and graduate degrees in the History of International Relations from the University of Yaounde I where he is currently pursuing his doctoral studies. He also teaches history at the secondary school level and serves as a GCE Examiner in Advanced Level History.

Tasama, Julliet Nahlela
Ms Tasama is currently a staff of the Cameroon Christian University (CCU) Bali and the BCA-USA Representative in Cameroon. She holds an MA in Linguistics from the University of Buea and founder of National Languages Sanctuary – NALSANC, a non-profit organization aimed at promoting the use of indigenous languages in communication, teaching and writing.

Titanji, Beatrice Kahboh Lebsia Lima
Dr Mrs Titanji is a senior lecturer at the University of Buea and formerly, Vice National President of Nkumu Fedfed, a position she held for seven years. She is the author of a widely acclaimed book chapter, *Literacy in Cameroon: The case of Mungaka*. In July 2015, she published a video on victims of human trafficking from Kuwait which attracted considerable interest within Cameroon and helped to sensitize the population about the heinous crime of sex and labour trafficking. She remains an ardent advocate against trafficking in persons.

Titanji, Vincent P. K.
Prof Titanji is currently Vice President of the African Academy of Sciences for the Central African Region, Vice Chancellor of the Cameroon Christian University Institute, and former Rector/Vice-Chancellor (2006-2012) of the University of Buea. He is a Fellow of several prestigious science academies including the World Academy of Sciences (TWAS), the African Academy of Sciences (AAS) and the Cameroon Academy of Sciences (CAS). He is a Knight of the Cameroon Order of Valour and a high ranking notable of Bali. He has published over 120 papers in international refereed journals.

FOREWORD

Thirty–one years have flown past since I acceded to the throne of Bali Nyonga in September 1985 after the passing on of our great leader and father HRH VS Galega II. I took over at a time when Bali Nyonga, like many other traditional societies in the country was experiencing a cultural shock caused by the rapid winds of change in a developing post independence Cameroon. In my opinion the main challenges facing the Bali Nyonga community included, not only issues of political, social and economic development issues that we were experiencing, but more the preservation of the positive cultural heritage and identity that were being threatened by modernization, westernization and globalization. We have therefore been very keen to encourage the documentation and preservation of the rich heritage left by our forebears, in order that its positive elements might contribute to the emerging national profile of our fatherland, Cameroon, in the globalized society.

Last year we announced the celebration of the 30th anniversary of our accession to the throne of Bali Nyonga together with the Lela festival in December 2015, but the occasion could not hold because, apart from the heightened insecurity in the country orchestrated by the hideous Boko Haram insurgency, renovation works in the palace were still far from completion. However, in preparation for our traditional end-of-the-year celebration, I appointed a number of committees to carry out specific tasks. One of these committees was the Bali Nyonga Heritage Committee that was charged among other things with the production of a book that reflects the cultural heritage of Bali Nyonga during the past 30 years. The present volume entitled, *Bali Nyonga Toady: Cultural Roots and Future Perspectives* is a collection of articles produced by the BHC. It highlights the history, geography, and aspects of the Bali Nyonga living culture spanning such diverse subjects as the evolution of the Mungaka language, traditional medicine practice, cultural symbols and practices, music etc.

For ease of exploitation the articles have been grouped into three sections. Part I highlights the past history and evolution over the past 30 years with two feature articles on BANDECA the Bali Nyonga Cultural and Development

Association ,which I created upon accession to the throne, and an article about the Bali Nyonga diaspora that has been very instrumental in promoting the our culture abroad. Part II covers various aspects of contemporary cultural practices in Bali Nyonga including the religions of the people, their honorific and funeral celebration practices that tend to dominate the cultural scene, aspects of traditional medicine practice, and most importantly two pieces on the revival of the Mungaka language.

Language is an indispensable vehicle of culture. After my enthronement I observed that the use of Mungaka was on the decline, not only in the North West Region where it once was the *lingua franca*, but also at home in Bali Nyonga, where it had to compete with the two official languages (English and French) as well as Pidgin English. I, therefore, took several actions to revive and then promote the use of Mungaka. These included opening the Alpha Nursery and Primary Biligual School where Mungaka is taught alongside the official languages, contacting the SIL (Societé International Linguistique) to introduce the new African orthography to replace the German-inspired one introduced earlier by the Basel missionaries, and to induce and support the revision and publication of the Mungaka dictionary. Part II of the book documents these and other efforts aimed at reviving and sustaining the use of Mungaka as one of the national languages of Cameroon.

Part III of the book on perspectives, departs from the traditional approach of ethnologists and presents two pieces of prose and poetry alongside a report on the Bali musicians at home and abroad. The third part thus illustrates the living culture of the Bali people as it adapts and integrates itself to the broader national culture of the Cameroonian nation.

I wish to end this foreword by saluting the efforts of the contributing authors, all of them sons and daughters of Bali Nyonga, who have found the time in their busy schedules to research and write their respective chapters. Special thanks go to Professor Vincent P. K. Titanji (Vice-Chancellor of the Cameroon Christian University) whose fidelity as a true son of the palace as well as his conscientious devotion to duty enabled this project to attain fruition. I encourage all persons interested in the study of African culture in general and that of Bali Nyonga in particular to own a copy of this highly informative book.

Bali Nyonga, this 29th day of August, 2016
Senator Dr. Doh Ganyonga III, Paramount Fon of Bali.

PREFACE

*B*ali Nyonga Today takes off from where its predecessor, *An Introduction to the Study of Bali Nyonga* (1988), left off. It covers a selection of topics on Bali Nyonga under HM Dr. Ganyonga III, Paramount Fon since 1985. The immediate stimulus to the writing of this book was the decision by the Fon to create the Bali Nyonga Heritage Committee charged among other things with documenting aspects of Bali Nyonga culture as a dynamic entity within the larger context of a multicultural Cameroon.

Three of the five authors who produced the 1988 book have contributed to the present volume, put together by twelve contributors. Like its predecessor, this book is panoramic; it is not limited to a single aspect of the ethnology or sociology of Bali Nyonga. Its unifying theme is the living culture of the Bali Nyonga during the past thirty years.

Part One revisits and updates the geography (Chapter 1) and fascinating history of the migration of the Bali people (Chapter 2) from the Chamba homeland in present-day north-eastern Nigeria and their settlement in their present location in the Mezam Division of the North West Region. Chapter 3 presents an in-depth description of Bali cultural and development associations (*Ndakums*) which under the impulse of HM Dr. Ganyonga III amalgamated to form the Bali Nyonga Cultural and Development Association (BANDECA). Chapter 4 profiles the activities of the Bali Nyonga Diaspora in the USA and provides refreshing insights into their effort to propagate the Bali culture abroad while supporting the socioeconomic development of Bali Nyonga back at home.

Part Two of the Book is more elaborate and diverse in its content as it features, not only topics on the cultural practices and religion of the people, but also a scientific description of traditional medicine practice in Bali Nyonga. An article on the coexistence of the traditional and modern calendars (Chapter 5) demonstrates how the old and new traditions are existing side by side and portrays the sophistication and flexibility of the population in switching from one system to the other even as the main events that guided the old calendar (Lela and Voma celebrations) are gradually receding into rare manifestations.

Chapter 6 provides a brief but penetrating snapshot of the religions (Christianity, Islam and traditional beliefs) coexisting, cooperating and even mingling in contemporary Bali Nyonga. Chapter 7 describes various rites, rituals and practices in the life cycle of the Bali people under the theme "Honouring the living and the dead" while revealing the tensions and adaptations facing the traditional system in the modern context.

A significant section of Part Two (Chapters 8 & 9) contributed by two female scholars discusses the revival of interest in Mungaka, the language of the Bali people, and until relatively recently the lingua franca in the North West Region, but which has been witnessing a steady decline in influence with the corresponding growth of political awareness in Cameroon. The language articles introduce the new orthography based on the pan-African alphabet which is destined to replace the previous, German-inspired orthography.

Two articles of a scientific/economic nature conclude Part Two. Chapter 10 describes the art and craft industry in Bali Nyonga and Chapter 11 traditional medicine practice in the same area.

Part Three, the final section, deals with Perspectives. Chapter 12 presents a creative writer's perception of the Bali personality. This is followed by Chapter 13 on Bali Nyonga musicians of the modern era who use Mungaka and English in their lyrics and traditional and modern instruments in their rhythm, thereby demonstrating how the Bali society is adapting to change in the 21st century. The book concludes with a poem on the emblematic cultural festival *Lela* which lies at the heart of the Bali culture (Chapter 14). The book is therefore not only about the Bali Nyonga of yesterday and today; it is also and more decidedly about what the Bali Nyonga of tomorrow could be.

The authors thank the Paramount Fon of Bali Nyonga, HM Dr. Ganyonga III, for creating the Bali Nyonga Heritage Committee and for commissioning them to produce this book. The authors are equally grateful to their informants for their invaluable assistance. Finally, we thank our publisher for his collaboration.

Bali Nyonga, 29th August 2016
Professor Vincent P.K. Titanji

Disclaimer
The opinions expressed in this book are those of the respective authors and do not necessarily reflect those of the Bali Nyonga Heritage Committee.

Part I
BACKGROUND PAPERS, HIGHLIGHTING THE PAST AND EVOLUTION OF BALI NYONGA DURING THE PAST 30 YEARS

1

GEOGRAPHICAL PRESENTATION OF BALI NYONGA KINGDOM

Mathew B. Gwanfogbe

INTRODUCTION

B ali Nyonga kingdom covers one of the 269 administrative sub-divisions of the Republic of Cameroon. It is one of the six sub-divisions of Mezam Division of the North-West Region of Cameroon. Geographically, the kingdom is located within longitude $9^0 40E$ to $10^0 50E$ and extends from latitude $5^0 50N$ and $6^0 10N$ of the equator. It is found in the South West border of Mezam Division and covers an area of 278 km2 with an estimated population of 85,000 people. Bali Nyonga is bordered in the East by Santa Sub-Division and in the North by Bamenda II Sub-Division. Both are sub-Divisions of Mezam Division. Meanwhile, it is bounded in the East and South by Mbengwi Sub-Division and Batibo Sub-Division respectively. These two sub-divisions belong to the Momo Division.

The trans-African international highway (Bamenda-Enugu) express road that connects Cameroon to Nigeria traverses Bali Nyonga Sub-Division from north to south giving the sub-division a unique easy access into the Region. The administrative status was first established by the colonial administration as a council area. On the 26th of August 1966, the council was transformed into an administrative District by Decree No. 66/DF/433. It was headed by a District Officer appointed by the President of the Federation and placed under the Minister of Territorial Administration. Following a careful consideration of demographic growth and political dynamics, another Presidential decree No. 79/469 of 14th November 1979, raised the status of Bali Nyonga to a sub-divisional administrative area. It is important to note that the Bali Sub-division is conterminous with Bali Nyonga kingdom.

Physical presentation

The kingdom is located physically at the foot of the Bambutos Plateau at the South-West limit of the Western Highlands of Cameroon. It is separated from the Santa Sub-Division in the East by an escarpment. Here, the neighbouring villages of Mbu (Baforchu), Chomba, Mbatu, Nsongwa and Pinyin are found on the south-western limits of the Bambutos Plateau.

From the south bordering Batibo Sub-division, the topography rises gently but with noticeable peaks and highlands ranging above 1,500m above sea level in a north-eastern alignment. Some of the important peaks include Mount Fukang (1.535m) bordering the Cameroon Protestant College and named by Swiss Missionaries in the 1950s as Matterhorn – after a similar mountain in Switzerland; Mount Olulu (1,467m), Kopin highland (1,388m) and other interlocking highlands such as Mbelu, Kubat, Kufom, Ntanko'o, Gawola and Gwenjang all covered by savannah vegetation.

As a result of these high peaks and the north-eastern escarpment, there are broad valleys slanting in a NE/SW orientation following the topographical structure. Some of the attractive valleys are Naka, Sepua, Tob, Bosah, Boh, Mantum and Gola.

Hydrology /Drainage

Naturally, the existence of the escarpment in the north-eastern borders and the sloping gradient towards the south-west implies that the drainage takes the same orientation. Hence Rivers Naka, Tob, and Mbufung take the same orientation forming tributaries to major rivers out of this territory such as the Menchum and the Manyu. From the foregoing, Bali is a basin receiving streams and rivers from the north-east and draining them towards the South-west.

Soil

The north-eastern escarpment bordering Bali is at the end of an extinct volcanic mountain. Hence the soil is volcanic. The alluviums brought down the escarpment by rivers add to the volcanic soils to offer fertile land for farming. It is however also noticed that the hill slopes are generally underlain by lateritic soils which are less useful for agriculture but good for the growth of grass which is widely used for a variety of activities such as roofing local houses and for cattle grazing and cultivation of cereals.

Climate

The sub-division is found in the humid tropical climatic zone with two distinct seasons (rainy season starting in March and dry season starting in October). The rainfall is relatively heavy varying from 2.000 mm to 3.000 mm per year. The rains are brought by the South-West Monsoon trade winds which blow north-eastwards over the land but often cannot go up the escarpment. Compared to the neighbouring villages on the escarpment, Bali receives relief rains because of its physical setting.

The temperatures vary from a maximum of 31^0c and a minimum of 12^0c. This can be explained by its topographical structure where the low lying areas with more moisture and tropical forest conserves more heat while the peaks and highlands are colder.

Vegetation

From the climate and topography of the land as well as the latitudinal location of Bali, it belongs to the savannah vegetation. But for the southern limits that manifest tropical vegetation, much of the land is covered by gallery forests and tall grass as well as large forests of natural and man-made raffia along the valleys. The Mantum Forest Reserve that used to supply timber and conserve rare species of flora and fauna has been seriously deforested. Rather eucalyptus have been planted on many hill slopes since it does well both in the valleys and on the hills. It is used for building and for fuel.

Land use

From the geographical factors presented above, it is evident that the Bali Sub-Division has a good climate, vegetation and soils type for agricultural and animal husbandry. It is therefore ecologically friendly and that explains why the land has for long been a battle field for human occupation.

Cattle do well on the slopes of the highlands in the northern part of the kingdom where a wide range of cereals and Arabica coffee are cultivated. Meanwhile, the forested southern ecological zone is good for the cultivation of tropical crops such as palm products, robusta coffee, tubers, plantains and bananas. In both ecological zones two types of raffia plants produce palm wine that are consumed both locally and sold out of the kingdom. There are also farmers in both zones that have opened poultry and piggery farms of reasonable sizes attracting buyers from within and out of Bali.

Conclusion

Bali kingdom is located in an attractive geographical environment. Favourable geographical features render the land gorgeous for human and animal occupation. For many centuries, it has attracted people from both the Equatorial forest in the south and from hilly mountainous grasslands of the north. These natural conditions attracted a wide range of human groups and only the very strong can occupy it. There is hope that the development agencies interested in exploiting these striking environmental factors will develop inventive ideas to convert the natural gifts for the welfare of the people.

2

BALI NYONGA: FROM MIGRATION TO SETTLEMENT

Mathew B. Gwanfogbe

Bali Nyonga is an administrative Sub-Division in the Mezam Division of the North West Region of Cameroon. For proper administration of its citizens, the Cameroon Government has divided the country into ten Regions which are again subdivided into 58 divisions. These divisions are further split into 269 subdivisions for closer administration. Bali Nyonga constitutes one of these subdivisions. It is also one of the five Chamba Fondoms of the North West Region of the Republic of Cameroon. The Fondom and the Sub-Division are conterminous. This paper attempts to sketch an overview of the historical evolution of Bali Nyonga from migration to settlement.

Much has been written on Bali Nyonga and the Chamba people. But researchers are not yet agreed on their original home. Most scholars (W.E. Hunt 1925; M.D.W Jefferys 1957; Chilver E.M. 1966; Chilver E.M. and Kabbery 1967; Soh P.B. 1978; Soh P.B. and Mohammadou E 1978; Fardon R, 1988; Nyamndi N.B. 1988) agree that Chamba ethnicity still calls for further historical research. Almost all are of the opinion that Chamba groupings encompassed heterogeneous communities which have been classified into two major ethno-linguistic groups: Chamba Daka and Chamba Leko. They are also in agreement that Bali Nyonga grew out of the Chamba ethnic origin. Meanwhile it is important to point out from the onset that Nyamndi N.B. has presented the most comprehensive account of the migration and settlement of all the Chamba Fondoms from where this article draws inspiration·

ORIGINAL ABODE OF THE CHAMBA PEOPLE

Richard Fardon, 1988 9-12 posits that the origin of the Chamba people is a

complex story of fusion and subsequent dispersion. In his preface, he postulates that "the heterogeneity of the Chamba communities and the problematic status of the ethnic term "Chamba" both call for historical explanation." As such further historical investigation into the Chamba ethnicity is inevitable.

However, existing research studies are agreed that Chamba groupings that were found in Lamurde – Jungun in the Atlantika Mountains, encompassed heterogeneous communities which have been classified into two major ethno-linguistic groups: Chamba Daka and Chamba Leko. Both groups were referred to as SAMA from which the term Chamba is conjectured to have been derived. But where did they originate from before settling in Lamurde-Jungun?

The first recording of their account suggest that they were found in these two geographical locations, with the Chamba Leko to the east between the Alantika Mountain and River Deo, while the Chamba Daka were to the west of the Atlantika Mountains in the 18th century. This geographical location eventually affected their history and has contributed to generated debate on their ethnicity. Fardon sees them as mere linguistic groups and at the best as an "embryonic tribe" (Nyamndi 1988:3). This may be explained by the fact that at the time, Chamba had no paramount ruler over the respective villages. But it should be noted that their common language, traditions and even history distinguished them from other peoples of the region. Nyamndi holds that the Chamba Leko villages had autonomous chiefs known as *Gara* or *Ga* appointed by a clan known as *Gatkuna* who in turn appointed sub-chiefs called *Wassama* to rule their sub-chiefdoms and render account to the *Ga*. This might explain why succeeding Chamba Leko followers in the Bamenda Region established strong centralized states, known today as Fondoms, led by *Fons* or *Gas*.

The question is where did they come from before settling in the Benue plain? Where was their original home? Some traditions state that they came all the way from Japan while others claim that they came from Bali in Indonesia and yet others assert that they came from Syria. These sources have all been proven unreliable because from the description of their physical features before intermarriages with other races during and after their migration from the Benue region, they are said to have been tall negroid people with distinctly imperious bearings, which is a depiction akin to that of the So or Sao people who are said to have been heirs to the Neolithic Revolution that gave rise to the Nok civilization in the Lake Chad basin (J.D. Fage, 1969:31). They are said to have been very powerful and energetic people whom the Kanuri tradition of the Kanem-Bornu Empire described as "giants" with whom they fought for many

years and could only conquer after suffering many vicissitudes, (J.F Ade Ajayi & Ian Espie: 72 - 74). However, the current known descendants of the Sao are the Kotoko, Buduma, Musgum, Garmergu and Bolewa. Is it possible that the Chamba groups emerged from this environment and left during either the height of the Sao civilization or later during the Kanem-Bornu pressure? The later empire conquered and absorbed the Sao, and it is possible that groups that did not succumb to their pressures must have emigrated from the Chad basin.

In the Lamurde-Jungun area (in the Benue basin) where they were settled in the 18th century, they claimed their original abode to be known as Sham in the north. This direction points to the Chad basin. It must be remembered that as the Saharan desertification intensified, human movement into the Lake Chad Basin increased and that explains why kingdoms and empires developed in the basin. But when the lake started shrinking, habitable land became scarce and southwards movements became inevitable. Undoubtedly, the Chamba people were inclusive among the emigrants.

J.D. Fage, (1969:31) also posits that the first displacements of the people in the Chad basin were caused by waves of the infiltration of Saharan pastoralists into the basin over many centuries with climax between the seventh and ninth centuries. Inevitably, they were seeking for pastures for their cattle as the desertification of the area north of the Chad basin was increasingly affecting the vegetation. These caused further southwards movements and probably amongst the migrants were found the original Chamba groups who are said to have resettled in the Benue basin.

It is also possible to argue that the conversion of the Sefawa *Mais* (King of the Kanem-Bornu kingdom) to Islam at the end of the eleventh century must have also instigated southwards movements of Negroid groups resisting the Islamic religion (J.D. Fage, 1969:32-33). Arguably too, the amalgamation of the Kanuri and Bornu kingdoms into one powerful empire must have threatened many peoples resistant to Islam to migrate southwards. It is possible that the Chamba people could have been amongst these anti-Islamic fleeing peoples. We are therefore of the conviction that the Chamba original home was in the Chad basin before their southwards migration into the Alantika Mountain region.

THE CHAMBA LEKO MIGRATION

Fardon speculates that the proto-Chamba period was in the 18th century when they lived in settlements distinct from one another (R. Fardon, 1988:9). The

Chamba Daka lived around the Shebshi Mountains while the Chamba Leko lived in the East with concentrations around the confluence of the Faro and Deo rivers The boundary between the two peoples was marked by the Alantika Mountains.

Both Chambas are said to have started coalescing before mid-18th century. The foundation of the chiefdom of Yeli in the Alantika Mountains induced their union. The first chief was from Chamba Daka but over time, the rulers adopted the Leko language. It is at this time that the rulers are said to have sent emissaries to the West to introduce chieftaincy among the Daka in the southern area of the Shebshi Mountains. The Chamba of this area were called Nakenyare. But what caused the Chamba Leko diaspora?

The Chamba land was one of great geographical diversity with inhospitable plains and ravenous lands although also characterized by fertile river basins. If this land was occupied just by the Chamba people, they would have found some reasonable level of satisfaction. But the region also inhabited ambitious peoples like the Bata or Gbata, the Bachama, the Vere and Koma to the north and the Mbum and Koutine in the south of their settlement. There were also Fulani chiefdoms that had established in the region. Towards the end of the 18th century, the Bata people from Demsa who were skilled horse men had arisen as the most powerful group in the land. Not long after, they were overwhelmed by the Fulani jihadists whose religious fanaticism gave them a dominant position in the whole region. The Bata and the Fulanis invaded the Chamba land from the north. But the attack on the Chamba people saw more pressure on the Chamba Leko who inhabited relatively more attractive land than on the Chamba Daka people who were mostly on the hill slopes.

The implantation of a cordon of Fulani chiefdoms within the Faro-Deo river valleys, predominantly occupied by Chamba Leko, as a result of the Jihadist conquest further instigated the displacement of the later. Unyielding to the Fulani Islamic religion, the Chamba Leko abandoned the riverine plain and emigrated in four waves.

These included:

- The Den Bakwa group led by Loya Garbosa which today is composed of the Donga dynasty in Nigeria.
- Another group was Daka of Gyando, whose descendants are found in the Takum area also in present day Nigeria.
- Then a third group was the Pere (Peli) led by Mudi which is known as Modi in Benue traditions and Muti in Bali traditions. Their descendants are found in Bali Chamba fondoms and are said to have introduced Chamba-led people into the Kashimbila area of Nigeria.

- Finally there was the Ba'ni of Gawolbe whose descendants founded the five Bali Chamba Fondoms of the Northwest Region of Cameroon. The Gawolbe group moved south-westward raiding and amalgamating followers from the Kufad, Tikali, Nabuli, Babele, Sungneba, Buti, Kontcha and Ti. It should be noted that in as much as the Modi and Gawolbe groups were separate and independent, they are said to have raided together until the Bamenda Grassfield.

It is therefore important to note that not all the Chamba Leko people who left the Faro – Deo region accompanied Gawolbe to the Bamenda Grassfield. Nor did all of them migrate with Gawolbe. The group under Loya Garbosa left from Dindin on the River Deo around 1810, passed through Tipchen near Koncha into the valley of River Taraba and continued southwards to Takum. But they could not settle here because of hostilities from Kumboshi's men. So they moved northwards into the banks of Rivers Donga and Batanji which are both the tributaries of River Benue. They founded the settlements of Donga, Suntai, Rafin, Kada, Nukpo, Tisa, Chanchanji, and Gankwe. They are today referred to as Benue Chamba.

The Ndangambila commanded by Gyando of the Chamba Daka clan and later by his son Kumboshi departed with two Chamba Leko groups that later on became known as the Takum Chamba and the Kashimbila Chamba. They actually left with Gawolbe and reached the Bamenda Grassfield before returning towards the Benue and settling in Takum. The Chamba of Kashimbila, also known as Chamba Peli or Pyeri later known as Bali Muti (Modi) also accompanied Gawolbe for so long that some sources insinuate that they were part of Gawolbe's group that abandoned, led by two leaders – (Muti or Modi and Gadi).

It should also be underscored that not all the Chamba Leko people migrated. Some of them remained behind and settled on the Alantika mountains. Eventually, they were forced out of the Faro-Deo areas by the Fulani. This last group is said to be the only Chamba people that migrated as a result of the Fulani jihad. They were led by Damashi. They travelled westward to the Shebshi Mountains where they settled among the Chamba Daka in villages now known as Sapeo, Duna, Balkossa, Kollu, Lapeo and Wapeo. Although up the mountains, they were still chased by the Fulanis until Damashi had to make peace with Modibo Adama. The Ba'ni Gawolbe's faction was led by Gawolbe, but who was Gawolbe?

Not much is known of Gawolbe before the Chamba Leko migration. Oral traditional sources state that his name was originally Wodbe and he was heir to a Chamba Leko chief known as Gangsin He is said to have killed his kin

brother Sama because of a disagreement over a cattle. It is said that he never returned home after the death of his brother. Rather he gathered some followers and migrated southwards. He was soon to make himself the chief of the people he led and took the reigning title of Ga and became Gawolbe.

Undoubtedly, this tradition is disputable because nothing is said of what happened to his father Gangsin and the rest of the chiefdom under his father. Nor does the account consider the Bata/Fulani pressure and the famine that is said to have been serious in the Faro-Deo area at the time as causes of the migration. Gawolbe could not have left unprepared with a few people whereas he is said to have led a large and varied contingent of followers.

It is rather convincing to speculate that Gawolbe succeeded his father Gangsin before migrating out of Faro-Deo. From the name he must have been crowned king before his departure. According to PM Kaberry Gawolbe in Chamba Leko language denotes a ruler from the water and Eldridge Mohammadou guesses that the water was the sacred lakes of Kolongti and Kollu in which Chamba Leko chiefs were cleansed before their coronation. Indisputably therefore, Gawolbe was crowned chief before the diaspora. He is said to have been the 6th chief of the Ndangabila people after Gangsin, Ganyam, Gabanjang, Gatumjang and Gawolbe I. He was therefore Gawolbe II.

When and from where did Gawolbe II leave the Faro-Deo?

The date or period of the departure from Faro-Deo is not specific. It was either at the tail end of the 18th century or at the very beginning of the 19th century. M.D.W. Jeffreys (1957) states that it was in the 1770s while Fardon situates their departure in 1830. These dates are inevitably incongruous because Gawolbe's death is said to have been around 1830 in the Dschang plateau, and if he personally led the people from Faro-Deo to the Bamenda Grassfield before meeting his doom in 1830, then he must have left earlier than 1830. Similarly, it does not also seem possible that he must have sojourned from Faro-Deo to Bamenda for 60 years if he took off in 1770. It must be noted that he did not die from age, he died in battle, which means that he was still active and of good age. It is therefore possible to situate their departure at the end of the 18th century, about 1795.

Similarly, no certainty is yet established as from where they took off exactly. The suggestion that they left the Faro-Deo from a group of Mubako-speaking villages called Bare Nyonga on the right bank of the River Deo opposite Malkoga does not seem convincing although the source claims that Bare Nyonga was a nick name of Gawolbe's Ndangambila. This Bare Nyonga must not be confused

with Bali Nyonga that emerged later from Gwaolbe's Bali Chamba.

In as much as the itinerary of Gawolbe Chamba movement is not yet agreed upon , it is generally accepted that they first travelled to Kontcha in the Koultine plain where they raided the people incorporating the Buti Koncha, the Nabuli, Babele and Sugneba conquered soldiers into Gawolbe's army (R. Fardon 1988:176). The encouragement acquired from the success in Kontcha led him to further raids.

They continued and raided the Nyam Nyam as they marched south-eastward sweeping through Tignere and invading the Mbum villages of Ngaoundere and Tibati onto Banyo. Here Gawolbe made alliances with the people he raided and that procured him an important contingent known as Kufad or Gbadineba (E. M Chilver and PM Kabbery 1967:16). This contingent was comprised of the most important non-Chamba alliance groups that became part of Gawolbe's cohorts. The Kufad people had significant impact on Gawolbe Chamba people. They addressed the Chamba people as Bare or Bari or Baari which Ndifonta suggests is a corrupt pronunciation of Pere or Pyeri or Peli by which the Chamba identified themselves (N.B. Nyamndi 1988:16).

From Banyo they invaded the Tikar country and incorporated the Tikali before invading the Kaka people in present day Donga-Mantung Division. From there they moved into Kovifem, the Nso capital, before turning onto the Bamum plateau. Here they met with another Chamba faction, probably Gyando's people with whom they jointly attacked Bamum during the reign of Ngu Moonzi, the seventh ruler of the Bamum kingdom. The Chamba alliance conquered Bamum, took over the capital, Foumban. Ngu Moonzi took refuge at Koundoum. But subsequently, the Chamba people were ousted out of Foumban by a Bamum Prince, Nzi Mayup.

On departing Fumban, Gawolbe incorporated contingents of people who had suffered from Bamum domination and preferred to submit their loyalty to Chamba sovereignty. These included BaSangam who were led by Mabang, BaSang led by Fotchumu, and then the BaNdyang led jointly by Fondiangho, Fonkom and Fongang, then, BaLap, BaNgod, BaMunyam, BaKundem, BaFuleng, BaSet, and finally, BaNdip (N.B Nyamndi 1988:20). From Fumban, Gawolbe moved to Kuti or Tsen where he was hospitably received by the BaTi people. But he did not intend to settle there, rather he continued to the Bamenda Grass-field with a large number of BaTi followers who (henceforth were recognized as Ti-Gawoldbe) accompanied him because they admired his leadership style.

It will be noted that his following or subjects multiplied in numbers not only because he conquered them but much more because of the admiration for his

human management style (E.M. Chilver, 1967:70-71). Henceforth Gawolbe Chamba had two major clusters:

Ba'ni comprising the Gawolbe's Ndangambila and other Chamba confederates, then the Kufad, Buti and Tikali.

Banten or Ba Lo'lo' consisting of all the adherents acquired after quitting Fumban.

With this large following, the mounted Gawolbe horsemen and their followers marched into the Bamenda region raiding and looting the chiefdoms they found on their way. They did not settle in any of the places that they conquered for long but lived on whatever booty they found and then forged ahead. They marched westward into Ngie area in today's Momo Division where the climate and vegetation proved inhospitable for them and for their horses.

At the same time Gawolbe's huge following was becoming unwieldy to manage and therefore almost disintegrating. Gyando's Chamba Daka confederate split off and moved north through Wum and settled in Takum where they are found today.

Gawolbe sent a troop led by one of his officers Gabana, to investigate if the extensive dense equatorial forest extending to today's Mamfe was habitable. Gabana and his squad went as far as Tali and Tinto and their horses could not stand the equatorial forest. Many of the horses and some of the cavaliers died from the diseases of the forest. As a result they retreated and marched northwestwards and arrived at Fontem, then continued further north at Dschang, located on a beautiful plateau where they found attractive savannah vegetation. They found the chiefdom of Bafu-Fondong as the main occupants of this gorgeously fertile land around where Djuitisa tea Estate is found today. It is possible that Gawolbe might have considered a conquest of the people to occupy their land or just to pillage and conscript some of them for his army.

Unaware of the Bafu-Fondong associated ethnic extension into the vast Bamileke territory, Gawolbe attacked and at the battle of Kolm outside Bafu-Fondong, he was unpredictably overwhelmed by a powerfully united Bamileke troop that overpowered him and his Chamba confederates resulting to his demise. The date of this battle was probably 1830. The death of this prodigious Chamba groundbreaker in the war brought total bewilderment in the Chamba camp. They had not prepared for such a calamity. Since they left their homeland in Faro-Deo Gawolbe was the sole leader and there was no thought of succession or a will. As a result succession crisis was bound to ensue.

Dissolution of Gawolbe's Bali Chamba and the birth of new Fondoms.

In the attempt to reorganize themselves and install a new leader to succeed Gawolbe, a succession schism resulted in the split of the king-dom and the formation of new ones which included; Bali Gham, Bali Kumbat, Bali Gangsin, Bali Gaso, Bali Muti, Bali Kontan, and Bali Nyonga. While some of the leaders were princes who struggled to succeed their father, some were powerful and influential king makers who sought for leadership. Meanwhile Bali Nyonga was established by Princess Nahnyonga who after secur-ing her own followers, handed the new found kingdom to her son Nyongpasi, a dynamic and valiant soldier who picked up the reigning name of Fonyonga I.

FONYONGA I OF BALI NYONGA

Unprecedentedly in the Chamba traditions, a woman founded a kingdom, Bali Nyonga. Oddly enough, her brothers did not protest against her effrontery. It can be argued that her generous attitude and gentle demeanour added to the valiant disposition of her eminent warrior husband, Doh Bani to scare anybody attempting to object to her ambition. Hence she was able to pull very many followers.

In spite of the respect she wielded, she did not want to rule the kingdom that she had crafted. She installed her son Nyongpasi, a soldier of great repute who became Fonyonga I. Besides his military capability, Nyongpasi was greatly admired for his impartiality, constructive ideas and astuteness. It is said that his presence commanded respect. In respect to the mother, he created the enviable post of Ma-fon or Queen mother to which he instated her, a position that has remained respected and valid in the culture of Bali Nyonga till today.

Fonyonga I believed in consultative rule. He involved people from diverse backgroups and extractions in the development and implementation of his policies. When he became assured of the loyalty of his followers, he embarked on a search for a permanent settlement.

Meanwhile from the Dschang plateau, the new Chamba confederates migrated through Santa and Awing. Bali Kontan travelled through Bamenda and settled in present day Bali Nyonga land. Others (Bali Gangsin, Bali Gaso, and Bali Kumbat) journeyed into the Ndop plain. Meanwhile Bali Gham and Bali Nyonga travelled eastward deeper into the Bamileke hinterland. Bali Gham stopped at BaGham Nindeng before moving back to their present site close to Awing. Bali Nyonga sojourned to the Bati land overlooking the rich and fer-tile Noun plain belonging to the Bamum. They camped at a place called Tsen

which the Bamum called Kuti, today known as Koutie or the land of the BaTi people. The Bamum also refer to this place as Kubale which means the land of the Bali people.

Fonyonga I and his adherents were very warmly welcomed by the BaTi people. Reasons for this hospitable reception are many and varied. Their earlier encounter with Gawolbe left happy memories. It should be remembered that in Fonyonga I's ranks were some Ti-Gawolbe. As a result, the BaTi people gave him full honour and looked up to him as their leader. At the same time they were suffering from Bamum suppression and saw Fonyonga I as an appointed saviour. M.D.W. Jeffreys observed that the exciting hospitality and submission caused Fonyonga to contemplate permanent residence. This required establishing his authority in the region. Consequently, he took advantage of the assistance of the BaTi, to embark on a series of campaigns that led to the conquest of the people of Bafoussam, Bangante, Banjun and Bansoa. Bali Nyonga became almost the supreme state in the region but for the powerful Bamum kingdom then under the famous Mbuombuo. It is important to note that Fonyonga's conquests left a durable relationship between Bali and the conquered people that yielded Bali Nyonga monarchs royal respect from these people until the establishment of the colonial administration.

Meanwhile inherent animosity against the Bamum caused the BaTi people to urge Fonyonga I to avenge Bamum's persistent harassments on the neighbours. They preferred to have Bali Nyonga replace the Bamum dominion in the region. Inspired by his recent successes in warfare in the area and the request made by the BaTi people, Fonyonga was very motivated to launch an attack on Bamum. With a large following of Bali-BaTi warriors, Fonyonga I launched a successful surprised attack on Fumban and defeated Mbuombuo but failed to occupy Fumban. Fonyonga imprudently retreated with his troops to Kuti to relish his success and plan strategies on how to administer his acquired empire. In the meantime Mbuombuo took advantage of the absence of Fonyonga I to strategize a counter attack on Kuti. In a similar surprised assault Mbuombuo captured Kuti and chased out Fonyonga and the Bali people together with their adherents from the region. Fonyonga escaped alongside all his Bamileke allies who could no longer remain in Kuti and face the inevitable wrath of the Bamum. These terrified people included people from Lap, Munyam, Fuleng, Dip, Ndiyang, Set, Sangam, Won, Kwen and Nggod .It will be remembered that majority of these people belonged to the groups that joined Gawolbe during his passage through this land.

Following the defeat of Fonyonga I by Mbuombuo and the amalgamation of

so many varied groups, Fonyonga had to search for a place to settle them. Attracted by the fact that the other Bali Chamba groups were well settled in the Bamenda Grassfield, he embarked on a westward march and crossed the River Nun. He camped for a short while around Bagam where he incorporated the Nggonlan before continuing westward. The Bagam plain has an attractive landscape, vegetation and climate that could have enticed him to settle there but Nyamndi argues that at that time Bali Kumbat was establishing and consolidating their impact in the area and they did not want to rival them. If they attempted to stay, they would have eventually encountered conflict with their Bali Kumbat brothers. From Bagam they climbed the Awing hill and stopped at Bambili where they spent a few months. From Bambili they took note of the beautiful and extensive plain occupied by Bafreng people (Nkwen) and decided to occupy it.

They invaded and raided the Bafreng land, dismissing them from their homeland. The Bafreng people took refuge in Bafut and Bikom as the Bali people settled and occupied their land for seven years. Thereafter, they invited the Bafreng people to return and share the land with them. Many reasons have been advanced to explain the sudden change that caused Fonyonga to ask the Bafreng people to return to their land after seven years of exile. But the most plausible reason is that Fonyonga intended to ally with them in order to face any eventual attack and also to employ their smiting skill for his war armoury. On their return the Bafreng people contracted a blood pact with Bali Nyonga promising to protect one another at all times. So they lived in harmony until an opportunity availed itself for Fonyonga to occupy a more convenient place.

Settlement in Bali Nyonga.

It was not long after the return of the Bafreng people from exile that Fonyonga received a proposal to occupy a more beautiful and spacious land hitherto occupied by their kid and kith, Bali Kontan and their conquered Widekum subjects. This was very tempting since Fonyonga had envisaged establishing an empire on an extensive and attractive land. He also saw a gain in the conquest and assimilation of Bali Kontan and their Widekum subjects. He therefore prepared an attack on Bali Kontan which apparently did not take place because the Kontan people were not prepared to fight against their own brothers. For a sign of peace the Kontan people surrendered their standard flag, the "tutuwan" to Fonyonga.

In order to appreciate the gesture demonstrated by Bali Kontan, Fonyonga declined from attacking Bali Kontan and settled away at Kufom, some eight miles away from Bali Kontan in the present Bali town. Meanwhile Fonyonga

made sure that his authority over the entire land was recognized and respected with regular supply of royalties. Consequently, Fonyonga's dream of establishing an empire thrived.

The establishment of Bali Empire

Fonyonga started building his dreamt empire by annexing all the Widekum villages that Bali Kontan had conquered and drafted the Fon of Bali Kontan into his War cabinet ranking him as one of his sub-chiefs. Then he felt like expanding south eastwards. The significant and lucrative state in this direction was Pinyin. He prepared an invasion on Pinyin which was a fiasco. The Pinyin army ambushed the Bali invaders in the forest that separated them and Bali. Being adept open field fighters they could not resist the surprised warfare in the forest so they lost the war which is said to have taken place in 1856. Shortly after that Fonyonga died.

As pioneer ruler of a migrant Chamba people, Fonyonga had achieved much. After establishing a monarchy, the mother Nahnyonga had handed the leadership to him and he never failed in his duty as a leader. He bequeathed a strong and powerful monarchy to his son who took the reigning title of Galega I.

GALEGA I (C1856-1900)

Galega I was a wise and shrewd ruler, who was born in Banyo during the Gawolbe Chamba southward migration. Galega grew up therefore as an eyewitness to all his father's accomplishments and ordeals. He was therefore determined to sustain the dreamt empire. He transferred the palace from Kufom to Ntanka (the present site) where they finally settled. Based on his alliance with Nkwen, Galega terminated a 15 years fratricidal war with their Bali Kumbat brothers who persistently pursued to annex Bali Nyonga and claim paramountcy in the region. They were defeated at the battles of *Paila* and *Ngwa'ndikang*. The Paila battle front was right inside Bali town and the latter close to the Santa border. Meanwhile Gagwanyi, Fon of Bali Kumbat was caught and decapitated by Bafreng, in accordance with their blood pact with Bali Nyonga.

Galega's paramount sovereignty over his people and the conquered neighbours became unquestionable. Henceforth, he became more focused on organizing and consolidating the kingdom. He established the Executive and Legislative councils of the Bali Nyonga kingdom, comprising *Fontes* or sub-chiefs and *Nkoms*. He also established the spiritual leaders comprising the *Nwanas* and the *Samas*. The members of the spiritual core were specially respected for

their role in performing all the mystical and religious rites and rituals of the kingdom. Subsequent modifications of the constitution accredited them even with more authorities that empowered them even to dethrone the monarch if he were to be found guilty of felony. As such, the *Nwanas* in the *Voma* cult and the *Samas* in the *Lela* cult were said to wield mystical powers.

After consolidating his internal administration, he embarked on conquering the immediate neighbours and amalgamating them into the dream empire that extended throughout much of the Grassfield region (today's North West Regions). Hence at the arrival of the Germans, he was recognized as the paramount ruler of the Grassfield. That is why the Germans sought for his help to establish colonial administration in the Grassfield.

Galega I is also accredited with his cautious and valuable reception and hosting of the pioneer Europeans in the entire Grassfield by 1889. He even allowed the first colonial administrative headquarters in Bali which was displaced later by his successor to Bamenda because he could not stand the effrontery of seeing a foreigner share in his loyalty. He equally invited the first missionaries who arrived Bali in 1903, after his death and were received by his son and successor. He bequeathed a strong and well respected empire to his son Fonyonga II. (1900-1940).

FONYONGA II (1900-1940)

Fonyonga II was the first monarch to be enthroned under the German colonial administration. Though barely introduced to literacy by the German Basel missionaries, he was an astute diplomat who tactfully managed the transition between the German and British colonial administrations during WWI. He welcomed the Basel Mission that his father had earlier invited, provided lodging and helped to build the first Mission Church and school.

In 1905, the German administration proclaimed him the paramount ruler of the hinterland region in succession to his father. But soon after, subsequent German administrators following the death of Captain Glauning in 1908 insisted on relinquishing Fonyonga's lordship over his conquered states, thereby dissolving the Bali Empire. The Germans even paid him 300 marks to release his hold on Babaju and Bangang. Then they followed up by liberating Bamumbu and Batibo. By May 1914, the German Governor Ebermaiers who was determined to dissolve the Empire freed all the suzerain peoples under Bali. The Fon's resistance to Captain Menzel's (Menzel was the successor of Glauning in the German headquarter in Bamenda) attempt to dismantle the Fon's powers led to

such a disagreement that on retreating from the region during the First World War, the Germans looted over £2000 *and traditional treasures before burning* the Fon's palace on 12th November 1915. This is a case that modern legal practice demands compensation.

After the defeat of the Germans and the establishment of British and French rule in Cameroon, Bali fell into the British mandated territory. Bali had cooperated with the British on their arrival against the Germans and that partially explains why they lost their palace in fire. The British recognized that favour. Besides the good turn they had from Bali during the war, the early British administrators such as Podevin and Duncan reported that Bali was the most developed and intelligent group within their area of administration. W. E. Hunt had a special admiration for the Fon and the traditional organization and administration of Bali.

Although Fonyonga started well with the British administration, the succeeding period was marked by the decline of the Bali Empire as almost all the vassal states sought to have their independence. Fonyonga then spent the rest of his life in domestic development and succeeded in constructing the first permanent structure made of burnt bricks in the palace. He established schools and encouraged the establishment of a Basel Mission health centre at Tikali.

He further expanded and consolidated the sovereignty of Bali over the conquered and assimilated people but maintained an open door foreign policy that enabled many people seeking for refuge to either gain temporal stay or absorption into the kingdom. It was from this policy that the frontier was opened to people of different background and ethnic origins. Fonyonga did not therefore hesitate to admit a batch of 3000 BaTi - Mbundam or Pati Nun people who sought for refuge in 1904 from Bansoa after they had wondered from southern Bamun. It is important here to distinguish between BaTi Gawolbe, amalgamated during Gawolbe's southwards migration, BaTi Fonyonga who accompanied Fonyonga I after the Bali-Bamum war and BaTi Mbundam who appealed on their own for immigration into Bali. They were provided settlement on their arrival at Kumnchu in Bali not far from the present day Bawock right in the heart of the kingdom in order to avoid an eventual self-declaration of sovereignty.

Chilver further states that between 1906 and 1907, a smaller contingent from Bawock (Bahouok) led by Nana the son of Ntukam who were escaping from antagonisms with their neighbours in the Bangangte area requested for refuge. Nana's choice of refuge in Bali seems to have been conditioned by the fact that his sister was married to the BaTi Mbundam man who was already

settled in Bali. Fonyonga 1 and his people readily granted them permission with the belief that they were people soon to be absorbed like the BaTi Mbundam, so that the kingdom could grow numerically. But the relationship between Nana and his brother in-law degenerated because the later quickly interposed himself between Nana and Fonyonga. He even started seeking for recognition from the head of the Basel Mission in Bali and the German Military station in Bamenda.

In 1912, the BaTi Mbundam decided to return to their original home in Mbunda. They took the Bawock people along with them but the later found it difficult to put up with their host. Hence they reapplied to the Fon of Bali for readmission into Bali. The Fon was hesitant to receive them but Rev. Adolf Vielhaur and the Basel Missionary in Bali pleaded with the Fon for their return (E. M. Chilver, 1964). They were installed on part of the land earlier occupied by the Bati Mbounda people on condition that they abide by the rules and traditions of Bali and pay loyalty to the Fon of Bali. That is why Chilver addresses them as a Bamileke group in Bali.

VINCENT SAMDALA GALEGA II (1940-1985)

Vincent Samdala Galega II was born in 1906. He was the first Fon of Bali Nyonga to be born in the land. Unlike the preceding monarchs, he received formal education and got trained and served in the medical profession. He started his reign in the second year of the Second World War and encouraged some of his people to enrol in the West African Frontier Force and fight alongside the Allies.

At his enthronement he recruited literate councillors and secretaries to modernize his administration and traditional judiciary to enhance good governance. He encouraged the establishment of adult education so as to get all nobles and family heads literate. He therefore had a good number of enlightened people who collaborated with him to develop the kingdom and maintain its eminence among all other kingdoms in Cameroon.

The end of the Second World War signalled the period of decolonisation of European colonies in Africa and Asia. Being one of the very few literate and enlightened traditional rulers of the age, V. S. Galega II was selected alongside Chief Manga Williams of Victoria as the first political representatives of Cameroon in the Nigerian Eastern House of Legislature in Enugu – Nigeria since Southern Cameroon was administered alongside Nigeria.

Having seen the establishment of the House of Chiefs in Nigeria, he became the architect of the establishment of the House of Chiefs which became the second chamber in Legislature in Southern Cameroon. From the inception of the

House of Chiefs in 1957 to its end in 1972, he held executive positions. As a result of his early exposure to national politics he subsequently worked closely with other Cameroonian nationalists to decolonize the country. He was the principal traditional ruler that fought alongside John Ngu Foncha for the reunification and independence of Cameroon. And after independence he embarked on the consolidation of national unity within the unique governing party.

Meanwhile at his local administrative level, Galega II had inherited the kingdom when most vassal states had gained their independence and were seeking portions of Bali land. He was faced with incessant appeals from the neighbours to surrender land to them. Fortunately the United Nations Mandatory administration could not allow arbitrary demarcation of land and maintained colonial boundaries as established by the German administration. The climax of the land problem surfaced in 1952 when almost all the surrounding neighbours in concert planned and attacked Bali to annihilate and take over the land. Unfortunately, they failed to achieve their ambition and were obliged to pay huge penalties to Bali. Even after independence pressures were ceaselessly mounted by these people to demarcate Bali land. The Fons' tenacity to withstand these harassments proved his capacity as an able leader.

It is also important to note that at his accession to the throne, Bali was just a council administered area. But by 1966, Bali was decreed an administrative district and in 1979 it was upgraded to the Sub-Divisional administrative status. He also continued construction of the palace and put up a befitting inner court.

It is also important to point out that the Christian Missionary societies that Fonyonga brought to Bali since 1903 continued to prosper and Galega II supported their growth and saw the development of primary education and the establishment of the first secondary school in 1949. He also followed up with the establishment of a district hospital and Mission Health Centres and Government secondary schools. Before his demise in 1985, he had made very valuable contributions at the local and national levels in the history of Cameroon. He rested sure of the future of his dynasty because of the excellent education he gave to his upsprings.

DOH GANYONGA III, PHD (1985-)

Doh Ganyonga III ascended the throne in September 1985 and embarked on consolidating the achievements of his predecessors. In his domestic policies, he has been very particular on economic advancement of the kingdom. Conscious of the fact that his people rely mostly on agriculture, he has encouraged

both subsistence agriculture and modern agriculture. While a large population is still dependent on small scale farming, a new and dynamic group has emerged with plantation agriculture (palm produce, coffee, cocoa and plantains) as well as animal breeding (poultry, piggery, cattle etc).

Many farm-to-Market roads have also been built from all the rural villages to Bali town. These roads help to evacuate farm produce from the countryside to the central market where the old traditional market has been transformed into a big lock-up market and now serves both as a daily market and as a weekly market.

The Fon has also called on his subjects to take note of the fact that the Bamenda-Enugu international highway that passes through Bali plays a major role in the economic development of the kingdom. All village markets along the highway henceforth serve as market attraction to the road users. The Fon has also reminded his subjects to make good use of the high-way and ease access to sell their products in the markets of the Regional headquarter town of Bamenda, to Mamfe and eventually to Nigeria.

His social policies emphasize good hygienic conditions. He has repeatedly called upon his subjects to know that cleanliness leads to improved health and reduces mortality rate. He has shown interest in the development of the District hospital, the Church hospitals and Health Centres in the kingdom. These Health facilities do not only offer curative treatment, rather they take very active part in health education which focuses on prevention of diseases. During the reign of Ganyonga III, Bali elites including Nkumu Fed Fed and Mbonbani in diaspora have made considerable donations to these Health units.

An important social concern of the monarch has been to encourage traditional social groups to revamp and update their activities so as to renovate their social norms to cope with modern trends and maintain good character. An inventory of social groups in Bali shows that there are currently, 110 groups comprising 70 male groups and 40 active female groups and about 30 non-gender based groups. The Fon's messages and instructions are communicated to the grassroots through these social groups which meet weekly or fortnightly. These groups also act as basic economic organs by cooperating in farm work and financial scheme. Fon Ganyonga has been very encouraging to these groups and has been seeking external finances to boost their activities.

It is important to note that because of the improved inter-village relations with their neighbours there have been many borrowed social groups. Even trade relations led to the borrowing of far distant dance culture (the Ekgwe or Nyamkwe) from the Bayang and Keaka people since the 1920s. Whereas the music was sung in their original form, they have been adapted and are now

sung in Mungaka.

As an academic, Fon Ganyonga III has been very concerned about the development of education in the kingdom. He demonstrated his love for education by opening a nursery and primary school in the palace where the pupils are taught first in the Bali language (*Mungaka*), then in English and French. Currently there are 55 Nursery and primary schools. The numbers of secondary schools have also risen from 3 to 12 Secondary General and Technical schools and the opening of Technical and Industrial secondary schools has widened the scope of education in Bali enabling youths to graduate as job professionals, thereby eliminating joblessness and delinquency.

Meanwhile a remarkable development in education has been the establishment of the Cameroon Christian University (CCU) which Fon Ganyonga III agreed with the Presbyterian Church in Cameroon (PCC) to start functioning since 2011. They have already graduated two batches of students. This university has specialized programs in professional education which is most appropriate at this stage of Cameroon economic growth. The magnanimity of the Fon to award extensive land for the university is a manifestation of his interest in education and the advancement of his kingdom.

He has also encouraged those who are unable to continue their education to embark on training in various trades and crafts. The Presbyterian Craft Centre at Tikali has trained both men and women in weaving, carving, embroidery, arts and painting as well as in developing different craft products for sale.

Just like his predecessor, His Majesty, Senator Dr Doh Ganyonga has shown a lot of passion for national politics. Enthused by his father's legendary political involvement to gain independence for Cameroon and backed by his academic specialization in the sociopolitical sciences, he has been inclined to participate in the political life of the nation since the beginning of his reign. It was not therefore surprising that he became one of the pioneer senators of the Cameroon House of Senate. Realizing that his people can best gain from the ruling party, he persuaded them to support the party and that made Bali to emerge with the pioneer Cameroon Peoples Democratic Movement (CPDM) council in the Mezam Division since the usher of the new multiparty political dispensation.

The relationship with the neighbours has remarkably improved and is currently quite cordial although occasional land boundary issues sometimes emerge. Ganyonga's diplomatic dexterity combined with the dynamism of his elite group and Government adroitness in maintaining peace has often brought amicable solution to tense situations. That is why the Bawock incident of 2008 was calmed down by the wisdom and astuteness of the Fon who restrained his subjects from

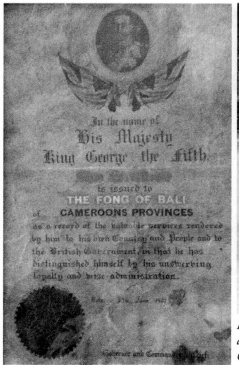

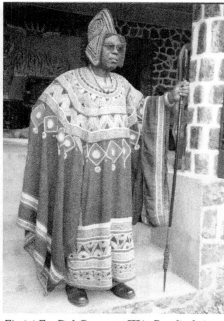

Fig 1.1 Fon Doh Ganyonga III in Regalia designed and fabricated during the reign of Fonyonga II. Credit: Fon's Archives

Fig 1. Certificate of Recognition by King George V. Credit: Fon's Archives

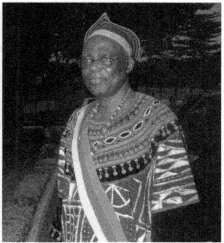

Fig 1.2 Left, Senator Fon Doh Ganyonga III in front of the National Assembly; right, Fon Doh Gayonga III's official photograph as Senator. Credit, Fon's Archives

23

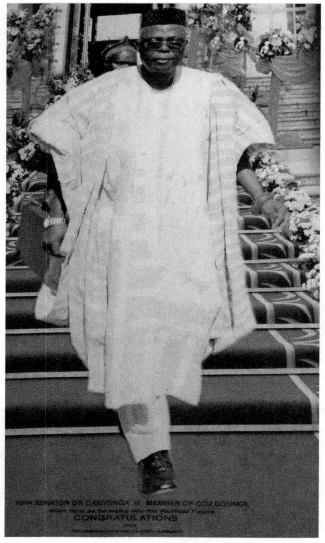

Fig 1.3 Portrait of Doh Ganyonga III donated by Cameroon Christian University. Credit: Fon's Archives

reacting unreasonably, and peace has reigned since then.

It is difficult to expatiate on his achievements while he is yet on but history will definitely evaluate his reign positively because so far he has already been recognized and decorated by the Government for meritorious services to the nation. The future is therefore bright and hopeful.

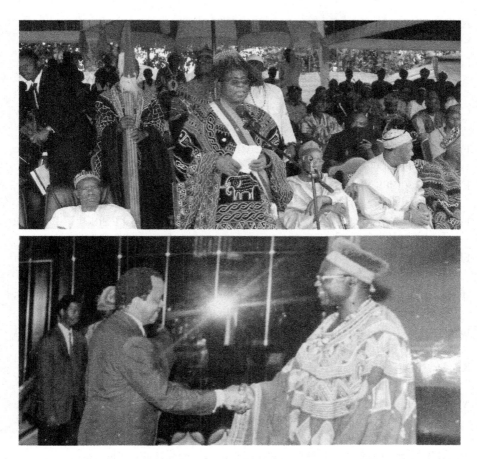

Fig 1.4 Top: Fon Ganyonga III addressing the Bali population at his civic reception as Senator. Credit: Fon's Archives; bottom, Fon Ganyonga III greets H. E. President Paul Biya (left) at the Unity Palace, Credit: Eric Photo.

References

Chilver, E. M. (1964). "A Bamileke Community in Bali-Nyonga: A note on the Bawock" in African Studies, 23, 3-4.

_____(1966). Zintgraff's exploration in Bamenda, Adamawa and Benue lands 1889-1892, Buea.

Chilver, E. M. & Kabbery, P.M. (1967). Traditional Bamenda; The pre-colonial History and Ethnography of the Bamenda Grassfields, Buea

Fage, J. D. (1968). A History of West Africa, An introductory survey, Cambridge University Press

Fardon, R. (1988). Raiders & Refugees, Trends in Chamba Political Development, 1750-1950

Fardon, R. (1980). "The Chamba: A Comparative History of Tribal Politics" PhD thesis, London, Vol. 1, p. 92

Hunt, W. E. (1925). An Assessment Report on the Bali Clan in the Bamenda Division of Cameroons Province, Bamenda

Ifemesia, C. C. "States of the Central Sudan" in A Thousand Years of African History; edited by J. F. Ade Ajayi and Ian Espie pp. 72-74.

Jeffreys, M. D. W. (1963). "Traditional Sources Prior to 1890 for the Grassfield Bali of Northwestern Cameroons" in Afrika und Ubersee Band XLV/S

Kaberry, P. M. & Chilver, E.M. An outline of the traditional-Political System of Bali-Nyonga, Southern Cameroons in Africa Vol. 31. 4. October 1961

Mohammadou, E. (1978). Les Royaumes Foulbe du Plateau de l' Adamaoua au xixe siècle. Institute for the Study of Languages and Cultures of Africa and Asia, vol. 1V, Tokyo

Nyamdi, N. B. (1988) The Bali Chamba of Cameroon, A Political History

Presidential Decrees No. 66/DF/433 of 26th August 1966 and No. 79/469 of 14th November 1979

Soh, P. B. (1978) A Study of Bali Nyonga History and the Lela Cult, Yaounde.

Titanji, Vincent et al (1988), Introduction to the study of Bali-Nyonga: A tribute to his Royal Highness Galega II, Traditional Ruler of Bali-Nyonga (1940-1985) Yaounde, Stardust Printers.

3

THE ROLE OF NDAKUMS AND BANDECA IN THE DEVELOPMENT OF BALI NYONGA 1985-2015

Robert Babila Sikod

ORIGIN OF NDAKUMS AND BANDECA

The idea of cultural associations is a very old idea which started during the reign of Fon VS Galega II. His reign which was partly during the colonial period i.e. the British administration and partly during the post-colonial epoch saw attempts to promote the lofty idea of self-reliance development and the idea of cultural associations. During the period of the British Mandate administration (1922-1946) the idea of self-reliance was promoted by the British system of Indirect Rule in which Native Authorities (NA) were created and traditional rulers were an integral part and an important arm of the administrative machinery. Traditional rulers such as HRH Fonyonga II (1901-1940) and his successor HRH Galega II served as NAs under the British administration among other NAs in the Bamenda grassland. They were empowered to raise funds through taxes for self-reliance development like road construction, the building on health centres a well as schools. When the British left the Southern Cameroons following the achievement of independence and reunification of the British Southern Cameroons and the Republic of Cameroon (Former French Cameroon) in 1961, the idea of self-reliance development was kept alive through associations.

The idea of a sociocultural association was brought up by HRH Galega II who had a vision to bring all the Chamba groups together i.e. Bali Nyonga, Bali–Gasho (Gasu), Bali–Gangsin, Bali-Kumbat and Bali Gham into a Chamba Union. This pan Chamba sentiment in him was manifested by the visits he undertook to the other Chamba chiefdoms and the invitations e regularly gave to his peers of the other Chamba chiefdoms. During the Lela festival, Galega

II and his counterparts from other Chamba chiefdoms could be seen on the rostrum seated side by side with one or two of the Chamba chiefs and following up the Lela ceremonies .Even though this happened, the idea of a Chamba Union never materialized owing to the fact that they were separated geographically by great distances and the fact that administratively, the were under different divisions and therefore could not easily come together and identify themselves as a people with a common ancestral origin, the issue of association or union was now narrowed down to the level of villages.

It all started in Bali Nyonga with the emergence of "ndakums" or meetings at home and outside the village by the sons and daughters of Bali Nyonga extraction to promote culture, development and their own mutual welfare. The idea of meetings by the indigenes people of Bali Nyonga started during the period of the Germans (1884-1916) and cut across the British period right into the post-colonial era. For instance under the Germans, slave labour form Bali to the coast tried to identify themselves through sociocultural meetings wherein, they tried to promote their own culture, and give welfare assistance.

This idea of meetings was kept alien under the British Mandate administration by the natives of Bali Nyonga within and without the village. So Bali Nyonga elite first came up with the Bali Elements Workers Union (BEWU) in the 1990s and they included: Ba Gwanyam, Late Ba William Nchamukong, Late Mr John Doh Fokunde, Mr Njimonikang, Masala Ntan and Mr Nana. As members of BEWU, their objectives were to promote workers' rights their own welfare, assist in the award of scholarships to Bali students who excelled in certificate or public examinations.

After some years of it existence, BEWU faced out and was replaced by the Bali Social Cultural and Development Association (BASCUDA) in the 1970s. The brains behind the creation of BASCUDA were the Bali Nyonga elite in Victoria (present day Limbe) under the leadership of Dr Gwanulla. They referred to it as the Bali Social Cultural and Development Association Fako (BASCUDAF). This inspired the creation of BASCUDA Yaoundé, BASCUDA Douala, BASCUDA Bamenda and BASCUDA at home. BASCUDA operated under the auspices of Fon VS Galega II by receiving money from the different branches of BASCUDA for the realization of approved projects at home.

Galega II created BASCUDA with the assistance of the late Honourable Gabriel Bambod Sikod, late Ba Fomban, late Honourable Cletus Tita, Ba Tita Sikod of Mbangom. Ba Tita Nji, Ba Daniel Ntah, Ba Ndangam Augustine an elite among others.

BASCUDA faced a number of challenges. First each group tried to be

autonomous financially and tried to project itself by realizing particular projects at home independent of the others. Besides, each branch of BASCUDA had its own appellation. For instance, BASCUDAF for Fako Branch, BASCUDAY for the Yaoundé branch and BACCUDA for the central or mother branch at home. Such division did not augur well for the association. In addition, BASCUDA did not indicate the particular Bali Group or village that it represented and there was a need for specification of the village that it represented. This now encouraged the creation of the Bali Nyonga Development and Cultural Association, (BANDECA) to solve that problem of appellation.

BASCUDA, the forerunner of BANDECA later went into oblivion but that was not the end to the development initiative and effort of the people as the burning ambition of Galega II was replicated by his son and successor, HRH Dr Doh Ganyonga III. As a man of vision, and mission with the burning desire to see the village developed, Ganyonga III revamped the activities of the defunct BASCUDA by creating the Bali Nyonga Development and Cultural Association (BANDECA) which went operational in 1995 following the election and installation of the first National Executive Committee with Ba Forkusam Langmia as President-General. HM Ganyonga assigned the task of drafting and new Constitution for BANDECA to Professor Vincent Titanji and Mr Forkusam Langmia ,a task which the carried our to the satisfaction of the constituent Assembly that met to approve it in Bali Nyonga and then to elect the first Executive. Subsequently Professor Titanji chaired two General Assembly meetings of BANDECA during the mandate of Dr Ndifontah Nyamndi as Director General.

Before this event, the Fon had visited the Bali Nyonga community in Yaoundé, Douala, Buea, Tiko, Mutengene and Limbe, where he briefed his kith and kin on the deplorable situation of Bali Nyonga in particular and the problems that Bali was facing such as the lack of pipe borne water, electricity in certain areas, sporting infrastructure, farm-to-market roads, health and educational amenities among others. He went further to tell the people that they could not talk of a strong and prosperous Bali Nyonga without their efforts and commitment to work. He reminded them that all hands must be on deck before their dream of development could become a reality. The Fon said that the government could not do it all but could only subsidies their development drive or initiative. It was the fervent wish of the Fon that the Bali people in the nearest future should buy his idea and make the new association functional by establishing branches wherever there was a community of people of Bali Nyonga origin.

The Bali people heed to the Fon's call and first BANDECA National Council meeting took place on 24th December 1995 in the Bali community Hall. It was summoned by the Fon himself with the purpose of presenting the amended constitution and to elect a national executive Committee that was to pilot the activities of the association. Present during the meeting were delegates from five Divisions that is Fako, Bui, Boyo, Menchum and Mezam. With this number, the delegates adopted that elections were to take place.

However, before this could be done, it was agreed that the President General was to be elected and the rest of the posts to be shared to the various Divisions for easy coordination as shown in table 1.

Post of Responsibility	Branch Appropriated to
President general	Bali
Vice president general	Yaoundé
Secretary general	Bali/Mezam
Assistant secretary general	Fako
Financial secretary	Bafoussam
Treasurer	Bali/Mezam
Legal advisers	Fako /Douala
Publicity secretary	Bali/Mezam
Cultural adviser	Bali

Table 1: Post of Responsibility on BANDECA National Executive Committee and Branches Appropriated to. Source: Minutes of the first BANDECA NEC meeting held in Bali Nyonga on 24th December, 1995.

Bali was well represented during the meeting and taking cognizance of this fact, the elections took place and the posts appropriated to Bali were occupied. The outcome of the election was as follows in table 1.2.

Post of Responsibility	Names of Officials
President general	Ba Forkusam Langmia
Secretary general	Mrs. Monkam Elizabeth
Treasurer	Mr. J.N. Bakoh

Publicity secretary	Mr. Terence Gwanmesia

Table 1.2: BANDECA National Executive

However, this executive faced a major challenge owing to the fact that the rest of the Divisions refused to conduct elections and send names of the executive. They apparently were protesting against the positions attributed to them as undemocratic and unfair. All these rendered the association dysfunctional as very little was achieved by the 1st executive.

In spite of this handicap, the Bali Nyonga people were more than ever before determined to rekindle hopes by revamping the association and making it a real catalyst for change and development through democratic elections. It was against this background that a new executive for BANDECA was democratically elected and put in place on the 27th of November 1999. During the election, there were at least five delegates from each of the Divisional Councils. The election results were as follows in table 3:

Post of Responsibility	Names of Officials
President General	Dr. Ndifontah Nyamndi
Vice President General	Ba Gwankehmia Alexander
National Youth President	Ba Nyamsenkwen Christopher
Secretary General	Akwa Usman
Vice secretary General	Ba Fosam Christopher Sato
Treasurer	Ba Gwanmesia Nkom Protus
Financial Secretary	Tatih Charles Dayebga
Development Officer	Godlove Kedinga Vininga
Legal Advisers	Barrister Nchuru Justice Sama and Justice Prudence Galega
Publicity Secretary	Gwanmesia Terence
Cultural Adviser	Ba Tita Fokum Dinga

Table 1.3: National Executive Committee of BANDECA, 1999

This executive was sworn into office on the 20th of December 1999 by HRH

Fon Dr. Doh Ganyonga III in the watchful eyes of the Lord Mayor for the Bali Rural Council and the Divisional Officer for Bali Sub-Division.

The new executive had some tasks to accomplish in line with the objectives of BANDECA and the "Ndakums" that constituted the base group.

OBJECTIVES OF NDAKUMS AND BANDECA

Article 4 of the BANDECA constitution spells out the objectives of the Association which is the same for the base group, "Ndakum" as follows:

- To study, preserve and promote the culture and historical heritage of Bali Nyonga.
- To develop Bali Nyonga in areas and aspects where local initiatives can complement government action in overall national development.
- To work for peace, unity and development, and foster these in Bali Nyonga and elsewhere.
- To contribute on a philanthropic basic to the education and cultural advancement of the Bali Nyonga people.
- To support and co-operate with any legally constituted organization that shares similar objectives.
- To support and co-operate with national institutions towards the achievement of the above aims and objectives. BANDECA was structured in a pyramidal form with the base being the "Ndakum" to the top.

STRUCTURE OF BANDECA

In order for BANDECA to function properly and realize its objectives, it was structured in pyramidal form from the top to the bottom under Article seven (7) of its constitution adopted on 28th April 2012. It had the following:

- The General Assembly (GA)
- The National Executive Committee (NEC)
- National Council (NC)
- The Divisional Council (DC)
- The Divisional Executive Committee (DEC)
- The Branches (Ndakum)
- The Branch Executive Committees (BEC)
- Functional Committees of NEC

The General Assembly (GA):

It is the supreme organ of the association composed of 10 members from each Divisional Council. It takes decisions on matters of general policy, elects members of the National Executive committee as well as chair persons of the Disciplinary Commission and Election Commission. It also approves the budget of the association.

The National Executive Committee (NEC):

It is made up of the President General and all his subordinates and collectively charged with the implementation of the decisions of the General Assembly. It prepares the budget of the association, presents a report of its activities to the General Assembly among other functions. Its members may be impeached on grounds of gross inefficiency or mismanagement.

The National Council (NC)

It is composed of the National Executive Committee, the President and Secretary from each Divisional Council, chairman of Bali Traditional Council, the leaders of BCA-USA, BCA UK, BCA Europe, "Nkumu Fed Fed", the leadership of village Cultural and Development Association resource persons and experts. It was charged with the elaboration and implementation of the association's policy; it approves all major development projects before they are carried out and set strategies for accomplishing them. The NC also prepares the running budget of BANDECA.

The Divisional Council (DC):

The Divisional Council shall be composed of five registered members from each Branch (Ndakum) of a given area. The DC had the duty to co-ordinate all BANDECA activities within its area and recommend new Branches (Ndakum) for admission into BANDECA.

The Divisional Executive Committee (DEC)

Its members are elected during Divisional council meeting and consist of a president, two vice presidents a secretary, a vice secretary, a vice secretary general, a financial secretary, a treasurer, a publicity secretary, a development officer and a cultural adviser. The DEC is responsible to the divisional Council, ensures the Divisional council, ensures the effective implementation of Divisional council resolutions and has the obligation to present reports of its activities at its annual general meeting.

The Branches (Ndakum)

The branch shall be any Bali Nyonga cultural unit or meeting house whose activities shall be coordinated by the various Divisional Councils in and out of the village that operate under BANDECA. The Ndakum shall be autonomous in its internal rules and regulations, be active members of the DC of its area and pay a registration fee as shall be fixed by the General Assembly.

The Branch Executive Committee (BEC)

This shall consist of a president, a vice president, a secretary, a financial secretary, a development officer and a cultural adviser. The BEC may be voted out by a two-third majority of members of said branch on grounds of mismanagement or inefficiency. Such measures shall not exclude court action.

Functional Committees of the National Executive Committee (NEC)

These include the disciplinary committee to handle matters of discipline concerning members of the association. Also, there is the Election committee which shall conduct elections into NEC in accordance with the constitution. The National Council or the National Executive Committee may at any meeting set up an Ad Hoc Committee(s) to deal with specific issues that may arise from time to time and make recommendations.

Finances of the Association (funding):

The sources of the association's revenue includes:
- Registration fees as fixed by the General Assembly and payable once by a branch.
- Special levies
- Appropriate annual subscription fees of Branches shall be levied by the General Assembly.
- Donations
- Proceeds from special fund raising activities
- Monies accruing from sales of membership cards and the constitution
- However, the divisional council and branch may raise funds for their internal up-keep.
- Legacies and charitable organizations.

Findings revealed that BANDECA has done a lot in the sociocultural realm. In fact its achievements have not gone unnoticed.

RESULTS AND DISCUSSIONS

Achievements of BANDECA

Since its creation, BANDECA has been very instrumental and playing a pivotal role in the accelerating social and cultural developments especially in Bali Nyonga in a bid to alleviate the plight of the rural masses and the Bali Nyonga people as a whole. BANDECA vis-à-vis other associations affiliated to it has done much in the domains of health, water, infrastructure, among others achievements.

The conception and realization of the Bali Mortuary project by BANDECA with the assistance of the Government of the Republic of Cameroon stand out as one of those giants achievements of BANDECA. This project which was officially inaugurated on the 15th of August 2003 by the President General, Dr Ndifontah Buma Nyamndi in the presence of His Excellency, Governor Koumpa Issa, the Representative of the Head of State, President Paul Biya. Other dignitaries present were the Senior Divisional Officer for Mezam, the Mayor, Bali Rural Council and HRH Dr. Doh Ganyonga III, the Fon of Bali. The significance of the mortuary project cannot be overemphasized. This is because it helped to relieve the pressure on the Bamenda Mortuary, reduced the stress that bereaved families went through by transporting corpses to distance places like Bafoussam or Douala. Besides, the Mortuary was a source of employment and fetched revenue for the realization of other projects. It was therefore a laudable and commendable effort by the Sons and Daughters of Bali Nyonga. In the same vein, the mortuary also served neighbouring and distant villages in the North West Region till when some of them emulated such initiative and realized their own mortuary projects. Below is a partial view of the mortuary from outside.

BANDECA made another great stride by providing the Bali–Nyonga community with pipe borne water until 1993 whey the management of water was taken over by the Bali Nyonga Community, water management in the village was in the hands of the National Water Corporation, SNEC. Owing to the high cost of water, only a few individuals could afford to pay and the majority continued to fetch water from doubtful sources which some time caused the people to suffer from water borne diseases. It was owing to this situation that the Bali Nyonga Community took over the management and provision of pipe borne water from SNEC on 29th April 1993 under the name Bali Community Water Supply (BACOWAS). The raison d'être for this take over was to provide clean water at affordable rates to the ever burgeoning population of Bali –Nyonga and to keep away water borne diseases.

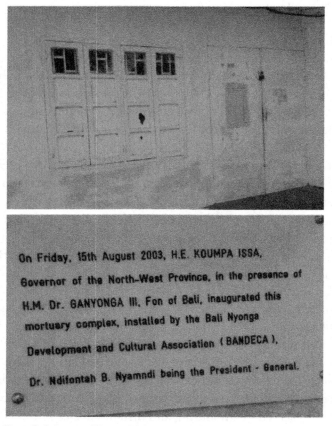

On Friday, 15th August 2003, H.E. KOUMPA ISSA,
Governor of the North-West Province, in the presence of
H.M. Dr. GANYONGA III, Fon of Bali, inaugurated this
mortuary complex, installed by the Bali Nyonga
Development and Cultural Association (BANDECA),
Dr. Ndifontah B. Nyamndi being the President - General.

Fig 2. Bali District Hospital Mortuary. Credit: Author's collection.

Water management in Bali was done under the supervision of Ba Tita Jani from 1993-2000. BANDECA officially took over water supply in Bali in the year 2000 with a caretaker community known as the BANDECA Utilities Committee (BUC) in charge. This Committee had as Chairperson Ba Gwangatua Forkusam. The dilapidation of equipment, poor management and neglect rendered the water scheme at Gola dysfunctional as there were still many homes in Bali without water and the bills for water were still high .Such disturbing situation led to the water by gravity project at Koplab .This scheme which cost the colossal sum of 100,000,000 Francs FCFA saw the government of Cameroon supporting with the sum of 75,000,000 francs FCFA while the remaining 25,000,000 francs FCFA was contributed by the sons and daughters of Bali Nyonga extraction both at home and in the diaspora. This project

materialized on 19th November 2004 under the president General of BAN-DECA, Dr Nyamndi. A BANDECA management committee was set up under the chairmanship of Ba Gwanfogbe Rudolf.

The population of Bali enjoyed the fruits of pipe borne water which was almost free of charge because the water bills were very low and accompanying this was the near eradication of water borne diseases in Bali–Nyonga. This was really self –reliant development. BANDECA managed the supply of water in Bali–Nyonga until recently when it was obliged by the government to hand over water management to the Bali Rural Council.

In another perspective, BANDECA has contributed infrastructurally through the construction of Bali–Nyonga palace plaza, the grandstand still in the palace, the BANDECA office building in Bali Nyonga, not leaving out the Divisional Council Buildings, The Divisional Council Buildings or Bali Community Halls in Bonaberi Douala, Etoug-ebe Yaoundé and all over the national territory including the women Empowerment Centre Yaoundé, speak of the self-reliance development spirit in the Bali people wherever they find themselves .In fact, the pavement at the Lela plaza as well as the construction and constant renovation of the palace grandstand together with the fence surrounding the fon's palace are worthy of praise .All these have helped to rescue the Bali community from embarrassments whenever they converge at home for the celebration of their annual festival the "Lela".

Fig 2.1 Picture of plaza and grandstand in the palace. Credit, author's collection.

In the same vein, the rehabilitation of the Divisional officer and the furnishing of the Gendarmerie and Research Brigade Bali stand out as other laudable achievements of BANDECA.

In another dimension, BANDECA has never relent in its effort to promote our cultural heritage. In fact, BANDECA is a forum for cultural promotion, revival and preservation .It has been instrumental in the revival of the *Lela* festival. The *Lela* was a festival which was celebrated every December and served as factor for unity and cultural preservation but which gradually lost its importance with time .It was owing to this that BANDECA encouraged the revival of *Lela* and the participation of the indigenous people of Bali in the celebration. BANDECA did this by looking for sponsors and providing the necessary funds for the organization of the event. The impact of *Lela* cannot be underestimated as during the occasion the message of the Fon is delivered to the entire community on crucial issues like the prevention of sexually transmissible diseases, environmental protection and the consequences of bush fires, the development of our motherland and cultural practices that need to be revamped and make less severe like widowhood rituals and death celebrations among other issues.

In the same vein BANDECA has also been encouraging the *voma* festival, an annual festival carried out during the planting season .The main objective of this festival has been to appease the gods or ancestors of the land for a successful agricultural season and for good yields in particular. BANDECA in its effort to promote Bali Nyonga culture has been providing all the necessary requirements for this festival. This includes the provision of goats, fowls, and win used during the appeasement and cleaning process.

Still in the domain of culture, BANDECA has been working relentlessly towards encouraging the Bali Nyonga language which owes its origin to the interaction between the Bali on the one hand and the Bamum and Bati on the other hand. This was in the course of migration from the North to the Bamenda Grassland by the Bali Nyonga, people. Mungaka was the native language of instruction used in the Grass fields by the Basel Mission in their schools and churches. In the course of time, Mungaka was loosing its popularity and BANDECA took upon itself to do something to revive it by organising lectures on culture and encouraging parents to send their children to the village during long vacations to study Mungaka.

BANDECA has also been encouraging cultural promotion and revival by organizing cultural manifestations at branch or divisional levels. During such occasions the indigenes were clad in their traditional regalia and the natives were thrilled with traditional dances and other talks on culture and development. In

fact, BANDECA was selected to represent the North West Province (Region) at the National Festival of Arts and Culture that took place in Dschang in 1995. The colourful display of their dance groups earned them another opportunity in 2001 to take part in the National Festival of Arts and Culture and to be accorded a civil reception in Paris, France where she presented the "Galena dance".

Furthermore, BANDECA has not been indifferent to certain obnoxious cultural practices like prolonged death celebrations and widowhood rituals. Through the effort of BANDECA working in collaboration with Bali Nyonga Traditional Council, the period for death celebrations was reduced for one week to three days. This was a welcome relief as it reduced the financial burden on the bereaved family. Still in the same vein, BANDECA in collaboration with the Bali Traditional Council in 2002, reformed the practice of widowhood in the village. The harsh treatment of widows after the death of their husbands which lasted for a period of the year was reduced to three days that is the period of mourning.

In the domain of health, BANDECA has also been very instrumental. In addition to the mortuary project BANDECA assisted with the construction of health centres in Gungong and Wosing respectively. The provisions of health units to the people of these localities was a welcome relieve as it spared them of the trouble of trekking over long distances to the Bali District Hospital or to the Bamenda Regional Hospital as the case may be. The realization of these projects was the work of "Nkumu Fed Fed" a humanitarian group affiliated to BANDECA. These health projects were realized by 1998 and cost closed to the tune of 4,000,000 FFCFA. The government only came in later to lend another hand to that initiative.

In a similar vein, BANDECA has over the years been donating equipment to the Bali District Hospital such as oxygen cylinders, air conditioner and sets of surgical instruments this is to enable the workers render better services to the population. BANDECA and its affiliated associations in the diaspora have donated medical equipment to the Bali District Hospital to the tune of 400 000 Francs FCFA.

Similarly, BANDECA has been organising medical or health fairs and seminars for sensitization, free screening and consultation by medical experts. The first of its kind was organized in 1999 by the BANDECA health committee under the chairmanship of Professor Doh Sama Anderson and a team of medical doctors from Yaoundé. They carried out free medical consultation and cancer screening tests on women.

Furthermore, BANDECA has not relented its effort in the fight against

the HIV/AIDS pandemic. The association has been working hand in glove with the United Nations Children Emergency Fund (UNICEF) and the Bali Nyonga students' Association (BANSA) to fight against AIDS and other sexually transmissible diseases (STDs). This has been done through seminars and workshops for youth sensitization on AIDS and other STDs. Youth have often been encouraged to form health clubs with condoms distributed to them as a preventive measure. As a matter of fact, the activities of BANDECA have helped to improve on the health situation of the people especially the youths who form the bulk of the active population.

Besides, the Bali Nyonga elite in the United Kingdom who form the Bali Cultural Association (BCA) UK, of recent, made a humanitarian gesture by donating two motorcycles and two incubators to the water commission of the Bali district hospital at Ntanko' and the Catholic hospital, Won, respectively. This was sharing concern for the health needs of the population and also good drinking water for as we all know water is life.

Another humanitarian gesture by BANDECA was the realization of the water scheme at Boh Etoma, and Gungong as well as the construction of a bigger water tank at Jam-Jam quarters. This was done by BANDECA in partnership with the Spanish NGO, MPDL and the benefits of these projects to the local population cannot be underestimated. In the course of realising the project, the local indigenes constructed local materials like sand, stones and gravel.

Similarly, BANDECA'S effort has led to the absorption of jobless certificate holders of Bali Nyonga extraction the association is noted to have recruited some teachers and paid them through PTAs to teach in some primary schools within the municipality. In the same vein, it has created a data bank for resource persons and qualified but unemployed youths of the Sub-Division which can be exploited when the opportunity arises. These are all in an effort to ameliorate the appalling shortage of teachers in our schools and the high rate of unemployment that is a social problem and a nuisance to the society.

In the area of education, BANDECA and its affiliated associations, "Nkumu Fed Fed" and the Bali Cultural Association, USA have not relent their efforts in promoting education among the sons and daughters of Bali Nyonga. This has been done through the construction of classrooms, the provision of a public library and the award of scholarships to needy children. For instance, it was thanks to "Nkumu Fed Fed" that three standard classrooms were constructed and equipped at GS Beisen in the year 2000. In the same vein, the association constructed and furnished three classrooms, an office for the head master and a store for GS Mantum where some of the classrooms were in a state of dilapidation.

The project was completed in 2003 and was a laudable initiative indeed.

Next, BANDECA in its effort to encourage research and promote education amongst the sons and daughters of Bali Nyonga set up a public library in 1994. This library which had about five thousand books was estimated at some 4000000 franc FCFA with most of the books donated by the Bali Cultural Association, USA.

Likewise in an effort to boost educational standards in Bali Nyonga and the sub-division as a whole, the Bali Cultural Association, USA offered scholarships to needy children in Bali sub-division; they donated schools needs and scholarships to primary and secondary schools in Bali and Bawock. They did this in partnership with "Nkumu Fed Fed" which works in the areas of education, health, human rights and secure livelihood and environment. Nkumu Fed Fed was represented by its President General, Justice Prudence Galega while the President of the Bali Cultural Association, USA, Julius Ndangam was unavoidably absent. The occasion which took place at the Bali Municipal grandstand in 2009 saw the award of didactic materials lie bags, text books and exercise books to needy and hardworking children. The representative of Julius Ndangam reiterated the importance of education as life's foundation for every young child in Bali. The sum of 2,125,000 FCFA was awarded to deserving students and pupils. The BCA-USA also unshelled its plans to hire and sponsor eighteen new teachers for various primary schools in Bali Sub-Division for the 2009/2010 academic year. The inspector of Basic education in Bali, Paul Mbaringong Anyenemba, the representatives of the Lord Mayor and the Fon of Bali all answered present for the occasion.

Despite these laudable achievements, of BANDECA and its affiliated associations it had its own challenges which have rendered the association dysfunctional over time. In fact, BANDECA has found itself wanting on some occasions owing to its weaknesses and challenges it has been facing.

Conclusion and the Way Forward

In spite of the challenges facing BANDECA as a tool or instrument for sociocultural development the sons and daughters of Bali Nyonga especially the elite are still optimistic about its future. This association would certainly in my humble opinion have a better future if certain things are done by the entire Bali Nyonga Community and the BANDECA Executive in particular.

There is the need for proper auditing, transparency and accountability so as to restore confidence and sanity in the association. The current National Executive of BANDECA under Ni John Ndasi Fomuso has been working hard to imbibe

these virtues that keep any association of this nature afloat. This is contrary to the former executive where financial statements, auditing and accountability were major problems no matter their good intensions. Such disturbing situation has weakened BANDECA and caused associations affiliated to it like the BCA-USA and "Nkumu-Fed Fed" to start operating independent of the umbrella association, BANDECA.

In addition, there is the need to rekindle the steam, confidence and will of the Bali Nyonga people at home and in the diaspora to contribute towards development projects at home. In fact, many have questioned the success level of BANDECA in galvanizing the efforts of Bali Nyonga people in one voice to play the leading role as the number one developer in the North West Region and beyond as history hold it. It has been a daunting task to the BANDECA scribes to convince elite and well wishers to buy the BANDECA uniform at 10,000 FCFA a fathom that yesterday sold at below 90,000 FCFA. There is the need for a change of mind-set of the natives that BANDECA is an elitist association intended to serve the needs of the elite. In fact, the natives are the first people to benefit from any development project at home and should therefore discard of this mentality.

Also, there is the need for the President General and his close collaborators to continuously embark on confidence-building mission to the sensitize, education, mobilize reorganize and create divisional councils, already, the President General and his team have visited Mezam Divisional Council and other Divisional Councils for that purpose.

Next the association should collaborate with the traditional authorities to enforce, severe disciplinary sanctions on indigenes who refuse to respect their financial obligations to the associations, taking cognizance of the fact that they would not be exempted from enjoying the fruits of community development projects. If the natives cease to adopt a lukewarm attitude towards the association and honour their obligations then BANDECA would certainly go far in realizing its goals or objectives of generating sociocultural and why not economic development.

In the same way, the BANDECA executive should do well to work in collaboration with international donor agencies, non-governmental organizations and international organizations which encouraged group initiative and community development. Such donors include the European Union and French Cooperation among others. Such assistance can enable the association provide some material, financial and technical assistance needed to boost the development of the village.

Besides, there should be cooperation within the National Executive Committee (NEC) of BANDECA. Those at the national level should always concert and do things in unison with their kinsmen in charge of running the affairs of the different divisional branches. As the saying goes "United we stand, divided we fall, unity among the various executive bodies would enhance the survival and success of BANDECA and ensure its continuity for posterity. In the words of the current National President, BANDECA "Ahead Ahead", "BANDECA for posterity".

In the domain of cultural revival, BANDECA must continuously play a vital role towards the revamping and revitalization of our cultural heritage. It must continue to serve as a rallying force where the natives are reminded and enlightened on the need to be deeply rooted in their culture in this era of globalization with its own impact on native culture and tradition. Culture is never static but dynamic but his does not imply that modernity and globalization should completely eradicate our culture heritage. Rather it should be used as a weapon to discard of certain cultural practices that are repugnant and obnoxious. For example, female students should be encouraged to develop their capacities and abilities like their male counterparts. Early marriages among young girls should be discouraged because it frustrates and jeopardizes their educational progress and aspirations too.

Finally, BANDECA needs to extend its development agenda to include the construction and maintenance of farm to market roads. This is because road construction is one of the key elements of development especially considering that most of he natives of Bali are farmers and face the challenge of transporting farm products to towns. By so doing, this will reduce post-harvest loss recorded especially during the rainy season due to the poor state of roads and the local peasant farmers will be able to improve on their welfare.

References

Books

Chilver, E. M. and Kaberry P. M.(1961) An Outline of the Traditional Political system of Bali Nyonga, Southern Cameroon, Government Printer, Buea ,Cameroon.

Iftikhar Ahamad et al. (1996). World cultures: A Global Mosaic. Englewood Cliffs, New Jersey: Prentice Hall, Inc

Nyamndi, N B. (2007). To seek a better Life. The hopes and purposes of the Bali Nyonga Development and Cultural Association, from selected speeches of the President-General Yaoundé: Mvomberg Publishers Ltd.

Soh, B. P (1985) The Passing of A Great Leader Galega II of Bali-Nyonga, (1906-1985), Bamenda: Institute of Human Resources, Mimeograph Document

Titanji V.P.K et al. (1988). An Introduction to the study of Bali-Nyonga. A tribute to His Royal Highness Galega II Traditional Ruler of Bali-Nyonga from 1940-1985. Yaoundé Stardust Printers

Newspapers and magazines
Lela Magazine; A cultural and Tourist Magazine of the North West Region, Bali Nyonga, Vol. II, December 2009.

Lela Magazine; A Cultural and Tourist Magazine of the North West Region, Bali Nyonga, Vol. III, December 2010.

The Post N° 01098, Monday, November 2, 2009, p.10.

Dissertations
Gwanmesia, T.G. (2003). Community Participation in the Development of Bali Sub-Division: the case of Health and Portable Water Supply DIPLEG dissertation in Geography, ENS Yaoundé, 2003.

Sabum, E S. (2005). Bali Nyonga Cultural and Development Association (BANDECA) 1970-2004 M.A. Dissertation in History, Faculty of Arts Letters and Social Sciences, University of Yaoundé I

Archival Materials
North West Regional Archives (NWRA)

File N° NW/5RD.1952/1 the Bali Water Supply by Dr Ben Page, University College, London, 1952.

File N° 26/55/1988/2MWFOC/DPOT.cb Bali Cultural Association, 1988.

National Forum on Culture 23-26 August 1991. General Policy Statements: « Culture and Democracy » Yaoundé, 1991.

Private Archives
Constitution of the Bali Nyonga Development and Cultural Association BANDECA, 28th April 2012.

Bali Nyonga Development and Cultural Association (Third Millennium (BANDECA), Contact Visit of National Executive of BANDECA, August 4, 2000.

Minutes of the first BANDECA National Council Meeting held in the Bali Community Hall, 24th December 1995.

Statement of the President-General BANDECA, Dr Ndifontah Buma Nyamndi, of the inauguration of the Bali Community Mortuary Bali, 15/08/2003

Speech presented by the out-going National President of BANDECA, Gwangahtua

Forkusam on the Occasion of the Installation of the New National Executive 20/12/99

Report of First Annual General Meeting of the Bali Community Water Committee (BCWC) Bali Sub-Division, 15/04/1995

Minutes and Resolutions of the Bali Water Supply, 25/02/1994.

Bali Community Water Supply Report: April to November 2000 by Ba Gwangatua Forkusam, Chairman.

Key Informants

Augustine Kehbila Mundam, 2015, retired teacher, family head, Bali Nyonga, NW Region, Cameroon.

Dr Fondi Ndifontah Nyamndi, 2015, former President–General of BANDECA, former Director General of Yaoundé Conference Centre, Bali elite, writer, Bali Nyonga, NW Region Cameroon.

Fomuso, John Ndasi, 2015, President-General of BANDECA until 2015, Retired Commissioner of Police, Bali Nyonga, NW Region Cameroon

Fondo Sikod, 2015, Professor of Economics, Economic Analyst and Consultant, Biyem-Assi, Yaoundé, Cameroon.

Forkusam Langmia Austin, 2015, First National President of BANDECA, elite, retired teacher/administrator, Bali Nyonga, NW Region, Cameroon.

Titanji V.P.K. 2015, Professor of Biotechnology, Vice Chancellor and CEO Cameroon Christian University, Vice President of the African Academy of sciences for Central African Region, Researcher/Writer on Bali Culture and History, Bali Nyonga, NW Region, Cameroon.

<center>4</center>

BALI AMERICAN DIASPORA: HISTORY, CHALLENGES & POLICIES

Jerry Komia Domatob

With advances in education, migration, telecommunications and above all, transportation, the Bali-American diaspora transforms exponentially by leaps and bounds. Barely, a decade or two ago, the principal Bali diaspora settlements were comparatively close. They included: Buea, Likumba, Limbe, Kumba, Tiko and more so, Douala where there is a neighbourhood named—Bali.

BALI-AMERICANS

Today, perhaps one of the most popular and fast growing diasporas is Bali-Americans, who reside in several counties in the United States. If you visit California, Carolinas, Colorado, Oklahoma, Texas, Massachusetts, Illinois and above all Georgia (Atlanta), Maryland (DC) and Virginia; you are likely to meet people of Bali stock. The numbers grow daily with lotteries and family members persistent assistance in bringing their kith and kin to the United States.

BRIEF HISTORY

Beginning with a brief historical account of Bali Nyongas in America, this chapter addresses the question: who constitutes the Bali-American diaspora and what challenges do they encounter? What policy options can enhance the Balis in the American diaspora and homeland?

Ambassador Lima: Pathfinder

Although research is mandatory on this subject, perhaps the first known

and recorded personality of Bali origin, who travelled to the United States was the late and astute Ambassador, Ba nkom Lima. The insightful pathfinder is the uncle of the current Fon, His Royal Majesty, Doh Ganyonga III. He is also the father of Atlanta based Ba Nkom Gwankudvalla, chairman of Bali Cultural Association's (BCA-USA's) Multipurpose Centre Committee currently under construction.

Ambassador Lima was the son of the famous Ba Lima, reputed to have served as the headmaster of one of the pioneer northwestern Cameroon schools. Ambassador Lima was a versatile, industrious and phenomenal achiever. A proprietor, educator, instructor and tutor, he left impeccable legacies in diverse areas of Cameroon's sociopolitical and economic landscape.

Ambassador Lima, a thoughtful, strategic and tactical leader, excelled as a nationalist and diplomat. When he earned his master's degree in the early nineteen fifties, an extraordinary accomplishment in those days, Ba Lima taught in New York University. The gorgeous sky was his limit. Yes, opportunities for progress abounded. Nonetheless, it was not that easy for men of colour, let alone black Africans to serve in such laudable capacities.

However, like Nigeria's first president, Dr. Nnamdi Azikiwe, who was also a professor in the United States, Ba Lima returned home to assist Cameroon and African states' quest for independence and sovereignty. Later in the nineteen fifties, Ba Lima headed to Cameroon where he served as one of the pioneer frontrunners, negotiators and later ambassador of the Federal and later United Republic of Cameroon to other countries.

From whichever prism Ba Lima is viewed, he arguably towers as one of the first Bali Nyonga path finders to have *veni, vendi, vinci*—to have come, seen and conquered the United States.

What he accomplished, however, bore manifest testimony that Balis specifically – and indeed Africans - generally, could come to the United States, survive, succeed and march on to bequeath lasting legacies for posterity. Ambassador Lima achieved that feat with a touch of finesse and splendour, charting the noble path for others.

Early Birds: Dr. Elias Nwana

Others who followed his noble footsteps included the renowned educationist: Dr. Elias Muthias Nwana. A graduate of Sasse College, where he was the senior prefect reinforced his love for education, which took him to the apex of that profession. He taught in that famous school as a tutor and that inspired him to dedicate his life to education.

Professor Nwana earned his bachelor's degree from the University of Legon, Ghana in Sociology. He returned home and served as the Vice Principal of CCAST Kumba in 1963 and, later CCAST Bambili, with late Mr. Dioh as the principal. Dr. Nwana worked with a group of Americans whose vision was to open a University in Bambui-Bambili, which finally materialized in the 2000, under the chancellorship of Professor Tafah Idokat Oki Edward.

Dr. Nwana proceeded to the University of California, at Los Angeles, where he earned his Master's and PhD degrees in Education. Other top notch and pioneer educators in that prestigious league included: late Dr. Mengot, Dr. Shu, and a few others like Dr. Tambo Leke and Dr. Yembe who followed suit.

When Dr. Nwana returned in the late sixties, he served as Vice Principal and later Principal of CCAST-Bambili, Education Delegate, Federal Director of Education and Professor in the University of Yaoundé, specifically, Ecole Normale Superieure. Dr. Nwana was not only one of the founding fathers of the Bamenda University of Science and Technology (BUST) but also presided as Vice Chancellor. At this time too other Bali Nyonga indigenes may have been in the United States.

Odilia Domatob Nwana

Dr. Elias Nwana married the elegant, gorgeous and illustrious Odilia Mahtan Nwana, the daughter of one of the leading Cameroon Catholic School teachers and headmasters and later pioneer Administrator –Justice of Peace, Executive Officer and Development Officer, 1940s-70s, Ba Vincent Phillip Domatob. A devoted and dedicated wife, Odilia along with Dr. Nwana raised a successful family of eight children who excel in various spheres of life all over the world.

Dr. Willie Tiga Tita, Dr. Rose Leke

Other Bali indigenes who followed his illustrious example and proceeded for higher education in the United States, included: Dr/Prof. Willie Tita Tiga, Dr/ Professor Rose Leke and Dr. Ba Nkom Thomas Tata and arguably others. Drs. Tiga & Leke were Dr. Nwana's students who distinguished themselves as pioneer science graduates of CCAST Bambili. They earned scholarships and studied abroad where they left marvellous records.

While Professor Rose Leke graduated from Queen of the Holy Rosary, Secondary School, Okoyong-Mamfe; Dr. Tiga finished from the famous Sasse College, which was a flagship institution then and to some extent, today. Like Ambassador Lima, these pioneers returned home and contributed to national development. Some out of sheer frustration searched for greener pastures and

opportunities abroad. Others returned to the American Diaspora.

Professor Tutuwan

A legendary figure who bequeathed legacies especially in the scientific arena, is the renowned scientist, Dr. Tutuwan. Professor Tutuwan earned a PhD from the United States (Howard University) and proceeded home where he taught at the University of Yaoundé and conducted research. Dr. Tutuwan was one of the pioneers who paved paths in the scientific arena.

Ba Nkom Tata

Dr. Ba Nkom Thomas Tata was also a path breaker. After graduation from CPC Bali, he proceeded to Egypt where he earned his degree in Agriculture. Ba Tata then obtained admissions in the United States where he graduated with a Master's degree in the same field. He later earned a PhD in London.

Ba Nkom Thomas Tata was not only the delegate of Agriculture at some stage in his career but also served Cameroon and abroad in sundry capacities. He rose to the rank of Secretary General in the Ministry of Agriculture and later worked with international organizations.

Helen Tata

She married the tall, elegant, intelligent and diligent Ma Helen Tata and they raised a great family. A pharmacist, she too served as an international public servant.

1980s: BALI DIASPORA'S EMERGENCE.

The current Bali settlement in the United States dates back to the eighties and 1990s. With the emergence of Cameroon as an independent entity under Presidents Ahidjo and Paul Biya in the 1960s, the government dominated as a major employer. Graduates in almost all disciplines found jobs in various economic sectors. At the immediate post-independence era, there was a dire need for civil servants in all fields.

By the 1980s, however, the government was getting saturated. The revolution of rising expectations which bloomed with independence seemed to be spurting disillusion. Some foreign educated graduates who returned home along with others trained at home with valid qualifications, suddenly realized that there were no jobs for them. Independence and its blessings seemed to have become a mirage for many. A reverse trend then started where many of these graduates

did not want to return home and some of those who went back made a U-Turn.

Some of the young men and women who travelled to the US and elsewhere seeking education to return home and contribute their quota shockingly faced the stark reality that such aspirations were empty, sterile and futile dreams. Some stubbornly returned home and later came back. By contrast, others obstinately decided to hang around and weather the storms in the United States and elsewhere.

When Bali and other African students graduated from American colleges in the late eighties and nineties some started looking for jobs. Almost all of them found lucrative employment where many excelled.

Above all, those who graduated in disciplines such as: Medicine, Nursing, Engineering, Technology, Radiology and other professional arenas made a fortune. Verily, some bought humongous houses, married glamorous men or women, acquired fanciful cars and to all intents and purposes wallowed in material wealth.

Bali American Diaspora Today

Is it any surprise that names like: Demas, Dohs, Fogams, Fofungs, Fofangs, Fomunungs, Fokums, Fokwangs, Fokumlahs, Fomusos' Fonjoes, Fondongs, Fogohs, Fossems, Fongwas, Fotungs, Fonyongas, Fokems Fomukongs, Fobesis, Fusis, Galegas, Galabes, Gwangwas, Gwanajis, Gwanmesias, Gwankudvallas, Gwanyallas, Gwanfogbes, Gwaabees, Kaspas, Limas, Mutias, Nukunas, Njafuhs Ndangams, Ngatis, Nfons, Njinibams, Njinjohs, Pefoks, Sibedwos, Tamons, Tangehs, Titas, Titamokhumi, Tita Njis, etc, started appearing in American phone phone books and records.

Around the 1980s besides Ma Maggie Fogam who was in the United States, were others like Ni Muted, Ni Charles Ntarh, Ni Sam Pefok, Ni Theo Tata, Ba nkom Protus Gwanmesia, Ni Gahlia Gwangwa. It was specifically late 1987/88 that the death celebration of a family member's beloved one, culminated in the informal discussions in Atlanta and later launching of the (BCA-USA) Bali cultural association.

BCA-USA's Genesis: Bali Diaspora Emerges

It can be submitted that BCA USA's official launching in Atlanta, Georgia on Thanksgiving weekend 1987/88 marked the formal birth of the Bali-American Diaspora. BCA-USA started, under the informal tutelage of Ma Maggie

Vakenna Fogam and the Fogams, who invited friends, kith and kin across the US to come celebrate their father's demise.

Others present at the occasion were: Ni Kehbuma Dema, Ni Godwin Fofang, Ni Henry Fofang, Ni Muted Fofung, Ma Maggie Fogam, Ni Vincent Fogam, Ni Ben Fokum, Ni Charles Forkwa, Ni Stephen Foncham, Ni Gima Gwanyalla, Ma Miranda Gwanyalla, Ni Derrick Gwanyalla, Ma Angela Kisob, Ni Eric Kisob, Ni Fritz Mesumbe, Ma Winifred Njowir, Ba Nkom Nicolas Tangeh, Ma Beatrice Tangeh, Ni Sama Christian Tanko, Ba Moses Tita Mokhumi, Ma Ema Todmia, Ba Gabriel Todmia, Ma Muluh Tankoh and late Colonel Peter Dinga.

Before this launching, people of Bali heritage in various parts of the US used to meet for discussions, social parties, food, celebrations, drinks and dance. The groups existed in Washington DC, Minnesota, Atlanta and above all, Dallas-Texas. Indeed, there was a formal Ndakum in Dallas where Ni Henry Fofang served as the first President. However, the pan-American organization grouping Balis across the United States can be traced back to 1988.

Quest for Excellence

One legacy these pioneers bequeathed and still promote to this day is the quest for excellence in worthy fields. Many people of Bali descent, wherever they may be in the US thus strive to excel.

By dint of their hard work and accomplishments, they underscored the primacy of education as the foundation for growth. They thus reiterate the centrality of shooting for the top even against all odds. That bequest prevails to this day as several youth, like the Fomunungs, Muteds, Galegas, Titanjis, Fokums, Fonjoes, Tangehs, Ntehs etc, and many others chart the path of splendid accomplishments These youths can be described as paragons of that quest for excellence their parents champion.

Bali Diaspora Today

The Bali-American diaspora in the United States today continues to grow. The exact tally as to who belongs to this population is at best a wild speculation subject to verification. Notwithstanding, perhaps a conservative estimate based on intuitive guess work might place the Bali Nyongas in the US at about 1000. People of that stock, in keeping with their quest for distinction, continue to make positive advances in several life arenas.

Many comparatively sparkle, even if they are still few in numbers as doctors, lawyers, engineers, nurses, pharmacists, computer experts, researchers, technicians, business executives, teachers, scholars, scientists, etc. In many spheres,

the numbers are still low. Nonetheless, the argument can be made that they have broken into these arenas where they steadily make their mark even if its simply a ripple in the river. There is plenty of room for growth. As the Chinese proverb asserts, "the journey of 1000 miles begins with one step." That step has been gallantly taken.

Challenges

Challenges also abound for Bali-American Diasporas. They range from the personal to the global. Personally, each individual grapples with daily human wars and woes as people everywhere. While some wrestle with health decay, others battle grave socioeconomic malaise, such as educational frustration, family feuds, social disasters and miscellaneous issues. In other words, they deal with problems arising from the human condition.

Additionally, Bali-Americans like others in the nation must address the problems of: good jobs, descent housing, adequate income, transportation, poverty alleviation, healthcare, and good credit. Moreover, earning professional credentials as: mechanics, nurses, doctors, lawyers, engineers, fees are crucial today. In short, like other residents in "God's own country," Bali Nyongas in the diaspora must tackle matters of daily life which affect and afflict each and all. Consequently, they must wrestle and tussle the social, cultural, economic and technological turbulence that buffet all persons as devastating hurricanes.

Policy Options

What policy options may enhance the lives of people in the Bali-American Diaspora?

Educational Quest

A marvellous facet of most Bali persons especially those in the American diaspora is that they value, foster and cherish education. Education in this context is diametrically opposed to literacy, though it is crucial.

Education refers to that broad, strategic and tactical search for knowledge and wisdom which enables people to adapt, survive and succeed in their milieu and any context. This involves traditional norms like learning Mungaka along with the culture, traditions and indigenous and above all modern skills.

It calls for a mastery of basic qualitative and quantitative tools needed in all contexts and situations like: counting, communicating, connecting, countering, cooperating, and contesting when the need arises. People of Bali stock advance everywhere because of their mastery of these fundamentals, which assures peoples'

march forward in all venues and contexts.

Excellence as Goal

A particular distinction, people of Bali descent showcase, is their love for excellence. That drive to be the best promotes excellence. Across the United States, that is becoming the norm. People like: Dr. Bobga Fomunung, Dr. Fogam, Ni Muted, Attorney Fogam, Dr. & Dr. Nukuna, Dr. Cabinda, Dr. Pam Fomunung, Professor Marie Fongwa exemplify nothing but excellence. Others not mentioned in this minuscule list abound in this arena.

In the Communication arena: Prof Jerry Komia Domatob, Dr Langmia Kehbuma have made their mark in that field. In the religious arena, church leaders like: Rev. Pam Fomunung, Ma Manyi Gabice, Rev. Fokunang Fongu, Rev. Pefok, Father Muma, Ma Dr Gwandiku are inspirational and "celestial" leaders. Public Health champions and researchers like Dr Frida Domatob-Fokum, Dr Nagella Nukuna, and Professor Gabriel Gwanmesia are also charting grand paths.

Be the Best

The message or take away from Bali in the American diaspora, boils down to the simple wisdom of our parents, grandparents and the sagacious amongst us: "be the best wherever you are."

In other words, their plea through words and above all example is the same. Do not only showcase or champion selected causes but also strive to demonstrate excellence in everything you do.

This simply means that whether you are a student, parent, professional, mechanic, priest, pastor, journalist, educator, doctor, lawyer, pharmacist, custodian, whatever, be the best. As the Latin maxim says, "*Auptimum aut Nihil*—Either the Best or Nothing."

Self-Development

Charity they say begins at home. This means that most improvements and progressive steps begin from the self. The suggestion is not a plea for megalomania or reckless egotism. Rather, it is an open appeal that each and every person of Bali stock, and indeed humans everywhere, constantly look inwards before focusing outside.

It is quite easy prescribing what others need to do. That is simple and easy. "Do as I say not as I do," is the motto some people abide by. Notwithstanding, it is imperative that as individual and collective Balis, everywhere, we take time daily to monitor ourselves, spiritually, mentally, socially, psychologically and

economically. This enables us to see where we lag behind. It provides a mirror that reflects growth or stagnation.

Basic questions then arise: Who am I? Where do I stand? What am I doing? Who am I accountable do? How can I improve myself, family, friends, community and humanity? Above all, how can I advance myself?

Once this introspection yields answers, strategies for advancement become imperative. Similarly, these challenges demand immediate implementation.

Family Revival and Revitalization

At the core of human existence is the family. Fathers, mothers, brothers, sisters, aunts along with extended kith and kin such as: uncles, and grand parents are crucial to our survival. Often families include reliable and dependable friends from elsewhere. Yes, families that pray and eat together stay together and that is outstanding. They provide solid basis for progression.

Families that stand together in joys and sorrows, gains and pains, tragedies and comedies meander through life's vicissitudes with unbridled courage and determination. Generally, they tower as entities which weather life's continuous storms with audacity and vision.

This does not mean that differences arising from the frailties and vagaries of human nature do not arise. Rather, they reinforce the need to mobilize those negative forces into positive catalysts for growth and development.

This chapter applauds most Bali-Americans love and appreciation for family and urges them to continue in that direction. It appeals to those who do not capitalize on this asset to review their stand, correct mistakes and do the best they can with family. As Pope Francis (2015) said, "Families are the place where individuals learn that they are sons and daughters, not slaves or foreigners or just a number on an identity card." He added that, families teach individuals and societies, "the value of the bonds of fidelity, sincerity, trust, cooperation, respect; they encourage people to work toward a world that is livable and to believe in relationships even in difficult situations; they teach people to honour their word."

Conflict Management & Resolution

Wherever humans converge, conflict inevitably arises. Since people vary in age, education, income, perception, race, gender, aspirations and capabilities, conflicts are bound to arise wherever, they gather. It does not matter whether they come from the same household, mother and father. Conflict is simply inherent in human nature, arising mainly from differences in interests, goals and expectations (Frere, 2015).

Faced with this reality, Bali-Americans like humans elsewhere must focus on the causes, progression and possible methodologies for their resolution. Just as humans come in myriad shapes, sizes, visions and missions, so do conflicts emanate from those micro and occasionally macro avenues.

Bali-Americans must therefore constantly scan horizons and attempt to spotlight where crisis are likely to emerge. Once they envisage that arena, wisdom demands that strategies for their resolution be envision. Foresight next warrants resolution and settlement. Men of the law matter but thoughtful action normally preempts conflict.

Food, Health & Nutrition

Health the saying goes is wealth. Yes, wellness is not solely physical. It encompasses mental, social, cultural, economic and psychological dimensions.

Since Bali's founding, the Balis who among other attributes were warriors, recognized the importance of food, nutrition, health and wellness.

Consequently, they focused on good food, exercise, nutrition and rest. Recognizing the importance of clean environments, Balis addressed questions of food production, preparation and preservation.

They also emphasized tidiness and sanitation. Besides the quest for descent houses which was reflected in neat huts and habitations, Balis cherished orderliness.

BCA-USA's Health Committee occasionally helps. Individual nurses, pharmacists and doctors provide prodigious assistance. However, there is a great deal that needs assistance. Bali-Americans along with the home counterparts must continue to improve this sector.

Professional Linkage

Blessed with capable and competent professionals in myriad fields, Bali-Americans like their counterparts at home recognize the importance of professionalism. Although major socioeconomic blockages hamper their expansion, the nucleus for such organizations exists.

Bali doctors, engineers, educators, jurists, business tycoons, accountants, environmentalists, agriculturalists and a host of others exists informally.

Evidently forming, building and sustaining any prescribed organizations require people, goodwill, time, sacrifice and above all resources.

Both abroad and at home, those material and human resources may exist or actually do. However, they need to be mobilized and organized for the community's good.

That's where leadership, especially, servant leadership, becomes a crucial and critical component for the home and Diaspora communities. Service at every level stresses forfeiture in many regards. That's where Balis and the Diaspora need to break new frontiers and capitalize on the professional connection.

Economic Well-being

Although economics is only one of the major variables that assure groups and communities success, it is a cardinal force.

Random House Webster's Dictionary defines Economics as the science that deals with the production, distribution and the consumption of goods and services or the material welfare of humankind. When used in the plural, it refers to the; economically significant aspects.

Getting to the core, the central question addresses the financial side of the matter. In other words, are resources available for building associations, linkages, and partnerships? Can parties involved execute simple projects without adequate resources?

Balis everywhere recognize the importance of economics. Even before the advent of the monetary western economics, they stressed hard work, community building, economic self-reliance and above all the ability to survive economically at home and abroad.

When Europeans arrived, they adopted the new economics and part of the past dispersal/diaspora emanated from the quest for economic wellbeing as it is still the case today.

Money talks. How true? The Balis recognized that truism and it is as relevant today as it was yesterday. Aware of that reality, let's always keep economic factors in focus whether we are at home or in the diaspora.

Technological Literacy

Besides basic education and literacy comprising of reading, writing and arithmetic, is technological proficiency. Though they are intertwined as everything else in life, in the case of technology, money might be involved since gadgets, which are business tools are expensive. Sometimes they are prohibitively expensive.

Notwithstanding, it is crucial that Balis and their counterparts at home and abroad master these technologies. Like elsewhere, it is crucial developing the experts—technicians, engineers.

Evidently, we need engineers and technicians who master these gadgets. Without them, dependency as it has been the case for decades and centuries will be the modus operandi. That's exactly what Africa's enemies desire.

Some of us may have access to more information than our forebears. Equally true is the reality that a few of us may have possibilities of accessing and taking advantage of the technologies.

Consequently, Balis everywhere must place emphasis on the technological mastery at all levels. The idea is not solely their acquisition but also their mastery.

Here again, money matters. Realizing that truism, it is our duty not only to promote technological usage but also its proficiency and efficiency. Whatever assistance we can proffer in that regard is immensely appreciated.

Administration, Governance & Leadership

Administration, governance and leadership are critical factors in any organization, body or movement. Without effective managers, most efforts in whatever direction are doomed to failure.

Consequently, efforts and emphasis must also be placed in that arena. Leaders do not only assist with the creation of vision, mission, strategies and tactics but more. They provide: moral, physical, intellectual, cultural and social guidance that assists follows to chart certain trajectories. Moreover, they sometimes control the forces of coercion which are indispensable for the survival and success of communities.

That of course requires a combination of factors which occasionally are complicated, chaotic and even confusing

CONCLUSION

The Bali American Diaspora like others in places like Germany, Britain grows by leaps and bounds. Although in terms of organization, the American groups seem to have forged ahead, there is still humongous scope for growth and improvement.

There are many folks of Bali origin, who need to participate not only in the diaspora projects, but to contribute to the efforts of those battling hard to improve the homeland in one way or another will enhance the cause.

Some Ndakums (from what we gather) in places such as Washington DC Houston, Dallas, Atlanta and Oklahoma thrive like victorious community centres. However, they are not devoid of grave challenges.

As everywhere, there are conflicts and contests. Moreover, many dangle on fragile strings, which can shatter any time. Others are rocked by internecine wrangles as it's often the case with human organizations. Notwithstanding, some thrive with a degree of excellence. Washington DC's Nda Ntod, in spite

of challenges is often lauded and spotlighted for serving as a model Diaspora organization

This leads to a second paramount diaspora lesson. Having survived in Nigeria and the US, it is eloquently evident to the writer that there is no paradise anywhere on this earth. Wherever you land, there are pluses and minuses, gains and pains as well as joys and sorrows. None escapes the vagaries of the human condition, which afflict all with impunity. So the simple truth therefore is: just make the best of your situation and capitalize on the strengths rather than the weaknesses.

Balis have made some initial forward moves in the American Diaspora. To all intents and purposes, some are monumental success stories. Bali Diasporas can rightly boast of: Attorneys, Accountants, Business Executives, Doctors, Engineers, Nurses, Researchers, Teachers, Technicians, and Professors.

Many, however, still shine as pioneers meaning that others must emulate their laudable accomplishments. This top notch class of professionals is growing. Many Bali youngsters are in colleges, schools and universities preparing themselves for distinction. A few glitter as model students in their institutions. Thus, baby steps have been taken with a large scope for more to be accomplished.

References

BCA Publications Committee (2013). Special Edition of Bali Cultural Association. USA Magazine. V. Gomia (Ed), Salaba, Atlanta, Georgia, USA.

Domatob, J. (2011). Positive Vibrations. Maryland: University Press of America.

Frere, Marie-Soleil. The Media and Conflicts in Central Africa. Boulder: Lynne Rienner Publishers.

Musa, B & Domatob, J. (2012). Communication, Culture & Human Rights in Africa. University Press of America.

Nwana, E. (2004). Tracing My Roots through the Njuh and Vatkuna (Tanunjam and Mfum Wadinga-Family Lines. Mimeograph Document.

Random House Webster's Unabridged Dictionary (2015). Random House, New York,

Part II
BALI NYONGA TODAY

5

THE TRADITIONAL AND MODERN CALENDARS OF BALI NYONGA: COEXISTENCE AND CHANGE

Vincent P. K. Titanji

The Bali Nyonga Traditional Society, like so many others around her, has been undergoing profound changes since the advent of westernization occasioned by the visit of the first European in the heart of the Cameroonian hinterland. In recent times this change is driven not only by the modern Cameroonian state as it superimposes on and replaces the old order, but also by the pervading influences of globalization. From the system of farming through dress, music and dance to architecture and communication the traditional system slowly, but assuredly gives way to the new multicultural, multi-ethnic dispensation.

This essay focuses on the traditional calendar and shows how in the past the two main traditional institutions Lela and Voma guided the actions of the Bali people throughout the year. These institutions which celebrate two main festivals toward the end of the year (October –December) have been described by western scholars as cults or religions which guided both the socio=economic and spiritual lives of the Bali people. Though these events are no longer celebrated every year as was the case in the precolonial days, their influences continue to guide the activities of the ordinary Bali people and by extension the many non-Balis who live and work in Bali Nyonga today. It is therefore pertinent to examine how the traditional calendar, which continues to be used by the Bali indigenes, coexists and adapts to the modern system which threatens to replace it altogether thereby severing the people from their cultural roots.

First of all the names, origin and significance of week days will be examined followed by the names on the months of the year and the main activities which take placed during these months in the traditional society. Subsequently the calendars of the Lela and Voma institutions will be described, showing how

these tied up with the political and economic activities of the Bali community in the past. It will then be argued that the replacement of the traditional by the western calendar has quickened the pace of disintegration of the traditional system of Bali in the post independence Cameroon. It should however be pointed out this transition is not unique to Bali Nyonga, but affects the surrounding ethnic groups as well, especially those which came under the influence of the Bali suzerainty in the precolonial era.

CO-EXISTENCE OF TWO CALENDARS IN BALI NYONGA

The week in Bali Nyonga contains eight days in contrast to the seven days that comprise the week in the western calendar. The juxtaposition of an 8-day Bali week with the 7-day week of the western Gregorian calendar illustrates the difficulties of living as a modern person in a contemporary African setting entrenched in its traditions. The natives of Bali Nyonga have thus devised ways of keeping track of week days. Though the traditional week is still the basis for planning of daily activities in the Bali, this cannot be done without paying attention to the western calendar which guides all official business of the country.

Names of days in Mungaka, the language of Bali Nyonga

The names of the days of the week are given below starting with the main week market day, which is recognized as the first day of the traditional week, in sharp contrast to the western calendar in which Sunday begins the week.

Ji-Mbufung: is translated as 'Public holiday in the Quarter of Mbufung.' Mbufung is the village of one of the early settlers of the present Bali Nyonga Fondom. This day corresponds to the main market of Bali sub-Division. On this day the *Ngumba* regulatory fraternity holds its meetings. Accordingly Bali Nyonga denizens are not allowed to go to the farm or organize any public manifestations on that day. If a person dies on this day he/she is buried quietly.

Ngo': The literal meaning of this day's name is not known. In the recent history of Bali Nyonga two of the Fons, Fonyonga II (1900-1940) and Galega II (1940-1985) died on this week day. It has therefore become a personal holiday (*nchu' ji*) for the Fon during which he stays in the palace and does not receive the public.

Ndansi: This name is derived from the expression *Nda- ghang nsi* which means 'house of the land owners' This week day was dedicated to the meeting of the landlords (*ghang-nsi*) that held in the palace of the Fon of Bali on the third day after the main market day. As explained elsewhere the Landlords'

61

meeting was the forerunner of the Bali Traditional Council.

Nkohntan: This name is derived from the expression *nko' ntan* which means 'coming/ travelling up to the market'. This was the day on which traders from the southern lowland villages came to Bali to trade. Then, the next day *Ntan* was the main weekly market day.

Ntan: This name is the short form of the name *Nchu Ntan Ba'ni* which means 'the Bali market day'. This was the day reserved for the weekly market of the *Yani* elements- which is thought to have been the main market day, but which was progressively abandoned in favour of the market day called *Ji-Mbufung*. The reason for this change is not known, but it could be speculated, that because the neighbouring tribes came to trade in Bali on *Ji-Mbufung* this market called *Ntan-Ko'o* even till today, became more popular with time while the Bali market declined.

Foncham: is a traditional holiday (*ntsu'ji*) during which people are forbidden to do manual work on the farms. Legend has it that those who failed to observe this day of rest and went to the farms ran the risk of meeting the ghosts, who could harm them. Nimbang opines that *Foncham* was a day of pardon when the Fon could grant clemency to prisoners. This view comes from a mistranslation of the word foncham (which can be broken down to two syllables -*fon* meaning king -*cham* meaning pardon or pity. Any native speaker of Mungaka would realize that this is not a correct rendering of the expression *Fon's day of pardon*.

The name Foncham also is known from ballads to have been a great prince. This day could have been named after him. Even contemporary lyrics of one of the songs known as *dang-nga* make mention of *Gawa Foncham* which is a Mubako language expression for Prince Foncham. Whatever is the origin of this weekday name, it is still observed as a public holiday in Bali Nyonga today.

Ntumgwen: This name translates as 'resuming farming, going out to the farms'. After the public holiday of *Foncham* work resumes on the next day so appropriately named.

Ntan-Mbutu: This day is named after the market day of *Mbutu*.(*Mbutu* is the Bali name for Mbatu a neighbouring village, located some 15 km to the east of Bali Nyonga) This last day brings the Bali week to a close assuming that Ji-Mbufung , the main market day, is the first day of the week.

Origin of the week days' names

It is likely that these names were given after the settlement at the present site of Bali Nyonga. Two of them mention neighbouring villages (Mbutu and Mbufung) which were obviously not in the Chamba homeland from where

the Bali people originated. The names are in the Mungaka, the language that Bali Nyonga adopted later in their migration, when they gave up their original Mubako language. These two observations seem to favour a recent origin of the week day names in Mungaka.

Week days' name rotation

The diagram below shows the week days in both traditions depicted in two concentric circles: the inner ring representing the western and the outer ring representing the Bali calendar. By keeping a day fixed in the inner ring e.g. Sunday and then rotating the outer ring anti-clockwise you can see how the names of the week days are given in bilingual pair; changes occur every eight days as shown below:

- Sunday-*Jimbufung* week 1
- Sunday-*Ntanbutu'* week 2
- Sunday-*Ntumngwen* week 3
- Sunday – *Foncham* week 4
- Sunday- *Nchu'Ntan* week 5
- Sunday- *Nko'ntan* week 6
- Sunday- *Ndansi* week 7
- Sunday- *Ngo'* week 8 (back to the beginning)

Although the system might look complicated, Balis living in Bali have no difficulty keeping track of the week days in their rotating bilingual nomenclature. As early as the 1950s bilingual calendars (in English/Mungaka) began to be published in Bali Nyonga and has been much appreciated by Balis living outside the sub-division especially in planning activities such as funerals, birthdays and marriage celebrations to be performed in Bali.

The eight day week is used in other communities of the North West region, particularly those villages which either traded with Bali or came under the influence of the Bali suzerainty in the precolonial days. In the immediate neighbouring villages the main market days are arranged so that they do not clash, allowing traders to buy from one market and sell in another. For example, *Foncham* is the main market day of the village of Guzang which is well known for oil palm production.

Names of months and seasons in Bali Nyonga

The names of the months are given in Mubako the original language of the

Bali people. The months were demarcated following the lunar calendar with four weeks of eight days each making a month and twelve months in the year. This gives a total of 364 days per year. No attempt was made to correct the discrepancy between the western year of 365 days and the traditional year. Although certain members of the Lela and Voma institutions were trained in keeping track of the lunar calendar there is no evidence available to us that there is an awareness of the leap year (366 days) every four years. Thus a simple alignment of both calendars was facilitated by the fact that the length of the year is twelve months for both systems.

No	English	Mubako	Main Activities
1	January	Soja	Celebration of the new year day at the palace plaza with war songs and gun firing.
2	February	Sonia	First fruits' Voma celebration/Millet harvest
3	March	Sojela	The first fruits Voma can also be celebrated this month.
4	April	Soduna	Framing
5	May	Sogamba	Farming
6	June	Buluwa	Small Lela celebration known as *keti nyikob* or the sacrifice. This is a form of thanks giving day that is observed annually
7	July	Sagwa'a	Harvesting the second groundnut crop and farming
8	August	Gwansoa	Literally Gwansoa means the month for nobles-though the significance of this name is not known.
9	September	Sosake'	All syllables are pronounced So- sa- ke. Dedicated to farming.
10	October	Vomsoa	The main Voma festival takes place during this month.
11	November	Sogeba	Pronounced So-ghe-ba. Late Voma or early Lela festivals can hold during this month.
12	December	Lesoa	The Lela festival takes place during this month.

Table 2 Names of Months in the Bali calendar

It should be noted that the Lela and Voma institutions were so important in the Bali ritual calendar that their festivals were each celebrated twice a year.

For Lela the main festival occurs in December while the minor celebration is in June. The main Voma festival is celebrated in October whereas the first fruits Voma a shorter event occurs in February or March every year. Thus most of the year was spent preparing for these four events that determined the rhythm of cultural life of Bali. These celebrations are no longer regularly held for various reasons some of them economic, others social and political.

There are two seasons in Bali the rainy season (*ndib mbung*) running approximately from March to October and the dry season (*ndib lum*) from November to February.

The attempt to harmonize the Bali and Western calendars

Shortly after taking over as the Fon of Bali, HM Dr Ganyonga III decided to harmonize the two calendars by striking off one day from the Bali week so that both weeks would have the 7 days each. The day suppressed was *Nkohntan* i.e. Day 4 as mentioned above. This reform which was straight forward in conception went down rather poorly with the people. Rather than abandon the old calendar, they would go through a lengthy description to describe each day in both the new and old calendars, a real nightmare. Following the new calendar the Bali market day began to clash with the main market days of some of the neighbouring villages which had not reformed their traditional calendars. This led to considerable economic losses, both for the farmers and the Bali Rural Council which depended a lot on income generated from market taxes and renting of stalls at the market. Even the celebration of the Voma festival in October was curtailed for the first time in recent history as it had to be concluded prematurely because the week had been shortened. When the Administration threatened to ban the reform, the traditional authorities restored the old calendar, which had never been totally abandoned in the first place.

Nowadays the old calendar seems to be fading away and is being replaced by the western calendar as Bali becomes more cosmopolitan, and the socioeconomic agendas are no longer determined by the traditional authorities. Thus a reversal of roles has emerged: The year in Bali no longer revolves around the Lela and Voma activities, rather these cultural events are forced to adjust themselves into the national calendar set by public authorities. This change accounts at least in part for the frequent postponements/non-observance of the Lela and Voma festivals in recent years. In the remaining sections of this essay I will briefly summarize the program of activities of the Lela and Voma festivals as a general guide to tourists and other interested persons.

Programme of the Lela Festival

The main Lela celebration takes place in the month of December. Exceptionally it may take place in late November or early January. As pointed out by Nwana (1978) the original Lela celebration had a military, religious and political connotations of the Bali kingdom. Today these aspects have been watered down considerably, and the Lela celebration is increasingly viewed as an occasion for family re-unions, feasting, exchange of gifts and commemoration of the past history of Bali Nyonga.

The sites

The Lela festival is staged in Bali Nyonga at four principal sites:

The Palace Plaza

The Palace Plaza (*Ntan Mfon*) is a large circular stadium the size of about two football fields located on the slope of the Jamjam hills in front of the Bali Nyonga palace. In its centre is the Lela shrine, a group of stones in the form of a cone with a flat top, about 3 meters high. It is the site of the traditional coronation and many other rituals of the Lela and Voma institutions. Currently two large fig trees planted by Titanji III (descendant of Galega I) and Tita Fonkwa II (descendant of Nyongpasi Ganyonya I) in the 1960s provide shade to traditional notables and drummers during the Lela festival and other gatherings. The plaza has been paved with concrete slabs through the efforts the BANDECA (the Bali Nyonga Cultural and Development Association.)

To the left of palace gate is the grandstand built and renovated by the Bali Nyonga community to provide sitting space for spectators. Across the plaza on the eastern side are the Court of First Instance (former Bali Community Hall) and the newly constructed Alpha Bilingual Nursery Primary School built by HM Dr Ganyonga III where Mungaka is taught as a subject to the pupils.

To the South of the Plaza and flanking the palace are the old community hall (*Gwagha*) and the statues of former monarchs of the Bali kingdom that were erected through the efforts of late Tita Samkia Fonyonga. The plaza is usually decorated with traditional artefacts for the celebration of the Lela festival.

The upper *Matua* stream at *Tita Foncham's Quarter (former Nted 2)* about 4 km from the palace is the site where the purification rites take place during the main Lela celebration in December. There is a small conserved park surrounding the area where the Lela purification rites are done.

Ntan Ko'o, the Main market area about 2 km to the south of the palace is the site where the military demonstrations (Lə'ti) are performed on the second

day of the Lela celebrations. During the reign of Fonyonga II this aspect of the festival was performed at Jamjam Quarter in front of the Fomuso estate. But due to the increase of the population the event was moved to the present site which is rapidly becoming small for the event as well.

Gwe-Tang stream, a tributary of the Matua stream lies about 1 km East of the palace and is the site for the Small Lela purification rites.

Principal Notables Compounds (Naa-Kah, Fo-Kunyang, Kah Mamfon Tita Nji and Kah Mfongwi) are all within 2 km perimeter of the Fon's palace. In precolonial days Lela was celebrated for a total of eight days (one traditional week). The first four days took place at the Plaza and other sites mentioned; the last four days in the compounds of the notables mentioned above (excluding Fo-Kunyang), each of them taking turns to host the Lela delegation for one day.

The roads connecting the palace to the other sites are important sites for the celebration. Usually the Lela delegation makes stops at the compound gates of any notables on their route for light refreshments and gun-firing.

The main celebrants of the Lela festival are:
- The Fon and his retinue,
- The Members of the Ba Sama Society
- The Tutuwan and Gwe Group
- The General population

The Sequence of Events in the Lela celebration will now be described.

The main Lela celebration in November-December takes place in three distinct phases: the preparatory phase, the main event and the concluding phase.

The Preparatory phase
The Fon decides on the timing of the Lela festival in consultation with members of the *Ba Sama* Society. The holder of the Tita Langa title is traditionally responsible for observing the phases of the moon and informing the Fon when the time comes up for the festival. In modern times the Fon may announce early in the year ahead whether he intends to celebrate the Lela festival in December in order to enable Balis living abroad to plan for their participation.

The preparatory phase usually lasts for about 1-3 weeks and kicks off at a ceremony held at night in the Palace to announce the opening of Lela. The Fon and the members of the Ba Sama Society attend this ceremony known in Mungaka as *ma lem ben* (literally to hide the dance). The full description of the ritual is not permitted by tradition, but is known that it concludes at midnight

with anointing of the Lela stones on the Fon's plaza and playing music with the Lela flutes and drums to announce the beginning of the festival. The days and weeks following this initial announcement are devoted to intensive preparations that include brewing corn beer, cleaning up the premises, making of traditional garments and stocking of food for the celebrations. As the date of the second phase approaches, Balis living abroad and guests begin to arrive in Bali Nyonga heightening the sense of expectations.

Phase II: The Celebration

Day 1: Suh Fu:
The Purification of the Flags, Dancing and gun firing, anointing the flags
The second phase of the Lela festival starts with the Second Announcement at a ceremony known as *ma pob Lela*. This ceremony takes place in the palace on the night before the first day of the manifestations and is attended by the members of the Ba Sama Society who spend the entire night in conclave at the palace. Their deliberations are not open to the public. At day dawn the Ba Sama group assembles around the Lela Shrine and performs some rites which end with fluting, drumming to the tune of Lela music announcing the effective beginning of the Lela celebrations. The Fon usually comes out of the palace to pour a libation at about 6 am and then invites the Ba Sama society to a meal in the palace.

The early part of Day One is devoted to the decoration of the palace plaza with hand woven mats, the feeding of workers who did the decorations and the solemn exit and display of the traditional emblems (*tutuwan*) of the Bali Nyonga people in a ceremony led by Tita Nyagang. These events may run concurrently or in succession. Children assemble on the plaza and practice drumming of Lela rhythms in preparation for the main event of the day i.e. the rite of purification of the emblems, symbol of the Bali city state. Around the village people prepare for the afternoon event by exchanging visits, sharing meals and drinks and dressing up for the afternoon manifestations.

In the afternoon at about 2 PM palace officials sound the rallying drum and royal bugles to summon the population. The Sama group begins to play Lela music around the Lela shrine. Guests of the Fon, the notables and the population gather at the plaza most of them dressed in while traditional robes.

When a sizeable crowd gathers at the plaza, Tita Nyagang the head of the flag -bearers informs the Fon that the stage is set and if the Fon wills the march to the stream of purification can begin. Meanwhile the Ba Sama group plays the

Lə'ti song as the crowd awaits the Fon. The Fon's retinue comprising notables (*Chinted, Ba Kom and Fonteh*) file out from the palace to signal the imminent arrival of the Fon. When the Fon emerges from the palace he stands at the main gate, receives the rallying double gongs and sounds them to indicate the start of the march to the purification stream. Thereafter Tita Nyagang leads the flag bearers in the *Lə'ti* performance to solemnly present the emblems to the Fon. At the end of the *Lə'ti*, the Fon hands a while ram or white cock to Tita Nyagang for the rites.

Tita Nyagang and his group lead the procession followed by the Fon surrounded by his retinue and the men folk. All are dressed in battle tunics and carry den guns or other traditional arms. The crowd then moves rapidly toward the Stream of Purification at the Nted II (Tita-Foncham's Quarter) some 2 km to the north of the palace. The outward march is mostly silent with a sense of expectation since at the stream the oracle will be consulted to determine the future of the Balis for the coming year.

Upon arrival at the Stream of Purification the vanguards known as (*Ba Gwe*) clear the bush and set the stage for the rite to follow. Upon arrival, the Fon sits on his throne facing the stream. Tita Nyagang approaches the Fon, greets him with hand clapping and obtains permission to begin the rite. Then Tita Nyagang and his group undress to the waist and then take the flags to the stream which is hidden by a thick forested bush preventing the population from observing the secret part of the ritual. Upon emerging from the stream Tita Nyagang assisted by the flag bearers slaughters the ram or cock and allows it to struggle. The way and manner in which the animal dies is part of the message of the oracle. If the sacrifice has been successful Tita Nyagang signals to the population and then gun salutes are fired. He then dresses up and formally approaches the Fon to report to him the findings of the oracle. After receiving the message, the Fon stands up to receive the salute from the flag bearers in form of the *Lə'ti* performance. Ward heads tune war songs to signal the end of the purification rite. More gun salutes are fired and the procession to the palace begins.

Meanwhile the vanguards roast the carcass of the slaughtered animal and give it to the children who struggle to share it among themselves by seeing who can tear off the biggest share. The boys gather stems from tall elephant grass, blunt them and head for the palace shouting *hilo–halo*. The first contingent of the boys to arrive at the palace plaza stages a mock ambush waiting to attack the later groups. This mock battle by the boys is supervised by the vanguards to make sure no one is wounded. At the end of the display all of the children are given food and corn beer as refreshment, just as soldiers are fed after a battle.

The return journey from the stream of purification is marked by singing, and gun-firing. The women folk and other villagers flock out to welcome the Fon and his entourage as they stop at the compound gates of some notables on their way back. One of the compounds on the way back is that of the Queen Mother, where the Fon and his retinue stopover for refreshments.

The Fon's return to the palace plaza marks the climax of the day's celebration. First the emblems arrive at the palace plaza and wait for the Fon. When the Fon arrives he and his notables make a short run towards the palace gate among ululations and cheering up of the crowd that meanwhile gathered at the plaza. He then stands at the palace gate again to receive the emblems which are brought to him in a run with the cloth fluttering in the wind to signify a successful purification at the stream. When the emblems fail to spread out and flutter in the wind, this is taken as a bad omen to be investigated and countered by traditional means.

Gun firing and dancing to the rhythm of Lela music is launched by the *Ba Sama* group, followed by the *Ba Kom, Ba Chinted* and other social/cultural groups. The gun firing session is followed by popular dancing to the tune of Lela soft music. Concentric circles are quickly formed around the Lela Shrine as people move in step anti-clockwise waving fly whisks in rhythmic response. As dusk falls the crowds begin to thin out and return to their various homes, but the notables and the *Ba Sama* group stay behind for the last part of the day's manifestation.

The ceremony of anointing the emblems (*Nu ma pob kong*) is the last event that concludes the first day of the Lela celebrations. This ceremony which is not open to the public takes place on the palace plaza and is attended by the Fon, notables, the Ba Sama group, Tita Nyagang and the flag bearers among others. The proceedings of this ceremony that can last until midnight, has been described by Nwana et al (1978) as involving the concluding rites of purification as well as the renewal of allegiance to the Fon and to Bali Nyonga city state.

Day 2: Lə'ti: The Commemorative March

The second day of celebration features War Games, the Silent March, the Triumphant Return, the private (non-public) handing over the Lela flutes to Tita Nyagang and his group. Brief descriptions of the essence of these events follow.

The first part of Day Two is devoted to merriment in different families, social groups and clubs. The Fon continues to receive delegations of Bali People and friends bearing gifts during the morning period. The official celebrations take place between 2 PM and 6 PM at the palace plaza and at the open field (*ntan*

Lə'ti) behind the main market some 2 km to the south of the palace. Men and women dress up for the event: men in battle tunics carrying traditional arms and women wearing hand-woven and or hand decorated dresses.

The event begins at the plaza with the presentation of the emblems to the Fon in a *Lə'ti* performance as was done on Day One. The Flag bearers lead the way followed by the Fon and his retinue (*bed M'fon*), and various sociocultural groups (*Manjong*) in a silent march to the field. The outward march is done in silence to commemorate the surprise attacks of enemies as the Balis fought their way more than 200 years ago from the Chamba homeland to the present site.

Upon arrival at the grounds, a sitting place is organized for the Fon and his suite. Tita Nyagang takes command, deploys the various groups as a general would do for his troops before a battle. The vanguards take their positions ready to attack in a mock battle. Tita Nyagang then tunes a song like a commander who pep talks troops before battle. Here is one of the songs:

Ke bi nko' ko',
Ke bi nswi swi;
Bi mbim bim bim;
Bi mbed bed mbed
Wo–ho Ncha-bed bon ntum –aa
(Translation:
Whether you go up,
Whether you go down;
Whether you agree with me,
Whether you are in denial,
Lo and behold,
Bravery wins the war!)
Another popular rhyme used for the *Lə'ti* goes thus:
Mun ye mu' kutu nda-m'Fon
Mbe a nyu musung oh
(Literal translation:
If you see fire on the Fon's roof,
It is a bird that has dropped it
Literary/ Contextual Translation:
The Fon's palace can never be burnt down by an enemy,
Because, we, his soldiers will defend it.)
On a lighter mood one of the songs says
U yu, koeng ma nda nke

Mbe a ku yin ka oh
(Translation):
If you hear people crying in a bachelor's house,
Know that it is the bachelor who has died.)
This song is an exhortation for young men to marry and make a family.

The vanguards join in the song and then Tita Nyagang opens the gun firing. Thereafter, the cultural groups take turns in a prearranged order to pay homage to the Fon, display and fire their guns. The singing and gun firing can go on for about two hours. It is concluded by the Fon saluting his people and firing a few gun shots into the air signalling the return to the palace.

The return march to the palace signifies the Triumphant Return of the Fon's own army after a successful military campaign. It is full of pomp and celebration. Women come out in their thousands to line the streets and welcome their men back home as in the past when troops returned to the village after successful military campaigns.

Nowadays the battle is for education and peaceful socioeconomic development. The silent march and triumphant return nowadays represent a time when Bali people celebrate their cultural roots and the successes of modern living in a united and peaceful Cameroon.

On the return journey the flag bearers, the Fon and his retinue make two stops on their way: the first at the compound gate of FoNgiam in Ntanfoang Quarter and the second at the compound gate of the former Queen Sister of Fon Galega II. This compound gate is very near the second gate from the palace—the gate from the residence of the royal wives described elsewhere in this volume. At each step refreshments are served comprising of corn beer and corn/ground nut cakes.

The celebrants' accent and installation at the Fon's plaza is staged in a manner similar to what was done on Day One. By now a sizeable crowd sometimes as many as 5,000 persons has gathered in the Lela plaza dressed for the dancing that would follow. First the flag bearers take their place at the southern entrance, When the Fon and his retinues arrive amidst cheering and ululations they conclude their last lap in short run. The Flag bearers present the emblems in a background of booming Lela music.

After the presentation of the emblems, the Ba Sama Group opens the gun firing. Then follow the various sociocultural groups taking turns to display and fire their guns. The gun-firing on the second day is more intensive than on the first day, and marks the climax of the Lela celebration. The Fon usually concludes

the gun firing display by taking the stage himself and firing a few shots. Although Day Three is the official date for announcements, the second day has also been used for announcements and decorations of meritorious persons by the Fon.

At the end of the gun firing and announcements the dancing resumes and continues to about 6PM. Then the crowds disperse to their various homes and drinking spots where the festival continues. As was the case on Day One the Ba Sama Group, Tita Nyagang and the *Gwe* group remain in the palace plaza for the Lela flutes' handing over ceremony. The rites and rituals marking this ceremony are closed to the public and open only to members of the Lela society. Consequently a detailed description of what obtains at this aspect of the ceremony is beyond the scope of this essay.

Day 3: Ben Mfon: The King's Dance

This day is dedicated to dancing, appointments to titles of nobility and decorations of meritorious citizens. The event begins at about 4 PM with the playing of Lela music. There is no gun-firing or presentation of the emblems which usually are planted in an enclosed area opposite the palace gate. The third day is a day to show off one's affluence. People dress in their best, and some even bring along several changes of clothing to display after each round of dancing. The music is provided by Tita Nyagang and the Ba Sama. On this day the vanguards paint their faces to disguise themselves as they go around the plaza jesting and displaying acrobatics to the amusement of the crowd. When the Fon appears in from the palace the music intensifies. He can then join the dancing making a round with his notables around the shrine to the ululations of the admiring crowd. At a given point the dancing can be stopped by the Ba Kom and the Fon can make announcement or appoint some persons to titles of nobility (see the Chapter on Honouring the living and the Dead in this volume) As was the case on the Day to the dancing ends at dusk and the people return to their various homes to continue in the feasting.

Day 4: Cho'ni Kong: The flags return to the Palace

The fourth day marks the closing of the public celebrations on the plaza. It starts with the ritual cleansing rites performed in the mid-morning in a private ceremony by *Tita Nyagang and Ba Gwe Group* at Gwetang stream. Towards the evening the population gathers at the plaza to witness the formal return of the emblems to the palace. After performing several rounds of dancing, Tita Nyagang obtains the permission of the Fon to start the closing ceremony. Then, follows the presentation of the emblems, firstly to the Fon at the palace gate and next

to the Ba Sama group at the Lela shrine, after which they enter the palace in a run. To conclude the dancing, the Ba Sama group switch over from playing *Lela* to *Saawa* music, a kind of hop dance to which the population respond by hopping and dispersing from the plaza shouting, hey!, hey!...

Day 5: Kad-Ngong
Tour of the compounds of key Hereditary Notables
This is a low key event performed by the Ba Sama Group, Tita Nyagang and the Ba Gwe Group. In the afternoon these groups gather at the palace, take the royal bugle and insignia and then proceed to visit the compounds of some notables as described above. Children may join the group. At each compound the *Lə'ti* is performed followed by dancing and entertainment of the delegation with food and drinks. The delegation moves to the next compound until it returns to the palace at dusk to handover the Lela flutes and drink the last dregs of corn beer before returning to their various homes.

Program of the Small Lela also known as the Sacrifice
This a one day event that is staged in the month of June (*Buluwa*). The choreography closely resembles that of the Day One of the Lela festival except that the purification rites are done at the Gwetang stream and there is no slaughtering of an animal. Instead incantations are made and a libation is poured by Tita Nyagang. The celebration of the small Lela was more regular in the past, and has more or less died out with integration of Christianity (that opposes it) into the mainstream Bali culture.

Programme of the Voma festival
Like the Lela festival Voma occurs in phases within a traditional week in the month of October that is traditionally named 'the month of Voma or *Vomsoa*.' The first phase is the Preparatory (*Voma keng*), the second is the exit and first tour of the village (*Voma tum kumvi nkad ngong*), followed by the accent and the dance with camping at the palace (*Voma ko' ku-ntan*), the second tour of the village and the closing (*Voma cho' kong*). The Voma celebration is open to both males and females, but only males are allowed to see Voma. Thus women who desire to dance to Voma music must do so with their backs turned to the musicians.

In a previous study the procedure of the Voma festival and manifestations were elaborately described and the reader is referred to this publication for details (Titanji et al, 1988). Herein we signal that two other celebrations do occur within the calendar year. The ritual closing of the Voma season known as *Vom-nunga*

is celebrated in a closed ceremony at the Voma shrine (*dola-ngu*) in January (*Soja*) and the first fruits Voma (*Voma kwad ngung*) in February or March.

It should be pointed out that the main Voma festival in October has occurred less frequently in recent years whereas the celebrations in January and February-March have been more regular. However, Voma outings to honour the funerals of its members and those of princes and notables have been regular thereby making Voma manifestations part and parcel of the people's cultural expression.

Conclusion

This essay describes the coexistence and adaptations of two calendars in a traditional society. The experience is not unique to Bali in Cameroon. In contemporary Ethiopia the western and the lunar calendars exist side by side. As long as the people do not abandon their language and culture such a coexistence is possible and can even be advantageous for the community concerned in that it is a mark of their cultural identity. In the case of Bali we witness a tendency of the western calendar adopted for official use to be gradually replacing the traditional calendar with the attendant loss of identity. This trend is aggravated by the tendency for the younger generation to prefer the official languages (English and French) to Cameroon's national languages including Mungaka, the language of the Bali people. A ray of hope resides in the national Government's decision to encourage the teaching/learning of national languages, which I believe inevitably will stimulate interest in the people's culture including its calendar.

Layout of the Lela Festival

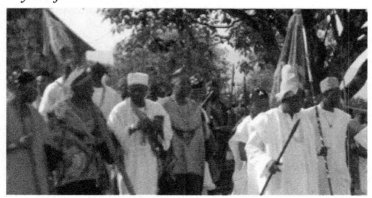

Fig 3. Fon of Bali Dr. Ganyonga III leads delegation to stream of purification on the first day of the Lela festival

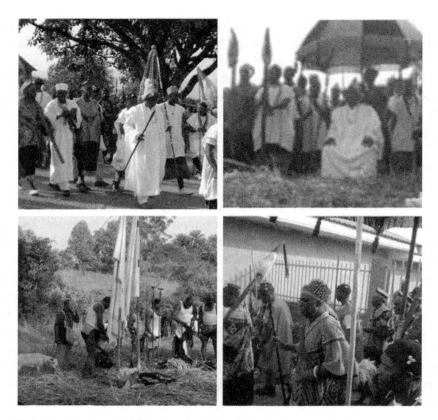

Fig 3.1 Top left, Fon of Bali Dr. Ganyonga III leads delegation to stream of purification on the first day of the Lela festival; top right, The Fon and the Notables watch on as Tita Nyangang and the Flag bearers perform the rites at the stream; bottom left; Flag bearers (Tutuwan) prepare for the sacrifice; bottom right, Fon of Bali leads the silent March to the demonstration field;

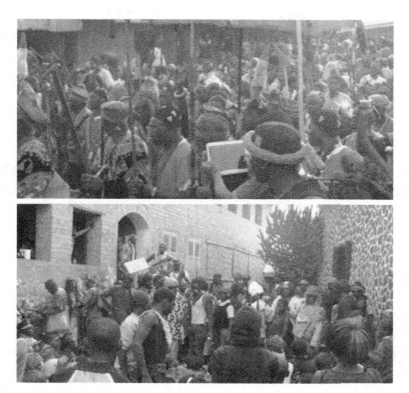

Fig 3.2 Top, the Vanguards (Gwes) taking refreshments in the Fon's Palace; bottom, The Triumphant Return

References

Green, M. (1982).Though the Year in West Africa. Batsford and Educational Ltd, London, UK

Soh, B.P. (1978). A study of Bali Nyonga history and the Lela Cult. Mimeograpgh Document. CERELTRA (ONAREST),Yaounde, Cameroon

Titanji, V P K; Gwanfogbe, M., Nwana, E ;Ndangam, G., Lima, A. S.(1988).An Introduction to the Study of Bali-Nyonga: A tribute to His Royal Highness Galega II,Traditional Ruler of Bali-Nyonga from 1940-1985. Stardust Printers, Yaoundé, Cameroon

6

HONOURING THE LIVING AND THE DEAD IN BALI NYONGA: CULTURAL SYMBOLS AND EXPRESSIONS IN A POST-TRADITIONAL SOCIETY

Vincent P. K. Titanji

PART ONE: INTRODUCTION

Bali Nyonga is in terms of geographic area a rather modest entity in North West region of Cameroon. Yet culturally and politically its influence is felt far beyond the limited confines of the Bali sub-division which it encompasses. This is not surprising since in the precolonial period the Bali suzerainty covered most of the south eastern part of the North West Region and its influence extended as far as today's West Region. With the advent of Christian missionaries its principal language, Mungaka, was adopted and used to spread the Gospel and eventually became the *lingua franca*, widely used in the Grassfields and beyond (Titanji Beatrice, 2014).With the attainment of political independence for the country in the 1960's the influence of Mungaka began to wane in the face of increasing ethnic rivalries of the neighbours, although many of its cultural practices were adopted and have today been incorporated into what may be described as the North West culture.

In this article, I will describe selected cultural practices, symbols and artefacts that are employed to honour the living and the dead in Bali Nyonga in an attempt to portray the living culture of Bali Nyonga. Frequently I will cast a retrospective look at what transpired in the past i.e. during the precolonial and colonial periods before describing the evolution, if any, in present day Bali Nyonga Society. To better present the notions of honouring people in the Bali society it is necessary first to briefly describe the Bali Nyonga social set up and its hierarchical governance structure.

HIERARCHIES OF THE BALI NYONGA SOCIETY

Like most traditional societies in the north western region of Cameroon, Bali Nyonga is a patriarchal monarchy headed by a traditional monarch popularly called the Fon. The German explorer Eugene Zintgraff described Bali Nyonga suzerainty of the late 1880s as a military autocracy (EM Chilver 1966); but things have changed since then and Bali has been completely integrated into modern post independence Cameroon. This notwithstanding, Bali Nyonga has conserved and continues to observe many of the customs of it precolonial past.

Ethnographers and historians have elaborated on the structure of the traditional governance structures which typify the hierarchical organization of the Bali Nyonga traditional society and from which titles of nobility and honorific ranks emanate. As described earlier (Titanji et al; 1988) the Fon in the traditional set up was the Head of the Bali kingdom. He was assisted in his duties by five Principal Institutions, namely:

- *Fonte* (Sub-Chiefs)
- *Nwana* (Heads of the Voma Fraternity dominated by non-royals)
- *Sama* (Heads of The Lela Fraternity dominated by royal descendants)
- *Kom* (Ward Heads or Ministers)
- *Tsinted* or *Chinted* (diplomats, administrators and retainers)

During the reign of Galega I additional institutions were added to the five described above as follows:

- *Ghan Nsi* (the Land Lords selected from the various ethnic entities that constituted Bali Nyonga) this was the forerunner of today's Traditional Council.
- *Nchu-bed Mfon* (*The king's army* which was divided into two wings *Ndanjem* and *Ndanji* led respectively by his two Elder sons Tita Nji I and Tita Mbo (later Fonyonga II).
- *Ghan Ngumba* (The Regulatory Fraternity-also known elsewhere in the North West Region as *Kwifon*)
- *Tadmanji* (Liaison Officers in charge of linkage with villages outside Bali Nyonga. These were selected from the members of the five principal groups at the Fon's discretum)

These latter groups introduced by Galega I, have all but disappeared, except the *Ghan Ngumba* group, which has survived nevertheless with limited powers. During the reign of current Fon of Bali Nyonga, Dr Ganyonga III

(1985- present) many profound changes have occurred, and while a detailed description is beyond the scope this essay we will limit ourselves to those that affect honouring the living and the dead. It should be noted that the five traditional institutions still exist today although their influence has reduced drastically. A new entity has emerged i.e. the *Bali Traditional Council*, headed by an appointee of the Fon. It is made up of representatives (two each) from the five primary groups and some individuals selected from the general population at the discretion of the Fon. At the same time the Tadmanji group has been revived and their functions redefined to emphasize representation of the Fon outside Bali Nyonga and voluntary fund-raising to support the palace. Another emerging group is the *Ba Poba* group. (*Ba Poba* is literally translated as The Annointed). This group is composed of prominent Bali Nyonga sons who have gained the confidence of the Fon and have undergone an initiation process, cryptically described as 'to catch a bird' (Titanji et al, 1988). They may be called upon to perform certain functions in the palace.

Titled Women

Although Bali Nyonga is a patriarchal society, it has well placed women in its hierarchical structure. The elevation of women to a place of honour date's back from the time of the legendary Nah Nyonga, the Princess who founded Bali Nyonga. After her father, Gawolbe II, was killed at the battle of Bafufondong the Bali kingdom split into seven groups: five of them were led by princes (Bali Gangsin, Bali Gashu, Bali Kontan, Bali Gham, Bali Muti); Bali Nyonga was led by Princess Nah Nyonga and Bali Kumbat by a palace retainer who later on became king and founded the Bali Kumbat dynasty. Nah Nyonga married Samjewa and they had a son Nyong Pasi who was enthroned as a King when he grew up. His mother, Princess Nah Nyonga, became the *Queen Mother* (Ganua in Mubako or Ma-Mfon in Mungaka) and served as a close advisor to him. Since then the mother of every reigning monarch has occupied this position, and if the biological mother of the king dies before he accesses to the throne, or in the course of his reign, one of his sisters can be given the position of the Queen Mother.

The other influential woman in the Bali Nyonga Kingdom is the *Queen Sister* (Mfo-Mungwi, literally King of Women) who is the titled half sister enthroned at the same time as the Fon to take care of women's affairs. The Fon's wife or wives command a lot of respect on account of their husband's position, but they are not referred to as queen(s). The Queen Mother and the Queen Sister may each appoint up to 3-5 women to the rank of Nkom and such women accompany

them on their outings. The Bali population is duty bound to construct the residences of the Queen Mother and the Queen Sister. Each of them has her own consecrated compound gate, and when they die they are given a state burial and funeral with gun-firing, an honour, which is reserved for men.

Recently in 2014/2015 the Fon of Bali appointed three women to the newly created title of *Na Jalla* (*The Fon's Neclace*) which in several respects is similar to the *Tadmanji*. These women have been recognized by the Fon for their contributions to the development of Bali Nyonga. Their rights and privileges as well as their protocol positions are similar to those of *Ba Nkom* except that they may not be admitted to certain secret societies of the palace.

GENERAL FUNCTIONS OF THE TRADITIONAL INSTITUTIONS

Each of these institutions had direct access to the Fon. Some individuals through the hereditary succession or by appointment of the Fon belonged to more than one of these institutions. Depending upon the occasion each of these institutions took priority over the others and the monarch could call them up for duties as need arose. In the precolonial period all of these institutions had a mixture of military, administrative, religious and cultural functions. There was no clear-cut separation of functions as every major decision ultimately depended on the will of the monarch. There were special rites of initiation for each group while special honorific attributes and symbols were reserved for group members and varied from one group to another.

Members of each of the groups had special privileges and were entitled to a share of the 'national cake' (*ghab ngong*). In those days this could be war booty, land, money and royalties of all sorts from dependent territories. In return they contributed to the up-keep of the royal house-hold by organizing to cultivate the royal farms, and supplying food and drinks regularly to the palace, especially during festivals.

During the colonial rule the balance of power began to change and colonial administrators, whenever they were present, took precedence over the traditional administrators. The advent of political independence and attendant influences like Christianity, modernization, democratization, republicanism, profoundly modified and in some cases replaced or abolished the traditional governance structures. However, honorific cultural symbols and attributes have survived the winds of change, though with modified renditions in some cases. The aim of this essay is to describe how people are honoured in Bali Nyonga at birth, when they achieve something significant and finally when the die. Thus you will find

in these essay descriptions of naming ceremonies, investitures, and celebrating the lives of those who have passed on. Another objective is to demonstrate the living culture of the Bali Nyonga people as a society where upward mobility is possible for all its members and success is rewarded, not only financially, but also through symbols.

PART TWO: HONOURING THE LIVING

Depending on one's achievements, rank and/or social class to which an individual belongs, certain honours may be bestowed on him or her by the powers that be in the Bali community. In this section we will examine in a systematic manner the honorific symbols and artefacts that are currently employed in Bali Nyonga. We will start with the naming of persons and then proceed to appointment and installation ceremonies before concluding with formal expressions of respect in everyday conversation.

Naming ceremonies and traditions

Naming the Fon
The Fon on acceding to the throne takes a name with the prefix: Gah which means king in the Mubako language or *Mfon* or *Fon* in Mungaka language. So far the following names have been given to the monarchs who ruled over Bali Nyonga:

Nah Nyonga (female founder of the Bali Nyonga dynasty, was the first Queen Mother)
- Nyong Pasi (Fonyonga I or Ganyonga I, reigned 1836-1856)
- Galega I (reigned 1856-1901)
- Fonyonga II or Ganyonga II (1901-1940)
- Galega II (1940-1985)
- Ganyonga III (1985- present)

The naming pattern suggests that with the exception of the first two names) a ruling monarch takes the name of his grandfather with an indication of the serial number in the lineage bearing the name. The naming ceremony of the monarch is embedded in the coronation ritual, which culminates in the mounting of the *Lela* shrine in the Palace Plaza to address the population of Bali Nyonga (Titanji et al 1988)

Naming of Children

All children regardless of gender and origin are usually named in an elaborate family ceremony within the first eight days of birth if the child is born in Bali Nyonga. Children born out of the village can be given a name without the ceremony, but the ceremony is usually conducted later, sometimes after years. The naming ceremony is usually combined with the ceremony of taking the child out of the house and compound for the first time.

Usually the female relatives of the child's mother prepare corn beer and food for the occasion which is done in the morning. The family head or some other senior members of the family preside over the ceremony. The ceremony starts with the aunties cleaning up and dressing the child. Then follows the ceremony of the first exiting (*ma tuhmu mon kumvi*). The mother of child to be named carries the child in her arms, steps out of the house and is lead by one of the paternal aunts of the child in an anti-clock wise procession round the house. When it is not possible to go round a particular house, another house in the compound can be chosen for the ceremony. At each corner of the house the leading aunt faces the mother of the child and both of them gently let their toes meet in a symbolic dance. This movement is done thrice for a male child and four times for a female. For a male child a man follows the mother and feigns to shoot at her using a toy bow and arrow to signify that the child will face dangers in life and the mother should protect him. At the same time one of the aunts goes ahead holding a cutlass/hoe and making a motion of mowing/hoeing the farm (for a male or female child respectively). Then they continue to the next corner until they go round the house. Then the mother and child enter the house with all the rest of the guests standing outside. The door is then closed and one of the aunts knocks at the door (thrice for a male, four times for a female child) and the mother then opens. As she exits cold water is splashed on her and the baby. The baby usually cries and all the aunts say comforting words to him/her. This is to signify that life outside is never easy, but when there are problems the family is always there to help. Following the first exit ceremony, the naming proper begins with the family head officiating.

The Family Head sits on the family stool in front of the family house and the mother brings the baby to him. A bowl of fresh *non-alcoholic* corn beer is also brought along. Taking a few drops with the tips of his finger (nowadays with a teaspoon) he places it on the child's lips pronouncing his/her name and urging him to drink the corn beer. For example, the person doing the naming may say, '*Sama, Nyi bouan* (Sama drink corn beer)'. This process is repeated thrice for a male and four times for a female child. The final step in the ritual consists in

dipping the child's feet thrice/four times in the bowl of corn beer, which is later on shared among all the guests excepting the child's mother and her sisters. Thereafter, the family provides a meal and drinks for all the guests. Nowadays the guest may also bring gifts for the mother and child to the naming ceremony.

Several publications have appeared giving commonly used names used Bali Nyonga in Mubako and Mungaka languages and their meanings in English (Fokwang John,1986 cited in Lima AS 1985). The names distinguish between male and female children, may be the names of relatives, living or dead, or they may commemorate events or seasons in which the child was born.

The naming of the *first prince to be born to the royal household* after the coronation is followed by a solemn presentation of the child in the presence of the notables at the Lela shrine. Although there is no rule of primogeniture in the Bali Nyonga tradition, the presentation of the first prince to the Lela shrine is usually taken as an announcement that the prince is the heir apparent to the throne, unless something goes wrong to prevent him from becoming the next Fon.

The naming of other royal children follows the same procedure as that on non-royals, except that for royal children special rubbing oil mixed with medicinal potions called *kasi* is used to anoint the royal child, while ordinary palm oil mixed with ground red wood powder (*bu*) is used for non-royal children. However, the use of these rubbing materials is fast disappearing.

The Red Feather Award Ceremony

It is a common tradition in the North West Region of Cameroon to decorate the cap of a notable or meritorious male with a red *turaco* feather. The red feather can be viewed as a medal. It is won as a mark of distinction, to delineate ranking from ordinary persons. In the North West Region, the traditions surrounding the award of the red feather medal vary from one ethnic group to another. Herein we shall describe what obtains in Bali Nyonga.

In the past the award of the red feather required that the recipient should go through a test of endurance administered by the *Nwana* group. The details of this procedure have been described earlier (Titanji et al, 1988). This process is however viewed by many as being too difficult for the modern person and the red feather is nowadays awarded to some individuals by the Fon directly without involving the *Ba Nwana* group. The culmination is the presentation of the person to be honoured to the Fon in the palace.

As a rule of the thumb all persons bearing the title of *Nwana*, *Nyagang*, or *Tutuwan* must go through the process of initiation/test of endurance before they are allowed decorate their caps with a red feather as a sign of honour. Only some

selected members of the other main traditional institutions may be awarded the red feather medal. In addition people who have done an act of bravery, or rendered service to the Bali fatherland can be awarded the red feather medal by the Fon. If a Bali Nyonga indigene is given a red feather medal by another Fon outside of the Bali Nyonga kingdom, he must present it to the palace of Bali for acceptance before he can use it in Bali. Otherwise, it will be seen as challenging the authority of the Fon with all the social consequences that can ensue.

The manner in which the red feather is placed on the cap corresponds to the rank of the notable. The Fon wears the feather on the tip of his cap directly above his forehead and in alignment with the tip of his nose. All other duly authorized persons wear the feather to the right, the inner side of the feather pointing upwards. As for sub-chiefs and other notables, who have not undergone the endurance test, the feather is aligned under the flap of the cap, or it is halved before being planted on the cap. Nowadays, these subtle distinctions are progressively ignored and all tend to wear the red feather in the same manner on the right side of the cap, with the tip pointing upwards and the inner side turned outwards.

The Gown with a Royal insignia

The Fon may decide to publicly honour a Bali man or a visitor by giving him a traditional dress item decorated with the royal badge. The royal badge is a multicoloured circular cloth sewn on the back of a traditional gown or tunic midway between the neck and the waist. The design of the cover cloth around the shoulder is usually is also circular instead of ending in pointed spikes In traditional embroidery the circular design represents the moon (*ngnwu*) and any cloth so designed is called moon-cloth (*nji-ngnwu*). Thus when the Fon gives someone a gown with a royal design on it, it is said in Mungaka that '*Mfon mmah nji-ngnwu ndu*, translated to mean 'the Fon has dressed him/her with a moon-design/decorated gown'. Such robes are reserved for formal occasions, and may not be won to the market, funerals or a drinking spot. The robes are not to be buried with its owner when he/she dies, but should be returned to the palace or kept by the family as a souvenir. The successor of the deceased owner of a royal gown may appeal to the palace for permission to use the robe. If it pleases the Fon he will bless it by sprinkling water on it, and this will be regarded as a medal award.

The Fon may decide to give other clothing items like a crown-cap (*feleng*), a loin-cloth with a red and white embroidery (*suhnji golabbe*) to some notables to reward them for distinguished service to the palace. Such items are usually

presented during a visit of the beneficiary to the palace, or sent to the beneficiary through a Palace Retainer (*Nchinted*) bearing the gift in a royal bag (*Bam Mfon*) specially designed for the purpose. The beneficiary can show appreciation by not letting the Fon's bag return empty without a monetary gift in return. Like the royal gown, these gifts are regarded as traditional medals and as such they are not transferable.

Appointment and ceremonial installation of notables

In Bali Nyonga, though some noble titles and positions are hereditary, some high profiled positions can be filled by appointment of the Fon (Soh Pius, Titanji et al 1988). In the next sections we will describe the ceremonies associated with the appointment of some notables laying emphasis on the cultural animations that accompany them.

Appointment of an Nkom and other notables ranking as such

The Position of *Nkom* is highly respected in Bali Nyonga. With the exception of the seven hereditary title bearers in this category all others are appointed on merit. The appointee has to distinguish himself in community service and be seen to be a leader. He may be recommended to the Fon for appointment by palace insiders, or may discretely seek the nomination himself. In any case when the Fon decides to appoint a *Nkom* the person concerned is informed and comes to the social function where the appointment will be made. The most common occasion for the appointment of a *Nkom* is during the *Lela* festival, which is celebrated in the month of December, but this can also be done at other occasions. When this is done during the *Lela* festival it takes a particular format. On the second or third day of the *Lela* festival there usually is a period when the entire population sits down for to receive a message from the Fon.

After the announcements, the Fon summons the candidate to be nominated to the Palace Gate where the throne is usually set up. The message is borne by one of the Palace Notables, the title-holder of *Tita Sikod* with these words:

"Where is X?" (*Lungko le ya* e?)

"Here I am" (*Mbah!*) the candidate replies and then moves up to the Fon sitting on his throne.

The Fon hands him to *Tita Sikod* saying, "Here is Gwan..." "Present him to the *Sama* group and the Bali People." (The word *Gwan* in Mubako stands for *Nkom* in Mungaka.)

Tita Sikod then brings the new appointee to the *Lela* Shrine which is located some thirty meters from the Palace Gate and tells the *Ba Sama group members*

the name. If the name is wrongly pronounced or inappropriate or has already been given to another person this can be pointed out by the *Ba Sama* group and the Fon may make corrections. Thereafter, Tita Sikod hands over the appointee to the *Nkom* title bearers who were selected to make announcements on that day. The announcer then holds up the right hand of the appointee with his left hand and holding the royal insignia, known as *Kong Mfon* proceeds to go round the vast, fully packed plaza shouting out,

"The Fon says this Gwan…; This is Gwan…." *Ba Gha yo Gwan … baɲ* e).

The people can show approval by clapping their hands.

Thereafter the appointee may give a spontaneous open-house reception in his compound to friends and other *Nkom* title holders to celebrate the appointment. About a year later, the appointee is expected to organize the ceremony to formally celebrate the *Nkom* title. This ceremony that is characterized by lavish spending and gift sharing is called *Sang Kom*. Usually the Fon sends three Senior Royal descendants (*Tita Bakom: Tita Nji, Tita Nukuna, Tita Yebit*) to witness the occasion. Rarely, the Fon may attend and preside over the occasion himself.

The nonhereditary title bearers who do not perform ritual functions like the *Tadmanji* and *Na Jalla* can be similarly appointed like the nonhereditary *Kom* title-holders. For nonhereditary appointees to positions with ritual duties another format is employed. We illustrate this with the appointment and investiture of *Tita Nyagang* - the leader of the flag bearers at the *Lela* institution.

Appointment and installation of Tita Nyagang

According to the Bali tradition the title of *Tita Nyagang* is nonhereditary. A new Fon has the right to appoint his own *Tita Nyagang*, who ceases to function as such upon the death of the Fon. But in the last three or four generations this title stayed in one family; that of *Tita Nyagang* of Munung Quarter in Bali Nyonga, until it was transferred after the death of the last office bearer in that family.

Without digressing into the politics of the change that was made, we describe the ceremonial aspect of the investiture, because of its importance as a cultural manifestation. After years of consultation the Fon decided to appoint one of the flag bearers (*Tutuwan*) by the name of Mbungu to this prestigious position. The installation was scheduled on the first day of the *Lela* festival and took place on the Palace Plaza in front of the Place Gate.

On instructions of the Fon a vanguard of the *Ngumba* Society dressed in a feather tunic with a face-covering cloth, and accompanied by a number of retainers went to Mbungu's compound and summoned him to the palace. Upon arrival at the Palace Plaza a sizeable crowd had gathered to witness the

occasion. The Fon then appeared from the depth of the palace dressed in the Bali battle tunic (*yadalla*). Standing at the palace gate he got the code of arms (*Ding Kwassak*, or *Ding vaksa*) from one of his close attendants and signalled for the appointee to approach him. The Fon then addressed him with these or similar words:

"This is my insignia. Will you ever let it be suppressed?" (*Yo kong a bah.Bofa umma'ti nga bofed tui masi e?*)

'No, Your Majesty, "he replied (*Ngang Ngunyam*)

The Fon repeated the question twice.

And thrice he swore to uphold the insignia and lead the flag bearers with honour.

Then the Fon handed him the code of arms i.e. the three spears and ordered him to demonstrate how he would henceforth do the presentation of the insignia, saying

"Go present it to the Bali people" (*Gho la nnahti mbo Ba'ni e*)

At this command the appointee performed the salute dance (*Lə'ti*) as the Fon sounded his rallying double gong (*gig-ga'a*), to the accompaniment of the royal drums (*dang dang*) and bugle sounds (*ntang mfon*). Thereafter Mbungu assumed the position of leader of the Flag Bearers (*Tita Ba Tutuwan*). Altogether this ceremony was filled with symbolism and represents the stuff of which drama and films are made.

Recognition and installation of hereditary title holders

The Fon is the first among the hereditary title holders. His installation and presentation has been described earlier (Titanji et al, 1988). In this section we shall describe the installation of other title holders which include the members of the institutions named above and family heads. It will be seen that the traditions surrounding these events vary widely depending upon the ethnic origin the protocol rank of the title holder. However, there are common aspects that are shared by all categories and our presentation will high-light some of these.

When a titled man dies, his extended family holds a meeting after the burial and before the funeral celebration to select the successor. In modern times this task is made easier if the deceased person had left a written will. Once the successor is selected his name is communicated to the Fon who may approve of it or ask for another name to be given from the same family .Sometimes a hearing is held in the palace if there has been no agreement in the family. There are cases, where in a large family with many potential successors, these consultations took years before a successor was selected. In such cases the designation of the

successor is postponed till after the funeral. Once the successor is agreed upon, the date for the ritual installation and presentation is fixed in close consultation with the Palace.

On the appointed day the ceremony takes place in three phases. Firstly, at the family compound the immediate and extended family gather, anoint and dress up the Successor according to the family tradition. Most successors wear a full dress (tunic, cap and loin-cloth made of white fabric that has been coloured with a red wood extracts.) The rest of the family dress themselves in traditional attires. Nowadays some families sew special uniforms for the occasion and others use their best partying apparels.

At the appointed time the family members, friends and sympathizers move in procession to the Palace bearing gifts of fire wood, uncooked food items and drinks. The Successor leads the procession, holding the family staff (*bang*). In the past the successor carried his late father's gun as he led the procession to the Palace.

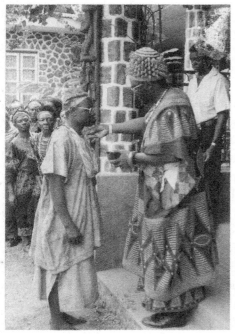

Fig 4 Picture of the Fon of Bali Dr Ganyonga III (right) installing Professor VPK Titanji (left) as successor of Ba Titanji III, a notable, King-maker and Fon's Representative during the reign of HRH Galega II (1993)

Phase two of the presentation takes place in the Palace court yard, with the Fon presiding. After the guests have taken their positions and greeted the Fon with hand-clapping, the Fon now asks for a presentation of the successor. This

is done by one of the senior members of the family. If there was a will, it is read out loudly for all present to hear. Sometimes the Fon may ask for a voice vote. After ascertaining that there is no opposition the Fon now continues with the traditional blessing. A suitcase containing a selection of the dresses and valuables of the successor's late father is presented. A palace retainer removes a marked item from the suitcase to symbolically show that the Palace has accepted the successor. The suitcase and the rest of its contents are returned to the family.

Upon invitation the successor removes his shoes, approaches and stands in front of the Fon. The Fon then proceeds to sprinkle water on his chest and the back of his neck, pronouncing words of blessing and encouragement. The final act is to pour a libation at the feet of the successor. Sometimes the hand of the successor is held up and shown to those present as a public confirmation of his new position. The second phase concludes with a presentation of dances in which the guests participate.

The third and final phase of the ceremony is the triumphant return to the family compound of the successor where he now sits on the family stool and receives hand clapping salute from his extended family and friends. Thereafter, there is feasting, dancing and rejoicing according the means provided by the successor and his supporters. Nowadays such presentations can attract sizeable crowds of hundreds to several thousand guests from within and outside Bali.

Inaugurating a new compound, house or Property

There are many rituals and rites associated with the inauguration and blessing of property and we will describe a few.

In the past, when a Prince became of age and built his own compound separate from the Palace and the compound of his grandfather where he grew up, the Fon may decide to inaugurate his compound in a ceremony called 'Ma Toh Nchubuh' (to open the compound gate). This usually took the format of a 'state' visit to the compound with all pomp and pageantry.

Through a proclamation of the Fon made public during a major Palace event or during the market day the decision to open the gate of the prince is announced. Serious preparations consisting in the renovation of the premises, preparation of food and construction of a fence covered with hand-woven mats are done by the Prince.

On the appointed day friends, relatives, invited guests and neighbours gather at the compound to be inaugurated to wait for the Fon and his entourage. The ceremony usually takes place in the mid-morning.

When the Fon emerges from the palace to head for the designated compound,

the royal bugle and drums are sounded to announce the beginning of the event. A palace retainer (*nchinted*) carries a lighted wooden torch and leads the royal party. Meanwhile fire is extinguished in all compounds near the one to be inaugurated.

Upon arrival at the compound the Prince to be honoured receives the Fon and his entourage with hand-clapping. The Fon then approaches the compound gate says a few words of encouragement and pushes down a bamboo pith barrier placed at the gate as a 'symbolic ribbon' declaring, "I hereby open the compound gate of *Tita* X." He then goes inside the compound and enters the house of the prince. The torch is then used to kindle fire from which all neighbours light their torches later on at the end of the function to return to their homes. These rituals are followed by heavy feasting, and dancing.

At the end the feasting the Fon then pours a libation and sprinkles water on the Prince, his family and friends as a gesture of blessing before returning to the Palace. Needless to say the Prince and his relatives present gifts of fire wood, food and money to the Fon and his entourage as a sign of appreciation.

The state visit instead of the gate opening ceremony (since this is supposed to have been done) can be performed in honour of the successors of royal descendants down the generations after they have taken up their late father's position and come to prominence. It must also be said that the ceremony is very similar in character to the ceremony to honour ministers and ward heads (*Ba Kom*) that was described above.

Also the Fon may not personally attend, but can send one of the Senior Royal Descendants to represent him. HRH Galega II performed this ritual in honour of Dayebga Tita Nji III (who served as Prime Minister throughout his reign) and Tita Nukuna Fonyonga (who was the Minister in charge of Palace affairs during the reign of Galega II)

Inaugurating houses and blessing property of non-royal descendants

A house warming ceremony (*nu mma feti muh ma ndab*) is presided over by the family head to mark the effective occupation of new premises. This usually takes place in the evening and is an affair for the extended family. At the appointed time, the family head accompanied by some family elders lights a firewood torch in the family house and moves in procession to the house to be inaugurated. In preparation the house owner puts out any fire and light that was in his house. The family delegation then arrives with the torch, enters the new house and lights a fire. The host provides drinks and refreshments .Then children sing and dance to entertain the guests. The family head concludes the occasion by pouring a libation. In Christian families the libation is replaced by

91

a prayer; many at times both traditional and Christian rites are performed for the same property at the same or different occasions.

Similarly, when someone buys a car, motor bike or a machine, they may opt to receive a family blessing. In this case the item is brought to the compound gate, or the frontage of the family head's house for the blessings. This blessing takes the form of a libation and water sprinkling. It should be pointed out that not all family heads have the right to pour libations and pronounce blessings. In every extended family there is usually just one head, affectionately called *Ba* (Father) who does these priestly duties for the family. Many modern Bali people still respect these traditions, but some are replacing them with Christian consecration rites or are omitting them altogether.

PART THREE: HONOURING THE DEAD

In the preceding sections we have described in some detail aspects of the living culture of Bali Nyonga people that are related to the honouring of the living. The next section we shall dwell on ceremonies associated with honouring those who have departed. But as the reader would notice these ceremonies are in many ways extensions of the honour given to the living. Thus, once a person of honour, you remain so even after you have passed on. This in a way explains why maintaining one's honour throughout life is so important to Bali people.

The 'Cry Die' is a major sociocultural event in Bali Nyonga

'Cry Die' and 'Death Celebration' are two expressions frequently employed in the North West Region and indeed in Anglophone Cameroon to describe events surrounding the burial, funeral and memorial of a deceased person. In the indigenous communities these ceremonies differ from a typical funeral as practiced in the European tradition. Quite often the event is a mixture of mourning and celebration, an occasion to feed the family and friends of the deceased, to display traditional dances and install the successor. As is often the case, the ceremony varies from one community to another, and within the same community, between individuals depending upon their rank, gender or age. In the Bali Nyonga Community these ceremonies represent the main cultural manifestations around which much of the socioeconomic dynamics operate. We shall therefore highlight the specificities of the *Cry Die* in Bali Nyonga and show how it has evolved in time over the past thirty years.

Stages of the Cry Die

In the 1950s before the major reforms carried out by Fon VS Galega II the Cry Die could last for several months and even years in the case of the Fon. There were at least nine stages:

- The Burial (*Tung Nku*)
- Planning for the funeral *(Tang Vu* or *Cho Vu)*
- The Announcement (*Toh vu*)
- The Cry Die /Death celebration (*Keng Vu*)
- Feeding the Bereaved family (*Tad Vu*)
- Shaving Ceremony (*Kom Tu-vu*)
- Farm Outing (*Tse'ni Vu ma-ngwen*)
- Sackcloth Removal (*Cho' Tu Vu /Suh Vu)*
- Widowhood Rites *(Nu Kuh)*

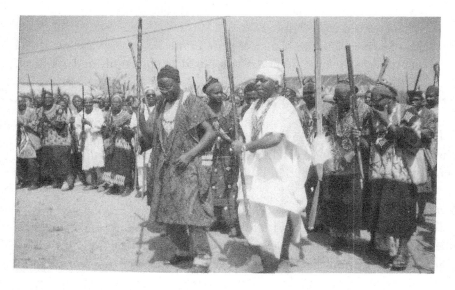

Fig 4.1 Picture scene from the opening of a cry-die. In the foreground, the successor of Ba Gwanjegana in white and the author in purple performing the royal dance. Behind, the traditional notables holding the royal insignia (Kong-seh)

Before the mid 1950's, the Initial phase of the funeral lasted for *four* days for a woman and *three* days for a man and included the first five or six stages described above. This was followed by a one day event three to six months later

93

when the sackcloth removal ceremony of *Choed Tu-vu*, literally translated as 'decapitating the death' was done. For persons who belonged to a social club, their club members usually transformed the house of the deceased to their meeting's venue over the next seven weeks following the inhumation of the deceased at the end of which the ceremony of sack cloth removal was (*Suh Vu*) was performed.

Each of the phases was characterized by singing and dancing, firing of guns for men and of course the provision of food and drinks for the mourners. The cost of the ceremonies was so great that it was unsustainable calling for reforms which took place in the mid 1950s and had the following characteristics:

- The Cry Die with drum beating shall last one day only;
- Gun-firing shall be reserved for the death celebration of men only, except for the Queen Mother and Queen Sister whose funerals take the format of a senior notable and includes gun firing
- No funeral except that of the Fon shall last for more than one day.
- The Fon's funeral shall last for three days. The Fons of other villages can come to commemorate their departed colleague on additional days whenever it is agreed upon.
- The death celebrations can take place immediately after the burial, the day after or at some other date proposed by the family and approved by the Fon.
- There shall be no drum beating for the funeral of children less than five years old.

The main stages have since been further streamlined to save costs and adapt to the modern calendar of events. In the following sections we shall describe the funeral rites as they now obtain in Bali Nyonga since the reforms.

When the Light goes out

The Fon is considered as the Light of the Bali People and his passing on is euphemistically referred to as the extinction of the light. 'The light is out' means the Fon is no more and this is a capital event in the life of the *fondom*. In an earlier publication (Titanji et al (1988) we described the events surrounding the burial of Fon VS Galega II, and the enthronement of the reigning Fon HM Dr Ganyonga III. In this report we shall summarize the main steps and refer the reader to the earlier publication for details

1. The burial of the Fon takes place in the depth of the Palace. The selection of the new Fon is according to the will of the deceased Fon. If he has not left a will, there will be consultations among the royal family in the presence of the King-Makers. Nowadays, the Administration

represented by the DO or the Senior DO will be involved.

2. The burial of the Fon is not public. The *Nwana* group of the Voma Society officiates. The *Sama* and *Ghan Kang* groups may come in to perform some rites, but must withdraw before the internment.

3. The installation and the initiation rites of the new Fon begin after the burial. The new Fon may decide to make appointments to the nonhereditary offices of *Tita Sama* (Property Manager) *Tita Sikod* (Aide de Camp) *Mfo Mungwi* (Queen Sister) during the three days of ritual installation or postpone them until later. The investiture of the Queen Mother (*Mfo-Mungwi*) is usually postponed till later, when she shall have completed the widowhood rites. Throughout the installation and initiation the *Ba Nwana* group keeps company with the new FON and instruct him about the secrets of the land. Other notables especially the initiated (*Ba Poba*) may also come in to brief the new Fon.

4. The First Day of the Mourning is devoted to the burial of the effigy of the late Fon. The new Fon does not attend this ceremony, although he closely monitors it through emissaries from the palace. In 1985 this was the day when the Senior Divisional Officer, representing the Governor attended the occasion and delivered a eulogy on behalf the National Government.

5. The second day of mourning is devoted to the presentation of the new Fon to the public. This occasion is full of pomp and pageantry.

6. The third day is the day of mourning and celebrations with traditional dance displays including the five original Bali dances in this order: *Dangnga, Lela, Voma, Saawa, Nguh*. Though originally belonging to the Bati group, the *Nguh* dance replaced the *Gbwana* dance, when the latter was banned in Bali Nyonga. The dancing is inter-spaced by gun firing. Other modern traditional dance groups take turns and several of them can perform at the same time. The choreography and the drama surrounding the burial of the effigy and the celebrations following this event have been described (Titanji et al, 1985 op cit)

Religious Rites of Interment

These depend on the religious confession and the social rank of the deceased. Christian burial and funeral rites have fully integrated themselves in the Bali Nyonga tradition, since the introduction of Christianity into Bali Nyonga at the dawn of the 20th century. Thus when a Christian dies his family may decide whether he will be given a Christian burial followed by a Christian celebration,

or whether the Christian burial will be followed by a traditional celebration. Some Christian denominations (The Presbyterians, for example) demand a Christian burial rite for their members and may join in a mixed traditional/ Christian celebration afterwards.

The Roman Catholics insist on performing the funeral mass and burying the corpse in their cemetery following the rites of their church. However, they may allow the family to bury the corpse in the deceased person's compound, following traditional rites, after the requiem mass. All Christian denominations tend to dissuade their members from combining both the traditional and Christian rites, even though there is a tendency for both types of rites to be performed for Christians who are royal descendants and/or title holders.

The Pentecostal Churches insist on following their brand of Christian rites, and do not officially participate in any traditional rites which they condemn as sinful. Similarly the Moslems bury their dead according to their tradition, and though not objecting to traditional celebrations following the burial, do not officially participate in them.

The Burial

In the past before the introduction of modern methods of embalmment Bali people buried their dead quickly. If a death occurred in the morning, burial took place in the afternoon on the same day. If the death occurred in the evening or at night, burial took place the following day, usually before mid day. With the advent of modern methods of embalmment, the burial ceremony can now be postponed till a date convenient for the bereaved family and the traditional authorities.

There is a long tradition of washing, anointing and dressing the corpse before burial. This is a gender based activity where family members of the same sex prepare the corpse for burial. In the past this preparation was done by close family members. But since the advent of mortuary services in Bali in 2001 this responsibility is gradually being shifted to professional morticians.

The typical funeral scenario begins with a wake keeping without corpse in the deceased person's compound during which there are animations by traditional and/or religious groups. On the following day the corpse is removed from the mortuary and taken to the compound of the deceased, followed by religious and /or traditional rites before the burial.

The burial can be public or private depending on wishes of the bereaved family and taking into consideration the rank of the person concerned. Generally burial is public. However some notables belonging to certain secret societies

may be buried by members of their societies in a private ceremony.

At the grave yard after lowering the casket, the family head may say a few words of farewell addressing the corpse as if it were a living person. After which he throws a shovel of earth into the grave. Then other family members, notably the wife/ wives of the deceased, or in the case of a woman the husband, followed by friends take turns in throwing a shovel of earth into the grave while saying words of farewell. Then the grave is then covered.

This internment ceremony is usually animated by the singing of dirges, crying and weeping and for a man, it may be concluded by the firing of guns when the Administration permits. The death celebration, *Cry Die*, may follow the same day or may be postponed to another day according to the decision of the family. In any case, following the burial, mourners are usually invited to a reception where food and drinks are served. Though the bereaved family provides most of the refreshments, friends and sympathizers also come with food, drinks and money to assist the bereaved family. The in-laws of the deceased family have special duties to assist in digging the grave and providing food and drinks to the mourners. Thus the cost of the burial and funeral is shared by the extended family, friends and sympathizers, in brief, by the community.

Scenarios of the Cry Die

By tradition every Bali person deserves a ceremony to mark his/her passing on. However, persons who had committed incest, murder or suicide are not honoured in this way. They are buried outside the residential area with no fanfare, the aim being to show that this was an outcast and the community does not honour him or her. In the past those who died from madness or from an infectious disease were also buried outside the residential areas in a quiet ceremony and no celebration was authorized for them. The Palace of Bali therefore decides on and authorizes funeral celebrations on a case by case basis and all deaths must be notified to the Palace. If a family decides to organize a funereal without the permission of the Palace, this is considered a breach of traditional law and the Fon can send the representatives of the Regulatory Fraternity (*Ghan Ngumba*) to stop the celebrations.

In the preceding section we had outlined the essential steps in a funeral celebration. These apply almost across the board. Because this article is about honouring the living and the dead we shall in the next few paragraphs highlight the activities that set aside the celebrations made in honour of the various categories of Bali Nyonga denizens, activities that are meant to highlight the place of the deceased person in the traditional hierarchy.

The Funeral of the Fon of Bali Nyonga

The highest traditional honours are reserved for the Fon as the leader and spiritual father of the ethnic group. The following features stand out and are reserved for the Fon's memorial celebration to the exclusion of all other persons:

- All Bali Nyonga denizens are expected to shave their hair bald and dress in white garments, and to personally attend the manifestations marking the passing away of the Fon. However, members of the *Nwana* group, are allowed to partially cover their heads with a white turban to hold their red feather medals.

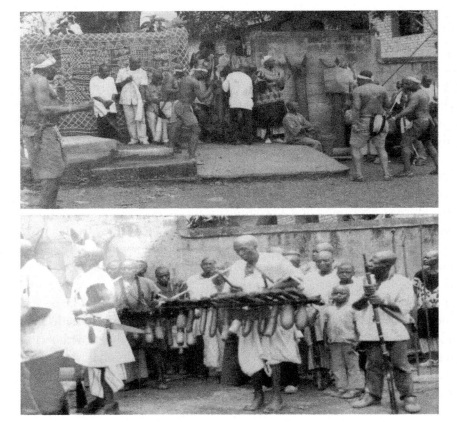

Fig 4.2 Top, Ba A.D. Titanji III presiding over the 2nd day of the funeral of Fon Galega II in 1985. Bottom, Xylophone players (Njang Kefat) at the opening of the 2nd Day of the Funeral of Fon Galega II in 1985.

- At the opening of the Funeral both traditional emblems (*Tutuwan*) ,which are usually displayed only during the Lela celebrations twice a year, are brought out and used in the salute –dance *Lə'ti*
- At the opening of the celebrations three sets of drummers play concurrently the horse riders' dance (*Yaa*), the Lela salute dance (*Lə'ti Lela*) and the xylophone dance (*Njang Kufat*). This music is accompanied by jingles and the blowing of the royal bugle. The number of drums played concurrently matters and is the highest (up to ten) for such an occasion. The horse riders dance is played on two drums, the xylophone is accompanied by two more drums and the Lela salute is played on four drums and four flutes. If the new Fon is present or the effigy of the late Fon is being displayed, two additional drums may be played by the palace retainers. The position of the drummers is also very important. The horse rider dance drummers are at the palace gate and to their left are the xylophone players. Then follow the retainers.
- Opposite this group about 30 meters away are the players of Lela salute dance. It takes some practice to synchronize all the drumming so that those displaying to fire guns may move in step with the music.

All traditional dance groups and institutions must present dances at the funeral of the Fon following a schedule, beginning with the *Lela*, followed by *Voma, Saawa, Nguh,* etc according to a plan released by the Palace. If a dance group does not display at the funeral celebration of the Fon it is automatically banned.

Funeral Celebrations for notables and victims of epidemics

The only other funeral celebration that can be celebrated at the Palace Plaza is that of war victims, or the victims of an epidemic that killed many people. Rather than let every family mourn their dead, the Fon through a royal proclamation may decide to honour the war and epidemic victims in memorial celebration at the *Lela* Plaza. The last time this type of celebration was done was after the disturbances of 1952 in which the surrounding villages attacked Bali Nyonga leading to losses of life and property. According to tradition, the last memorial for epidemic victims was done during the early part of the reign of Fonyonga II when influenza broke out and killed a lot of people in the fondom. Although the HIV/AIDS epidemic which started in the early 1980's has not yet ended, its worst period seems to have passed. Understandably there has been no traditional celebration to mark its end, since HIV /AIDS is still a major health hazard in Bali as it is in the rest of Cameroon.

Mourning for Royal descendants and Notables

The funeral celebrations for royal descendants and titled notables resemble that of the Fon except that they are less elaborate. Thus, the funeral celebration is staged at the deceased person's compound, not at the Palace Plaza. External honorific symbols vary in kind and number. By way of illustration we cite the following:

- For a male royal descendant the horse riders' dance (*yaa*) is the first to be played at the opening of the funeral (*Toh vu*) which usually takes place at the compound gate. This is accompanied by the xylophone music rendered by descendants of the Kufat ethnic group. The xylophone is played in harmony with the horse riders' dance as the representatives of the various traditional groups (*Ba Nwana, Ba Sama, Ba Kom , Bon Mfon*) take turns in performing the salute dance and gun-firing.
- A special dance called 'the Mother of Dances or the Big Dance' (*Mma-Ben, Ben Ngu*) is staged for royal descendants, but not for a non-royal notable.
- The following institutions animate the funeral of a Prince or a titled royal descendant, but not that of a non-royal notable: the night dance of the *Ngumba* society and the exclusively male dance of the *Voma* Society.
- The *Fon* usually sends a delegation bearing his insignia (*Kong Mfon*), the royal ivory bugle (*ntang Mfon*) and the royal hand-woven decorative cloth (*nji ndop*) to be displayed to mark the royal presence. Exceptionally and at his discretion the Fon may attend and preside over the funeral of a notable of non-royal descendant.
- It should be pointed out that the funeral celebration of a Princess is further simplified, and proceeds with no gun-firing, no performance and non-attendance by *Ngumba* and *Voma* societies. However music of the *Voma* society can be sung to the accompaniment of drums. The opening of the funeral is performed inside her husband's compound to signify, that though she is of the royal household, she is her husband's dependent. This type of reasoning, though unacceptable in contemporary Cameroon is still common to patriarchal societies.
- *Lela* music can only be played at the funeral of royal descendants and/ or members of the Lela society, and even then only drums are used to accompany the singing. The simultaneous fluting, singing and drumming of Lela music are reserved for the funeral of the Fon alone. For members of the Lela Society (*Ba Sama*) fluting and singing are permitted when the corpse is lying in state, but never simultaneously with

drumming. For all other funerals in which the Fon is represented Lela music can be sung to the accompaniment of drums, but never with the accompaniment of flutes.

• In Bali Nyonga, only two women, the Queen Mother and the Queen Sister have a right to a state funeral celebration reserved for male Princes and notables of royal descent.

Mourning the ordinary people

The funeral celebration of ordinary people is usually staged in the compound where they lived or were born, and do not have any of the trappings of the celebrations described above for notables. However the main phases are observed from burial to the closing of the funeral as described earlier in this article. Depending on the means available to the family the celebration may be modest, average or even grandiose.

Rites of interment

As may be expected the rites of internment depend on the social rank to which a person belongs, and nowadays whether or not they are adherents of one of the organized religions. It would be fastidious to attempt to describe fully these variations in this short essay. However, we shall describe two rites that set aside the Bali Nyonga people from their neighbours. These are the commendation (*Nu mma Nnung Ngung*) and the uplifting of the corpse before burial (*nu mma cham ni gela*)

Before a Prince, Princess or royal notable is buried he/she is handed over to the ancestors in a solemn commendation ceremony which may be public or private. The ceremony is performed by a member of the *Nwana* group assisted by senior members of the royal family. For this ceremony the corpse is laid in state and the celebrant takes millet grains (*ngung –koh*) from a bunch and pronouncing the names of the departed relatives drops a grain each time when each name is called the mourners answer "this your son, daughter or brother/sister on his/her way the coming" and a grain is dropped into the leaf cup.

This litany can go on for very long as the names of the royal relatives are mentioned back to the time of Gawolbe. Sometimes for brevity only 1-5 names (male or female) are mentioned from each generation.

The ceremony of the Commendation is followed by the Uplifting ceremony. In the past, two fig tree poles were used to make a stretcher covered with hand woven royal cloth and the corpse was then uplifted unto the stretcher and taken to the grave amidst singing and crying. Nowadays a forked fig tree branch is

used symbolically to represent what was used in the past. As the reader would have noticed only royal descendants (*Bon Mfon*) can be given this honour.

Symbols and honorific Language in Bali Nyonga

In this section I briefly survey those external symbols that depict the rank and position of individuals in the Bali Nyonga traditional society. I start from the compound, followed by the house before looking at personal dress items that are used as marks of distinction. To conclude the section I shall describe some honorific expressions that are frequently used to show respect in daily interactions among the people.

The reader should however note, that like in every African society, a lot of respect is given to the elders, whether they are titled notables or not. This article is not about such universal norms. Rather it is about those symbols of honour that can be conferred on individuals irrespective of their age and which serve as rewards for having earned a place up the pecking order in the traditional hierarchy either through merit or by inheritance.

The Compound Gate (of the Fon, the notables, ordinary people)

In the past the structure and layout of a compound, the main house in the compound clearly corresponded to the rank of the owner of the compound. Thus a simple citizen was allowed to construct only a one-room house of bamboo and mud. The house had only one door and no window and could be part of a compound or stand alone. A titled person (*ngang chubuh*) was allowed to build a two-room house (*sah-fam*) with a bedroom and parlour. The number of doors in a two roomed ordinary house was limited to two.

The next grade of houses could have more than two rooms and was called *ge-sungti*. It could have five doors, and each of them was dedicated in a special ceremony. On top of the roof was planted a cactus tree believed to wade off thunder storms and lightening. During the reign of Galega I and the privilege to construct and live in such a house was given to his eldest son, Tita Nji I (aka Yebala Njingwanyam) since his house also served as a reserve palace. Tita Lavet, the third son of Galega I and a contender for the throne of Galega I, is reputed to have arrogated himself the right to construct such a house and was tolerated in this by his half-brother Tita Mbo who had become the Fon Fonyonga II after the death of their father in 1901. (It will be recalled that Tita Nji I, the presumptive successor to the throne of Galega I had died some 5 or 7 years earlier (Chilver, 1966). This writer saw this type of houses in the 1950's and 1960's in the old palace before it was demolished and replaced with the

present stone edifice, in the compound of Tita Nji III (see photograph) and in the compound of Tita Lavet II.

When it became possible to build modern tin-roofed houses the Fon had to give permission for this to be done. Thus before the liberalization introduced by HRH Galega II there were only a few privately owned tin roofed houses in Bali Nyonga in Tita Fokum's compound (which he inherited from his mentor HRH Fonyonga II) Fomuso 's compound, Fokejah's compound and of course the Palace. Other tin-roofed or tile roofed houses belonged to the Basel Mission (later Presbyterian Church) and the Bali Native authority School (later Government School, Bali).

Because of the socioeconomic expansion of Bali and its increasing assimilation into the main-stream administration of the country, the restrictive housing policy of the traditional administration could not be sustained. Fon Galega II took a lead in liberalizing the policy and urging Bali people to construct as large and modern houses as they could without restriction based on traditional title and rank. It was also during this period (late 1940's to early 1950's) that an earth road network was constructed linking the quarters of Bali, thus progressively transforming it from a village into a town. The symbols of rank and authority were transferred from the shape and sizes of houses to the design and layout of the compound gate (*Nchubuh*). During the reign of Fon Galega II, the palace was fenced and had four gates. The main gate (*Nchubuh-Ngu*) opened to the plaza and was used for rituals and served as the location for the customary court. To its left was the gate reserved for royal wives and other women when they were in their periods and thus were considered to be ritually unclean and therefore not allowed to use the main gate. The next gate located some 300 meters away allowed for entrance into the court yard of the royal wives (*nkah nted*). The final gate located a further 300-400 meters was termed mothers' gate (*Nchubuh-banna*) was reserved for the step mothers of the Fon, who still lived in a section of the palace reserved for royal widows. Thus the Fon alone had the right to have a compound with so many gates.

All other notables usually had a compound with only one main gate (*Nchubuh Ngu*) and a symbolic women's gate (*Nchubuh muwad*, literally menstruation gate). The mat covering the fence was made of ordinary bamboo pith, except for the palace and certain notables' gates where one of the mats was woven from a mixture bamboo bark and pith (*njah-kong*). Thus even the type of material used in making mats for the compound gate depended on the rank of the individual. To the right of the compound gate was a stone seat for the compound head and to the left stone seats for his male children and guests. These details have

disappeared in most compounds, except when the compound gate is being prepared for the opening ceremony of a funeral celebration.

The compound of an ordinary person had only one gate and the fence was not necessarily decorated with hand woven mats.

Designs and marks of distinction on garments

There are many designs of caps, the most common of which is the skull cap (*nkap-nwih*) mostly won by elderly men and compound heads. The hand woven rainbow- cap (*ndap*) was won with traditional tunics by men initially, but is now used by women as well. The crown-hat (*feleng*) is reserved for the Fon, who as we have seen above can donate it to some notables of non-royal descent to show recognition for a particular achievement. It should be emphasized that no royal descendant except the Fon may wear a crown-hat. Other designs like the *fuchah* (beret) and the *chohtu- (mu)nyangkwe* (skier's cap) are freely used by men and do not delineate ranks or social positions.

We have dwelt at length on the red feather medal which can be used by authorized persons to decorate their head gears as a mark of distinction, and will not further elaborate on it. Equally we have described the royal badge that can be sewn onto the back of a traditional gown to show that the Fon has recognized its owner for an important achievement. I was given one such gown by HRM Dr Ganyonga III, when I became the Vice-chancellor of the University of Buea in 2006.

The loincloth design can also be used to distinguish between notables and ordinary citizens. The Fon may decide to award a loincloth with a white and red mosaic design (*go-labbe*) to some notables for use during the Lela festivals and other special occasions. This particular design is reserved for the Fon and only exceptionally awarded to some notables. Nowadays some Bali Nyonga people buy clothes with these mosaic designs from the Bikom tribe of Boyo Division and use them in Bali without permission of the Fon. It is therefore no longer employed to discern class distinction.

Women's dresses also had marks of distinction. Only royal wives, princesses and female royal descendants were allowed to wear aprons decorated with beads (*ngwasi mfa*). Royal wives during the rule of Fonyonga II wore a head band of cowries (*mbum*) to designate their status and this was exclusive to them. The wives of Fon Galega II covered their heads with loincloths like Muslim women, though many of them were/are Christians. The wives of the present Fon wear bracelets of cowries on their right wrists to show that they are royal spouses. The Fon's wives do not shake hands with any person. The use of mini-aprons

(*ngwasi*) as a dress item has been banned because it was no longer considered appropriate and distinctions between the dresses of women based on social class are disappearing faster than those between men.

Honorific Addresses and Responses

Elaborate rules of etiquette exist in formal and colloquial Mungaka, the language of the Bali Nyonga people to show respect. For want of a better name we shall refer to them as honorific addresses and responses and show that they vary from one social rank to another and between age groups and gender.

Within the family, children never address their parents by name. They would normally address the father as Ba and the mother as *Na*. By extension any other parent of the same age may be addressed with the prefix *Ba* and *Na* followed by the name of the person e.g. *Ba-Gomia, Na-Satmia*. An elder brother is referred to as *Ni* and an elder sister as *Ma*. Similarly uncles are referred to as *Ba-Mbot, Nimbang* respectively for paternal and maternal uncles. The prefixes *Doh* and *Kah* are used for the grandmother and grandfather respectively and elderly people of that age

There are also honorific responses and addresses for notables that differ according to rank of the notable in the traditional dispensation. The most elaborate and varied honorific addresses are reserved for the Fon. The words *Chaabu* (the most powerful) *Ngunyam* (leopard) , and *ndum-ntu* (great heart) are frequently used in court language to address the Fon and to respond to him.

In the Bali traditional protocol, Princes who have come of age and male successors of royal descendants are referred to as *Tita*. The formal response to them is *Mmo*, an abbreviation of the phrase *Mmo Mfon* (Son of the Fon). However, non-royal descendants who have been granted the *Tita* title in its alternative meaning of 'Leader or Commander' are not entitled to the honorific address *Mmo*. Instead they are entitled to the address *Ndey*, which is also reserved to the *Kom* Group, the *Tikwanga, the Kom Chinted* and to others ranking as such.

Although the *Tita* title and its honorific address are higher than the *Nkom* title its corresponding address/response *ndey*, recently there has been a gradual reversal by the population who regard the *Nkom* title as a higher honour because it is earned and not inherited. These niceties of the traditional protocol can be a source of bitter arguments or amusement depending upon the particular situation involved. The honorific addresses and responses are summarized in the table below.

105

Position/Group	Honorific Address/ Response	Comments
The Fon	*Chaabu, ngunyam*, mbeli, *ndum ntu*	The Fon has many more honorific addresses especially when he is presiding at major traditional occasions like the Lela festival.
Princes and Notables of Royal Descent	Mmo	Male royal descendants may be honorifically addressed with word *Bulung,* and female royal descendants *Mbaw* while ordinary males and females can be addressed with the words, *Ngon/ ngwen ngwed, la-tam* depending upon their ethnic origins
Sub-chiefs (*Ba- Fonte)*	*Mmo, zz-mfon*	The sub-chiefs of the Ba-Ntankah group insist on being addressed as *Mbe or Nge* and their subjects comply.
Ba Nwana	*Ndey,*	Except for Tita Nji, holder of the *Nwan-vaksi* position who is of royal descent
Ba-Kom, Ba-Tik-wanga, Ba- Kom Chinted	*Ndey*	This is the most widely used honorific address/ response and is held in high esteem by the general population although royal descendants are sometimes offended when this is applied to them.

Father	*Ba*	In the family calling your elder by name without a prefix is considered very rude. The honorific responses and addresses are translations of the corresponding words to which they are aligned eg Ba means father, Na means mother etc.
Mother	*Na*	
Elder Brother	*Ni*	
Elder Sister	*Ma*	
Uncle	*Nimbang, Bambot*	
Aunt	*Tangwi*	
Grand Father	*Doh*	
Grand Mother	*Kah*	

Table 3 Honorific addresses and Responses in Bali formal/court language

CONCLUSION

In this brief narrative I have distilled out of the rich fabric of Bali culture, certain practices that demonstrate the ways in which the traditional society can honour its members. Significantly none of the honorific attributes is monetary or even material. This might sound strange in an increasingly materialistic society where everything seems to be measured in terms of material goods and money. Traditional society sought in its members more than fiduciary affluence. They rated honour, valour, community service and other moral values like honesty, and fidelity in marriage, higher than material things and this is a legacy that should be preserved and entrenched in our youth.

References
Bamenda online: http://bamendaonline.net/wp-content/uploads/2013/12/Lela078.jpg accessed 25 October 2016

Chilver, EM (1966) Zingtraf's exploration in Bamenda, Adamawa and the Benue Lands, 1889-1892, Government Printing Press, Buea (Cameroon)

Fokwang, John Koyela (1986). A Dictionary of Bali popular names. Bamenda: Unique Printers.

Ndangam, G. (2014). Cultural encounters: Society, culture and language in Bali Nyonga from the 19th century. Instant Publishers, United States of America

Titanji, B.L. (2013).Literacy in Cameroon: The case of Mungaka. In: Language Policy in Africa-perspectives for Cameroon. Miraclaire Academic Publications (MAP) Kansas City, USA, pp 52-60

Titanji, V; Gwanfogbe, M; Nwana, E; Ndangam, A & Lima A. (1988). An Introduction to the Study of Bali Nyonga. A tribute to His Royal Highness Galega II, Traditional Ruler of Bali Nyonga from 1940-1985. Stardust, Yaoundé.

7

CONTEMPORARY RELIGIOUS CO-EXISTENCE IN BALI NYONGA

Babila Fochang

No positive religion that has moved men has been able to start with a tabula rasa, and express itself as if religion were beginning for the first time; in form, if not in substance, the new system must be in contact all along the line with the older ideas and practices which it finds in possession. A new scheme of faith can find hearing only by appealing to religious instincts and susceptibilities that already exist in its audience, and it cannot reach these without taking account of the traditional forms in which all religious feeling is embodied, and without speaking a language which men accustomed to these old forms can understand.

INTRODUCTION

This statement by William Robertson Smith is our grid for understanding the presence, and cohabitation of religions in Bali Nyonga. While the traditional religion of Bali Nyonga can be considered as the original religion of the people who call themselves by that name, it should be considered that Bali Nyonga is a conglomeration which makes it difficult to classify their Traditional religion as original. It is also interesting to note that the conglomeration presupposes a diversity of Traditional religions (Fochang 2011: 25).

The concern of this chapter is to look at contemporary religions in Bali Nyonga today, their interrelations and how they impact on the lives of the people. Our study of these religions bases on the definition of religion as "belief in God or gods, together with the practical results of such belief as expressed in worship, ritual, a particular view of the world and of the nature and destiny of man, and the way someone ought to live his daily life" (Howkins 1988: 575).

There are three main religions fully established in Bali Nyonga. In their primary order: Traditional religions, Christianity and Islam. Traditional religions are the uncontested host although not all of its elements were there at inception. Human beings are deeply religious and Africans especially are very religious, although Hunt considered that the Bali people had no religion (Hunt 1925:29).

The Impact of Traditional Religions on the Bali Nyonga People

Today it is also being contested whether Christianity has not become the traditional religion of the Bali Nyonga people. In this sense we limit traditional to being 'prior' to all others.

Traditional religions manifest itself in the daily lives of the people in all spheres of activities. While it is true that Christianity has penetrated all the nooks and crannies of Bali Nyonga, it has nevertheless served only as a compliment to traditional religions. Notwithstanding the complexity of the conglomeration, certain cults represent the whole community thus ensuring a kind of national religion. Lela and Voma are singled out for the purpose of this study.

The Lela festival is a high point of social interaction and is a religious festival that is intended to serve all the Bali people. Although many now consider it as a means of social interaction only, because it brings together sons and daughters from all over the world, it is however a festival celebrating the aftermath of sacrifice to the gods of the land. The gods are thus invoked to ensure peace, fertility and protection. On its part, "Voma has the responsibility of enthroning a new Fon because it is the custodian of what constitutes mystical power in Bali." Voma is a vengeful god that destroys wrong doers, but is also responsible for fruitful harvest. These are deities that are inextricably linked to royalty and as such it forges the unity of the people, be they Muslims or Christians (Fochang, 2011: 28).

Every family compound has a family shrine where the family head serves as family priest. More than a century of Christianity has not been able to destroy these traditional forms of worship. On the contrary it has developed a kind of shock absorber and continues to be perpetuated even within Christianity, thus demonstrating the spirit of a very receptive host who rather has to seek for compromise in other to survive (See Fochang 2011: 28-35). The perpetuation of religion is in so far as it benefits humanity. If that is so, one realizes that traditional religion has been seen as a great benefit in Bali Nyonga in these predominant areas of life: birth, marriage and death. Even when any of these begins with or ends within a Christian context, it has to find its fulfilment with a traditional religious rite.

The Impact of Christianity on the Bali Nyonga People

Christianity has been in Bali Nyonga for more than a century and has been embraced by almost everybody. The dominant denomination is the Presbyterian Church in Cameroon, which is the offshoot of the Basel mission that first entered Bali in 1903. The second populated denomination is the Catholic faith. The Cameroon Baptist Convention has a timid presence and came in just a few decades ago. The other denominations that have established their presence within the sub division are, the Apostolic church, the Full Gospel church and the Global Frontiers whose membership stagnate at less than a hundred members. Mushroom charismatic and Pentecostal sects are present in insignificant numbers. The Apostolic church though a late comer into Bali Nyonga, has had the privilege of having a Bali son as its pioneer National President who died a few years ago. On the other hand, the PCC which came to Bali since 1903 produced their first Synod Clerk (2nd highest office of the PCC) only in 2015; this being the first time a Balian has risen to such high position in the PCC despite their massive contribution to the growth and spread of the gospel. The great Nigerian theologian E. Bolaji Idowu stated that the great advantage of Christianity is that it brought "demonstrated salvation"; that is to say it is not about salvation of inheriting and enjoying eternity, but salvation that addresses the present. In this sense Christianity has had a great positive impact on the lives of the Bali people.

This positive impact goes back in time. The first missionaries to the Grassfield regions of Cameroon first settled in Bali Nyonga. Bali Nyonga became the citadel of learning as the first school and Christian church within the region all started there. The Mungaka language was put in print form and became the language of learning for the whole Grassfield region. Stories in the Bible were translated into Mungaka, text books were printed in the language and by 1960 the whole Bible was translated into Mungaka language.

The first ever secondary school was opened in Bali, Bali College, now called Cameroon Protestant College. The church has impacted the lives of the Bali people positively as both the Presbyterian and Catholic churches have many basic education schools and both run colleges that have produced some of the best of Cameroon's intellectuals, members of government and scholars of very high profiles.

Islam and its Impact upon the Bali Nyonga People

Few years after they had established in Bali Nyonga, the missionaries had to go open a Mission station in Foumban. The main reason was to check the

advancement of Islam. To read between the lines, this is already an indicator that it would have been an uphill task for Islam to be fully implanted in Bali Nyonga. Nevertheless, Islam entered Bali Nyonga not too long after Christianity. Although there is the popular "Hausa quarter" in Bali Nyonga, Islam has not gained adherents amongst the indigenes. Islam is mostly for the settled Hausa people. A few diehard Bali men converted to Islam and compelled their wives and children to join them. I say this because upon the death of those men, their wives and children are now Christians though still bearing the Islamic names that were given to them. The reason why Islam has not gained adherents amongst the Bali Nyonga indigenes confirms Lamin Sanneh's thesis that Islam does not gain new grounds in Africa because it is non-translatable whereas Christianity thrives and expands because of translatability.(This is however contestable because some school of thought hold that Islam has more adherents in Africa than Christianity). On a lighter mood, Islamic presence through the Hausas has made a contribution by the preparation of the famous "Dagwa" and "Bakurukuru" delicacies which the Hausa children sell around town.

Triune Religions in Bali Nyonga: Soul mates or Antagonists?

The early converts to Christianity in Bali Nyonga exhibited a kind of religious arrogance which found its outlets through songs. In song they asked the Fons to abandon the duties of Fonship and come inherit eternal life because Fonship is transient. They interchanged Fons with Koms etc. this was mockery. The reaction of the nobles came out in expressions like "the whiteman has put teeth in the mouth of fowls", or "the porridge is now cold so people can drink through the nostrils" they also coined names like 'Nyongpua" - we now have a new world, things are no longer the same (Fochang, 2004:93).

Today there is a paradigm shift as there is peaceful coexistence. Christianity has permeated all spheres of traditional life, yet traditional religion has maintained its stronghold on the people as earlier mentioned above. Today it is difficult to agree whether traditional religion is "anonymous Christianity" or whether African Christianity is syncretism. However, if we were to base our premise on the quotation of William Robertson Smith above, we can only conclude that it is difficult to define syncretism since no religion is a tabula rasa.

Secondly, since Christianity thrives on translatability, it cannot avoid using the people's thought forms and cultural elements to enhance Christian practice. This is because it is difficult to separate a people's religion from their culture. When you ask people for instance why they do what they do, they may tell you it is "kontry fashion"; meaning it is a cultural practice. But if you ask them

what would happen if they do not do it, they will tell you that would provoke the wrath of the ancestors and the gods of the land. This tells you that religion and cultural practices are to a certain extent inseparable. As such some cultural practices have become an integral part of Christian presence and continuity.

Again it is difficult to draw a thick line to separate Christianity from traditional religion. I take the simple example of the phrases "Nyikob wu'" and "Nyikob ni ndzö" meaning God is there and God is seeing respectively. These phrases are commonly used by both Christians and in purely traditional religious contexts, but the expressions are not of Christian origins. This is not a test of faith of the Christian converts in Bali Nyonga like elsewhere in the continent; it is simply a matter of stating it as it is that African Christianity is to a certain extent 'one foot in and one foot out.' Traditional religion is seen to compliment the Christian faith and at other moments it is Christianity that compliments traditional religion.

It is in this light that charismatic Christianity is seemingly having a firm grip upon the people because unlike the surface understanding that they offer more in Christianity, they actually in truth have just transposed the African religious worldview into Christianity and have become a replacement of the solution providers that were found in traditional religions like the Nkambe men and native doctors. Even in this transposition they are often in competition with each other because the clients move from a 'Man of god' to a native doctor, or from a native doctor to a 'Man of God' without any qualms. To the people both serve the same purpose and none is held in high esteem over against the other.

We have very little to contribute concerning Islam and how it interacts with traditional religions because the indigenes of Bali Nyonga have not been enthusiastic in embracing it; most probably because of its non-translatability. It nonetheless maintains a cordial entente between tradition and Christianity. According to the chief of the Hausa community in Bali Nyonga, Christianity and Islam have never had any reason for conflict. Muslims often allow Christians to preach to them and the cohabitation of both Muslims and Christians within the Hausa quarter is a testimony of peaceful coexistence.

As far as their relationship with traditional religion is concerned it is that of detached tolerance. For instance when the traditional flag of the Bali Nyonga is passing by one is expected to bow to it, but Muslims would prefer to run away rather than to bow to the flag. The Koran however enjoins that Muslims must respect the traditional hierarchy. In the case of Bali respect of traditional hierarchy may not exclude the traditional laws, customs and traditional religions since there is an overlap.

Conclusion

St. Augustine of Hippo said humanity is made for God and as long as he has not found god his soul remains restless until it finds rest in him. No argument is justifiable enough to explain the credibility of one religion as superior to the other or why people prefer one for the other. The importance of any religious presence is how it enables people to meet with their daily needs, assails their fears and frustrations and gives them the assurance of a better future. To this end our conclusion is that the presence of these three religions in Bali Nyonga has come to stay, but how it creates a positive impact on the lives of the people is left for them to testify.

8

THE REHABILITATION AND REVIVAL OF MUNGAKA FOR LITERACY

Julliet Nahlela Tasama

GENESIS OF THE PROJECT

Many people have expressed the need to have the Mungaka language revived; but curiously and perhaps through some (political) manipulations, Mungaka, one of the pioneer national languages to be developed was completely sidelined in the selection of national languages to be further developed and popularized. Surprised by this treatment from the powers that be, and faced with challenges and threat to introduce the teaching and learning of an entirely different mother tongue for basic education in Bali, I was motivated to regenerate the nursery right at its own roots here in Bali Nyonga, Mezam Division. Again, I was not satisfied working and or developing the alphabets for other languages and promoting them when my mother tongue was not in line with current trends of writing our national languages. This singular decision of mine followed the Fon of Bali's earlier moves to revive the Mungaka language. This came as a wonderful springboard given that so many people had it in mind but they just needed somebody to take it up. After graduation from the University of Buea, I therefore returned to Bali and volunteered my services to coordinate the rehabilitation of the Mungaka language.

PROJECT MOTIVATION

Educating the Africans in general and the Bali mind in particular cannot be realised without literacy in the language of the individual. It is through these languages that the Africans interpret the world and their interactions have been centred on these languages. Even the Africans, who through education have

114

acquired foreign languages, cannot avoid facing the realities of their societies which are best expressed through the mother tongue. Just like education without the foreign language cuts the learner from the outside world, the neglect of African languages in literacy makes the African a tree without root. Nforbi (2000:29) lays emphasis on the importance of African languages in literacy when he says:

> applied linguists must fight for the introduction of African languages in the school curriculum as the first language(…) African languages can become powerful tools of development if they are used as a means of education, commerce etc, and especially in education. It has been proven that a better mastery of a foreign language depends on a good mastery of the mother tongue. People can better conceptualize things in their own languages than in a foreign language.

Worthy of note is the fact that no community can pretend to achieve any sustainable development by using a foreign language. The Cameroon government has proved through its numerous decrees and laws in favour of the promotion and usage of our indigenous languages, to be very much aware of this fact. Some of the decrees and policies laid down by our government which favoured my total engagement to this revival venture are considered below, as identified by Nforbi (2012).

GOVERNMENT POLICY TOWARDS NATIONAL LANGUAGES

1. Law no 96/06 of 18th January 1996, carrying a revision of the Cameroon constitution of June 1972a. In article one section three; it is stated that the Republic of Cameroon adopts English and French as official languages of equal status. It also works for the protection and promotion of national languages.
2. The law no 98/004 of 14th April 1998, carrying the orientation of basic education in Cameroon states that education has many objectives amongst which are the promotion of national languages.
3. Decree no 2002/004 of January 2002, carrying the organization of the ministry of basic education, article 107 treating the pedagogical inspections favours mother tongue education
4. Decree no 2004/0660 of 31st March 2004 focuses on the organization of the ministry of basic education. Section VII (of external services)

section II (of pedagogical inspections, article 101) talks on the provincial inspection of pedagogy in charge of the teaching of letters, arts, foreign and national languages.

5. Law no 2004/018 of 22nd July 2004, which fixes the applicable rules in communities applies to mother tongue. This law is based on the alphabetization and personal training, culture and the promotion of national languages. For example, the organization at the local level of cultural days, cultural manifestations, traditional, literary and artistic competitions

6. Law no 2004/019 of 22nd July 2004, fixes the applicable rules in regions. This is also based in the field of education, alphabetization, culture and promotion of national languages.

7. Law no 2002/018 of 22 July 2004 puts in place rules for councils and law no 2004/019 of 22 July on rules applying to regions.

8. The ministerial arête No 099/0053 MINESUP DDES on the general guidelines of teaching and evaluations in the state Universities of Cameroon recognizes the creation of the department of African languages and Linguistics. In its recent orientation, the Ministry of Higher Education has ordered the creation of centres for Cameroon languages and cultures in the Universities, which can serve as a follow-up to the implementation of mother tongue education in the primary and secondary education.

9. The decree no 98/003 of 8th January 1998 on the organization of the Ministry of Culture emphasized on the development and safeguarding of national languages. In article 20, it talks of the protection of cultural heritage. A service of national languages is created under a director.

10. In article 25, it indicates the role of the service of national languages, which is supposed to take care of strategic of the promotion of national languages in schools, universities as well as its follow up and application.

11. In 1998, Law no 98/004 of 14th April was passed laying emphasis on the Organization of the Ministry of National Education. In it, there was a focus on the significant role of National languages in our educational system.

12. Decree no 06/049 of 12 March 1996, organizing the Ministry of Youth and Sport. This decree though not explicit on the use of national languages however lays implementation of adult literacy programmes in Cameroon. The recent national literacy programme in the official languages (English and French) collaborate with local languages committees

in implementing literacy in national languages.

13. Law no 98/004 of 14th April 1998 on the orientation of education in Cameroon equally clarifies the situation of national languages. In title one, article 5, line 4, it has the following objectives assigned to the Ministry;

I. Based on the sociocultural and economic realities of the country, the Ministry has the obligation to promote national languages in the Cameroonian educational system

II. At the international level, it has to promote sciences, technology and bilingualism (French and English).

- The law no 96/06 of 18th January 1996, in the constitution of Cameroon, in its preamble, recognizes the linguistic diversity of Cameroon and opts to enrich it. In its first article, it acknowledges the bilingualism of Cameroon (English and French). It equally guarantees the protection and promotion of its national languages.

- At the international level, the following positions are adopted:

- In 1976, the general conference of UNESCO on the development of adult education called explicitly on "the teaching of mother tongue" as a means to foster adult education which plays a vital role in development.

- The UNESCO general conference of 1992 in its no 12 resolution adopted the term "multilingual education" to indicate use of at least three languages in education; the mother tongue, a regional or national language and an international language.

- The universal declaration of 2001 on cultural diversity, which evokes the importance of languages for the promotion of cultural diversity, highlights the importance of mother tongue.

- The third objective of the orientation instrument "strategic framework" adopted by the third African union summit in July 2004, integrated amongst the objectives and priorities of the African Union that of " the assurance of cultural growth in Africa".

A review of the above laws and texts both at the national and international level indicates the following.

1. National governments are very aware and prepared to launch fully in mother tongue education in African languages.

2. The international community as well has seen this need and expressed a willingness to encourage it. It should be noted that globalization is a

recent phenomenon that is highly influencing international diplomacy. In a world governed by the laws of give and take and the domination of the weak by the strong, the issue of African languages education can only be a major concern of Africans. There is need for African countries and their governments to improve on the implementation strategy on the several laws and texts already existing in favour of African languages education to make it a reality

In Cameroon, one can see a green light in the horizon as the ministry of basic, secondary and higher education recommended the implementation of these languages in schools as from the 2008/2009 academic year.

Over the last 30 years, serious research has been going on in the domain of mother tongue literacy. The results are available in most of the Cameroonian languages and any educational policy of these languages is now timely. Though Mungaka has not been part of these developments, it is high time she came on board.

It has been demonstrated beyond all reasonable doubt that mother tongue literacy does not bring division. It brings unity as more people come out of ignorance and understand how to live with each other. In fact, it brings people to discover that they are actually close to those they believe to be strangers when they start reading about the history, culture and other aspects of neighbouring villages. They get to realize that the languages have the same roots; the belong to the same ancestral origin.

THE PROBLEM

The traditional Mungaka orthography developed by German- Swiss missionaries since 1903 can now be considered moribund vis-à-vis the current and General Alphabet of Cameroon Languages (GACL). Though unique in style, this orthography places Mungaka at a serious disadvantage. Presently in Bali and elsewhere in the country where Mungaka is used, only a few people can read and write the language in its present orthographical state. There has been dire need to revive the language in consonance with the recent educational philosophy to reactivate the teaching and learning of our indigenous languages. Efforts to reawaken literacy in Mungaka are noticeable but the draw-back has always been that we cannot continue to use an alphabet that makes the language an island in the midst of other languages that now enjoy a common writing system.

Again, as recorded by Nforbi (2012:58)

Mungaka that was highly developed needs revival because it is virtually silent [...] the absence of a cultural consciousness is evident in the fact that after the departure of the colonial masters, there is no indication that the traditional authorities of Bali continued with the imperial policy that colonial masters had established. If they continued with it, they would have been in control of West Cameroon culturally just as the English who came later at a distance are in control linguistically of this part of Cameroon and beyond.

This research project is therefore built around the problem of transiting from the traditional Mungaka alphabet developed by German/Swiss missionaries using a slightly modified version of the German alphabet, to a revised alphabet based on the General Alphabet of Cameroon Languages adopted in March 1979 by the National Committee for the Unification and Harmonization of the Alphabets of Cameroon Languages.

MUNGAKA: AN ENDANGERED LANGUAGE?

A number of authors and experts have written about the assessment of language endangerment. Among them, we find UNESCO (United Nations Educational and Scientific Organization) experts (2003) and Bitja'a Kody (2004) when one considers what these authors have said, we might be tempted to think Mungaka emerges as an endangered language.

We shall discuss and comment on some of UNESCO's criteria with regard to Mungaka to access its degree of vitality or endangerment. The UNESCO (2003) ad hoc experts group on endangered languages elaborates nine criteria for assessing language vitality and endangerment. They argue that the nine factors can be grouped into three sub-groups; the first six factors evaluate language vitality, the next two assess language attitudes and the last one evaluates the availability of documentation. I present the different factors with its application on Mungaka.

These factors include, inter-generational language transmission, absolute number of speakers, proportion of speakers within the total population, shifts in domain of language use, response to new domains and media, curriculum materials for education and literacy, governmental and institutional language attitudes and policies including official status policy and use, community members' attitudes towards their language and amount and quality of documentation about the language. A point to note here is that these factors are interwoven.

119

We shall analyse some of the factors below.

Inter-generational language transmission: This criterion is valid in Mungaka as it is used in families, the most important setting for language inter-generational transmission. Mungaka is transmitted from mother and father to children, but the daily widespread of English used as the first official language in the locality is not of good omen for Mungaka. It constitutes a major threat if nothing is done. Another threat is the fact that a majority of Mungaka speaking parents in the urban towns of Cameroon do not transmit this language to their children. Thus we begin to wonder aloud the fate of this language in the next three to four generations.

Absolute number of speakers: Mungaka like most African languages is not used in the wider circuit of international communication like English, French, and Arabic. Although Mungaka is and has been the official language of the Presbyterian Church in Cameroon (PCC), this fact is today in theory than practice. Even though Mungaka is credited with a population of about 85,000 speakers, it is still endangered because it is not yet used as a means of wider communication. By the same token, Genoble and Whaley (2006:6) pointed out that the absolute number of speakers though an important demography is not a good tool for determining the vitality of a language.

Response to new domains and media: Mungaka is not yet introduced effectively to new domain; by new domain, we are referring to information technology (IT).

Curriculum material for education and literacy: Before starting this project on Mungaka re-codification and revitalization, a number of books existed in the language which were reviewed. However, a majority of them are Christian literature and very few literacy materials existed, but for *Ke'fun Ntsudab* and the Mungaka dictionary which contained a brief description of the grammar of the language. All existing literature is available in the Mungaka traditional alphabet and is not very much available. So we cannot effectively talk of cur-riculum materials for education and literacy. Thus the status of Mungaka as an endangered language is to be discussed as a topic on its own.

PURPOSE OF THE PROJECT

The overall goal of the project was to revise the Mungaka alphabet. That is, from the "old" alphabet developed by German/Swiss missionaries in the early 1900 to a new and acceptable form based on the General Alphabet of Cam-eroon Languages, adopted the National Committee for the Unification and Harmonization of the alphabets of Cameroon Languages in March 1979; to

fall in line with government policy on the promotion and teaching of national languages, such that Mungaka is included in to school programmes. The specific objectives were as follows:

The development of the phonology of the language in its current state to come out with phones and tones, the equation of existing graphemes (Mungaka traditional alphabet) to the new ones (Mungaka revised alphabet) to ease transition by those of the old school to the new school; the training of trainers in the revised alphabet; to create a language centre in Bali and to introduce the language in to the school curricular.

The first part of the project was to redo the phonology of Mungaka. A brief description of the grammar of Mungaka presented by Stöckle 1994 was reviewed and modifications made where possible to enable the establishment of the writing and reading principles of the language.

LITERATURE REVIEW

In the domain of literature review, we were concerned with the review of different works carried out in Mungaka, tracing its importance to the current project.

We understand the first publication in this language was done in 1903 but we were unable to locate a copy. We came across a number of biblical texts /writings on the language along with the Bible. The only book that gave an insight in to the grammar of the language is the Mungaka Dictionary by Stöckle 1994. Here, a brief description grammar of the language is presented. These materials have been very useful and have served as a very solid foundation for this current work. Some existing literature considered for this project included amongst others;

Nsun u, yi, I boṅ ntsa sun bu me' a – 1923
Ntsi Nikọb bi ndzọbdzọb ni tsu Ba'ni – 1930
Nwa'ni Psalm ni tsu Ba'ni – 1949
Ke'fụn Ntsundab – 1953
Ntsi Nikọb bi ndzọbdzọb ni tsu Muṅgaka – 1967
Tradition, Tales and proverbs of the Bali Nyonga – 1994
The Mungaka-English dictionary – 1994

THEORETICAL FRAMEWORK

Since the project involves the two main branches of linguistics; general and applied linguistics, different theoretical frameworks are taken into account for

its realization. We used the generative approach for segmental analysis and the auto-segmental approach for supra-segmental analysis.

The sociolinguistics and applied linguistic approaches: A greater portion of our work is focused on the revitalization and popularization of Mungaka

Framework of mother tongue literacy

This framework is also known as framework of community literacy. It is different from national literacy in which the official language(s), English and French and some other foreign languages is/ are the main medium of communication and formal instruction in Cameroon. As noted by Chiatoh (2004:26, "the expressions mother tongue literacy, community literacy and vernacular literacy, are quite often used interchangeably". UNESCO recognizes that this form of literacy captures three levels of utility of mother tongue not only in education, but also in the whole development process of communities. This form of literacy captures and balances to community members psychological, sociological and educational factors. This explains why mother tongues are of great importance in the life and development of mankind and his or her community and thus, should be fully integrated into the processes of planned changes. Mother tongue literacy is closely related to culture which according to Chiatoh (2004) is "neither elite nor institutional. Being the language in which the Bali natives think, express themselves, their dreams, excitements, fears, and even judge social relations, literacy in Mungaka from this moment should be the first concern of the Bali community. This is because Mungaka here is viewed not only as the people's first medium of communication and work but also as a direct link between them and their natural environment, thoughts and beliefs.

Structure of the Mungaka Rehabilitation project

A Mungaka Rehabilitation Committee (MRC) was created by HRH Dr. Ganyonga III on September 4th 2010 with Chief Robert Ndangoh Fomunyam as Chair person and Ms. Julliet Nahlela Tasama as Technical Adviser. Four sub-committees and a general coordination committee was put in place to facilitate the effective realization of the project.

Committees, members and their terms of reference

Coordination committee: Members of this committee were chairpersons of the four sub-committees, the chair person, the Technical Adviser,
- Chief Robert N. Fomunyam (Chair)
- Tita Fonkwa

- Fomboh Philip
- Tita Samkia (finance sub-committee chair)
- Gwansona Doh Francis (3rd Deputy Mayor, Bali Council)
- Augustine K. Mundam (follow up sub-committee chair)
- Stephen Fohtung
- Sama Pryde
- Musa Umarou
- Tasama Julliet Nahlela

This committee was charged with taking major decisions concerning the progress and realization of the project. The other sub-committee chairs reported the work progress of their respective sub-committees and challenges to this general body. The general body in turn reported to the paramount Fon of Bali. The technical adviser was the major link between the committee and the major language development organs in Cameroon like Summer Institute of Linguistics (SIL), Cameroon Association for Bible Translation and Literacy (CABTAL) and NACALCO.

Sensitization Sub-Committee: This sub-committee was charged with the identification and implementation of strategies of sensitizing the Bali community in and out of the country on the projects objectives, how it would be realized and the community's involvement/participation. Members of this sub-committee were:
- Silvanus Fongoh (Chair)
- Peter Tambi
- Nandet Lucy
- Musa Umarou
- George Fonchamnyo

All presidents of sociocultural groups in Bali and Quarter heads were co-opted as members of this sub-committee.

Data sub-committee: members of this subcommittee were veterans in Mungaka. They were to provide all necessary required information on the language. Members were:
- Gwansona Doh Francis (3rd Deputy Mayor, Bali Council)-Chair
- Stephen S. Fohtung
- Dinga Johnson
- Gwanjalea Fombasong Ndagu

- Tita Doh Njenka
- Njeko Victor Dohkea
- Nyonka'a Emmanuel
- Rev. Gana Yebit.

This group met every working day in an office space provided by the palace for three months. They translated the SIL comprehensive African word list by Keith Snieder, the Swedish word list and other material handed to them by the technician. This was to serve as data for analysis. Each working session lasted for three hours with 5 minutes break after each 45 minutes. This group was very committed to their task. By February 2011, they handed over the translated work which was then recorded for transcription and analysis.

Finance sub-committee: under the chairmanship of Ba Tita Samkia, this committee was mandated to draw a budget for the project and source for funding, and manage the funds and all other resources for the Project. Members were:
- Ba Tita Samkia Gabriel Fonyonga (chair)
- Feh Gregory Adolf
- Yangni Ephraim Ndansi
- Ba Gagwane (President of Culture)
- Victor Titabai
- Foncham Paul Babila, Inspector of Basic Education

Follow up committee: Chaired by Mr. Mundam Augustine, the four members of this sub-committee came in from time to time to assess work progress of the three other sub-committees.

Work done

While coordinating the activities of the four sub-committees, the Technical Adviser reviewed all available accessible literature in Mungaka. The data collected was also transcribed and analysed. The result was the first draft of the revised alphabet which was presented at once to the language Committee.

The Committee members were introduced to the revised alphabet and they all agreed it seemed less complex than the former especially considering that each sound was represented by a particular symbol. However, a majority of them were literate in the old alphabet and had difficulty adjusting to the new writing style. As a solution, they were drilled with the process of equating the symbols of the traditional alphabet to those based on the GACL. This was an easier task to accomplish considering that community members literate in the

old alphabet had to make an extra effort to master the new symbols representing the sounds they were familiar with. After six to seven drilling sessions with the Committee members on the revised alphabet, it was time to test on a larger scale by way of training of trainers.

Training of trainers in the revised alphabet.

Nforbi (2009:55) holds that "every educational system needs training and orientation components especially for the teachers. The quality of this exercise determines the quality of the education". Here, we look at training already done by the potential teachers, their needs and logistic considerations. It prepares training programmes for pre-service, in-service teachers and supervisors as well as the orientation of learners and personnel." In this light, the first training of the Mungaka speaking community members was organized by the MRC which was launched by the Assistant Divisional Officer, Bali- Mrs. Adamou Martina on June 17, 2011 at Government School Group I Bali Town.

Prior to the training, a communiqué was sent out by the Sensitization sub-committee for all churches in Bali and sociocultural groups (that had contributed to raise funds for this project) to send representatives to attend this training such that they will return to their respective groups and serve as trainers, thus causing a multiplier effect. However, only 50 persons indicated interest and of this number, 37 actually took part in the training and 12 successfully completed the training. A majority of trainees were interested only in acquiring basic literacy skills in Mungaka to enable them read their Bibles in Mungaka and as soon as they acquired such skills, they abandoned the training process. Others left half way through because they were more comfortable with their knowledge of the old alphabet. This explains why the number that completed the entire course is minimal.

The second training session was organized by National Languages Sanctuary Cameroon (NALSANC) and sponsored by Bali Nyonga Development and Cultural Organization (BANDECA) which ran from the 1st to the 20th of August 2013. This second training was more intense as experts were brought in from Yaoundé –the department of National Languages and Culture of the Higher Teachers Training College, ENS Yaoundé. This training had as priority, to train teachers and church representatives for evangelical purposes, as preparations are ongoing for the revision of the Mungaka Bible. The trainer focused on the pedagogical grammar of Mungaka.

The Revised Alphabet (MRA)

We will not be very scientific in our presentation here, considering that this work is meant for all and sundry. The MRA is made up of 33 distinctive graphemes /symbols. They are twenty one (21) consonants, nine (09) vowels and three (03) marked tones. These phones and tones are presented below.

Consonants: According to Crystal (1997:432), consonants are speech sounds that function at the margins of syllables, produced when the vocal tract is blocked or so restricted that there is audible friction.

Vowels: Tasama (2008:33) defines a vowel as a sound made without mouth closure or audible friction, and can function as the centre of a syllable.

Tones: It is no secret that Mungaka is a tone language. According to Pike (1948:3), a tone language is one having "significant, contrastive but relative pitch on each syllable". Nevertheless, there are sometimes restrictions on the occurrence of tone. Since these restrictions can be very pervasive, Welmers (1973:90), quoted in Tasama (2008:58) suggests that Pike's definition of a tone per syllable is too strong. He proposes instead that a tone language is a language in which "both the pitch phoneme and segmental phonemes enter into the composition of at least some phonemes. Mungaka makes use of both registered and contour tones, treated in detail in Tasama (2013: 6). Worthy of note is the fact that high and mid tones in Mungaka is unmarked.

At this point, we will present the phones and tones here. That is, the grapheme and examples of words in which they are found and the translation.

SN	GRAPHEME	EXAMPLE	GLOSE
1	*Aa*	*alɛ*	thus, therefore
2	*Bb*	*bàm*	bag
3	*C(Ch) c (ch)*	*Chi*	salt
4	*Dd*	*Dù*	honey
5	*Ee*	*mfe*	feather
6	*Ɛɛ*	*Bɛn*	dance
7	*Əə*	*Kən*	born
8	*Ff*	*fatì*	disgrace
9	*Gg*	*gana*	Masculine name
10	*H h*	*he'!*	Exclamation

11	*Ghgh*	*ghan*	thief
12	*Ii*	*li'*	eye
13	*Ɨi*	*Misiŋ*	bird
14	*Jj*	*jɔ'tì*	broom
15	*Kk*	*Kə*	take
16	*Ll*	*lɔ̀ŋ*	chair
17	*Mm*	*mon*	child
18	*Nn*	*no*	drink
19	*Nyny*	*nyo*	snake
20	*ŋŋ*	*ŋu*	moon
21	*Oo*	*to*	come
22	*Ɔɔ*	*Bɔ̀'*	mushroom
23	*Pp*	*Pəmtu*	Bald head
24	*Ss*	*sòŋkù*	Trousers
25	*Tt*	*tita*	peper
26	*Uu*	*tu*	head
27	*Vv*	*ven*	pick up
28	*Ww*	*wo*	stone
29	*Yy*	*Yĕ*	do (something)
30	'	*Kə'*	cough
31	`	*dù*	honey
32	∨	*lă*	pass
33	∧	*Lâ*	but

Table 4, Phones and tones used in Mungaka

Word structure for Mungaka

Our analysis of the current data for this work confirms with that of Lima (1988:128) where he reduces the syllable structure for Mungaka in to the following formulae:

C3 initial that is, C3_____ ____C3____

and

C1 final (max) that is, _____C1,

Where C3 implies that the word structure for Mungaka permits the occurrence of three consonants in sequence at word initial position and word medial

position;

The second formulae imply that at word final position, Mungaka words only permit a consonant.

Let us consider the following examples:

Syllable type	example	gloss
1. C	n	yes
2. V	I	he/she
3. CV	kə	take
	fa	give
	vu	death
	so	heo
4. CVC	bin	breast
	bon	children
	kaŋ	fry
	bɛn	broke
5. CCV	mbi	goat
	ndî	today
	tăd	jump
	mba	mad person
6. CCVC	mbaŋ	pot
	ndab	house
	ŋkì'	basket
	mfiŋ	wound
	mbum	egg/body
7. CCCV	ŋkwan	slave
	ŋgwan	cane
	ŋgwɛd	oil
	ŋgwa'	loan society/njangi

Observation

We have observed that in all all C3____ words, the initial C element is always a nasal, which according to Tasama (2014:5) is as a result of the phonological process of homorganic nasal assimilation

Again, we noticed as quoted too in Lima (1988:129) that the word /mìŋgwi/ "woman", wherein the maximum C element at midial position is C3, the presence of a nasal is imperative.

The nasal plays a very significant role in Mungaka especially when it comes to the derivation of nouns from verb stems. This change of word category is

achieved by prefixing N ___ in most cases to the verb stem. A point observed also by Lima (1988:29) and **Stöckle** (1994:7). Let us consider the following:

Verb	Gloss	Noun	Glose
ba	Be crazy	*mba*	mad person
kad	To visit	*ŋkad*	visit
fɨ	Be blind	*mfɨ*	blind person
kĕn	Donate	*ŋkèn*	gift/ present
lɔŋ	Be iddle	*ndɔŋ*	an insult

Table 4.1 Word structure in Mungaka

Summary on Tone

Lima (1973:35) points out that Mungaka makes use of a combination of register and contour tone system. He further states that the tone in Mungaka is neither entirely of the type described by K. L Pike as level pitch register tone system for register tone languages, nor of the type which he describes as gliding pitch tone system for contour tone languages. Instead, Mungaka makes use of both register and contour tones. Ndangam (1972:22), quoted in Lima (1988:130) holds the same view when he states that *"...there is also a rising tone which means that the language (Mungaka) is a register tone language with contour (glide) overlap"*

Our analysis for the current work on the revision of the alphabet reveals the same findings.

Let us consider the following illustrations:

Words with High tone (HT) melody
bó	hand/them
ká	request payment of debt
dú	vomit
táŋ	count (Arithmetic)
ná'tí	show/teach

Words With Low Tone (Lt) Melody
bò	us/we (pronoun, 1st plural inclusive)
kà	container to transport fowls

dù	*honey*
tàŋ	*ceiling/form of scabies*

Low low (LL) tone melody

ŋwà'nì	book
Nyìkɔb	God

High Low (HL) tone melody

fá'nì	quarrel
mbómtì	gathering
bétì	question

Low High (LH) tone melody

ŋwà'ní	write
nyàmtí	mix

We have two distinctive contour tone melodies for Mungaka. The rising and falling tone as we see from the illustrations below.

Rising tone (ˇ) melody

lǎ	pass
sě	tear away
ghɔ̌	go
tǎd	jump
sǔ'	wash

Falling tone (ˆ) melody

lâ	but
ŋgâ	that
ŋjɔ̂	how/as (adverb)

An aspect of the orthography rule for tone marking in Mungaka states that only the low, rising and falling tone melodies are marked. The high and mid tone melodies remain unmarked. Tone is also not marked on proper nouns.

More on the revised alphabet, plus an orthography guide is contained in the Transition Primer by Julliet Tasama, produced by the Bible Society of Cameroon.

Morning prayer

M'fa njikà mbo wǔ ba nì ntì a mɛ'
Njɔ̌, ù lɔ̌ mbeb a nì yɔ̀ mfinyùm a
N'dɔ̌ nli nì bɔnì, ŋgə' ti yə a bə.

N'kù' sà'ni, ntĭn, ŋku' ndĭn mà fǎ'fà' a.

Lâ, mbu'mbo ŋgâ, u beb a ndi, N'chi ntìn
Kì yə mŏ'ŋgə' à chǎ mbo ma a bə;
Ni mfâ'yǎ fà' nitìn, ni ŋgyemti bùn
Ni yu'ni u, kì fǎn nù mi a bə
sĕ boà bòn ba
Beb ba mì, nǎ mì, mfɛ̀d ba, nsùn ba sĕ
Ni ŋgyemti yab, bo mfâ'yǎb fà', ǎ mbɔŋ.
Ni ndâ yǔ mànjì bì' à bo ŋkàŋka,
Nda'nti' u kìnindəŋ, nchi ntìn mbĭ kɔŋ, Amèn

Challenges

The level of excitement with which this project took off is dwindling due to lack of funds. The major challenge to this revision process from inception has been lack of permanent funding. So far, all work done from 2010 to 2013 has been achieved through the efforts of the Finance Sub-Committee that was charged with raising funds. The money came in bits and was realized through individual contributions, group levy and donations by Bali associations. A majority of the work is a result of personal initiative with the end result put for testing at a larger scale before major conclusions arrived at. An important point to note is the adoption of the revised alphabet by the coordination committee which has led to the introduction of Mungaka as a subject in Basic education within Bali. Though this move is still at the pilot stage, it is hoped that in the years ahead, Mungaka would have been brought back to the fore.

The Bali council has not yet taken upon itself the promotion, preservation and extension of the domain of use for this language, as stipulated by the text. However, rent and bills for the house hosting the Mungaka language centre is taken care of by the Bali Council. It is hoped that in future, it will be more involved as required by law.

RECENT DEVELOPMENTS

Considering that the wish expressed by many to have Mungaka revived has now become a reality, the following projects have been realized in the language: The Jesus film project in Mungaka, i.e. script adaptation of the Jesus film has been attained, record has been done by Jesus film team from Orlando, USA. This project has been realized and launching is in December 2016. Its impact will be

multidimensional as the entire Bali public and the church will now listen to the preaching and teachings of Jesus Christ in their own language.

The Bible Society of Cameroon has adopted the project on the revision of the Mungaka Bible, which is to kick off effectively in January 2017, considering that literacy in the revised alphabet is a prerequisite condition for the Bible revision exercise, intensive literacy programme for the popularization and promotion of the revised alphabet is underway, as literacy materials are now available in the revised alphabet which include:

- A primer,
- A transition primer
- An Arithmetic book for Beginners

It is hoped that these books will be used in teaching and that it will help others to develop more literacy materials in the language.

CONCLUSION

The present awareness of the need to get rooted in our context and cultures so as to contribute to the globalization is fraught with psycho-pedagogical problems. Those of us who are already educated and literate and serve as elite in the society are generally not literate in their mother tongue. This is very true of the educated Bali class. The educational system most of them went through did not provide such education in the curriculum. It is not their fault therefore, if they resist the philosophy on Mungaka literacy. They are however, faced with the problem of insertion in the new and favourable mother tongue educational policies which are examined above.

The introduction of mother tongue literacy in our educational system from the basic level, creation of the department of Cameroon national languages and culture in the Higher Teacher Training College, the opening of centres for Cameroonian languages and cultures, the great efforts by individual linguistic researchers and non-governmental organization like CABTAL, SIL, NACALCO, NALSANC, those of religious bodies and organisations not forgetting the numerous official texts and decrees are all evidence that we are at the verge of mother tongue education revolution and the Mungaka speaking community must not be left out.

It is a fact that Mungaka serves as a crucial bridge between the local community and the school. A lot will be achieved if we introduce our children to the phenomenon of written communication in Mungaka for as has been observed,

language is the best way to transmit culture from one generation to another so the teaching of Mungaka supports the need for an authentic cultural identity. Besides, language has always been the best means of expressing a culture. No other means of communication has surpassed it. We must teach our languages in schools if we want a cultural identity to transmit to future generations.

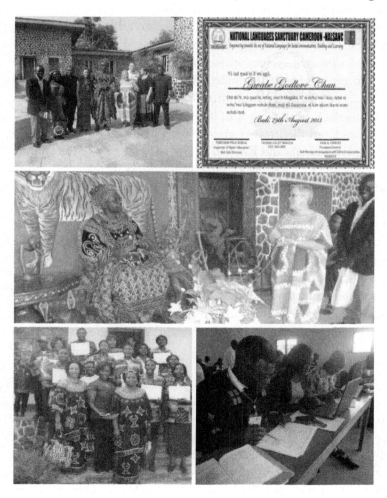

Fig 5, Top left, HRH Dr. Ganyonga III receives The Jesus film Production team led by Mama Sue McDaniel in June 2015; top right, Certificate given to trainers in Mungaka; Centre Picture, HRH Dr. Ganyonga III with Mama Sue McDaniel, production manager, Jesus film Francophone Africa and Emmanuel Ngeh, National Cordinator, Jesus film, Campus Crusade for Christ, Cameroon; bottom left and right, Mungaka trainees.

The need expressed by many to have Mungaka revived is today becoming a reality though a lot still has to be done to sustain this revival. Considering that the Bali community home and abroad is gradually embracing this new alphabet, especially as it has been introduced as a subject in Basic education in some schools within Bali, it is hoped that this language would in the near future regain its place as a major language in this country; this is because a lot of literature already exist in this language but now only need revision and adaptation to the revised alphabet. Nevertheless, a lot of work is ongoing and still needs to be done to get this revised alphabet at a comfortable place. The need for an effective functional language committee is paramount; the life and death rise and fall of Mungaka is in the hands of its speakers and users – Bali people and to a greater extend and the Presbyterian Church in Cameroon, which still has Mungaka along with Duala and English as official languages of the church.

Beginning education in a language a child already knows increases his ability to absorb knowledge and to learn other languages. Therefore, it is necessary to teach Mungaka before or while teaching in English-the foreign but official language of Cameroon. This is because teaching in our African languages stimulates children's scientific and technological awareness at an early age.

Our greatest wish is to have all Bali sons and daughters of various disciplines related to language, culture and development come together on the same plat form to fight for the maintenance, promotion, popularization and extension of the domain of use of Mungaka to maximize growth, development and a cultural identity for the people, and by extension, the North West Region, Cameroon and beyond.

References

Bongsu, T. K (1995). Language Problems in Anglophone Cameroon: Present writers and future readers in Ntsobe A. M et al (1985) (ed) Sosongo

Chumbow, B. S (1980). Languages and language policy in Cameroon: In; An African experiment in Nation Building: The bilingual Cameroon Republic since Reunification Ndira (ed): Westview Press, Boulder, Colorado, USA

Epie, V.N. (1979). Mother tongue literacy in Cameroon: A tardy but necessary venture. Bachelor of Arts Dissertation, Higher School of Journalism, University of Yaoundé 1, Cameroon

Lima, A. S (1974). The Mungaka language with Special reference to its Pronouns. M.A. thesis University of Leeds, England, UK.

Nforbi, E. (2005). 'Community involvement in Mother tongue Education through a

dynamic functional language committee' AJAL, vol: (47-61)

_____ (2012). African languages Education in the era of globalization; Harmattan, Cameroon.

_____ (2009). Back to mother tongue literacy. Harmattan, Cameroon

Shell, O. (1980). Philosophy and Procedure for Primer making in Cameroon. SIL, Papua New Guinea

_____ (1987). Guide pour l'Alphabétisation en langues Africaines. Collection PROPELCA No 34. Université de Yaoundé.

Snider K. And Robert,J. (2000) Suggested outline for Tone Description; SIL, Chad.

Stöckle, J. (1994). Mungaka (Bali) Dictionary. Archive Africanistischer Manuskripte: Harausgegeben Von Gudrun Meihe Band I. Rüdiger Köppe Verlag, Köln,Germany

_____ (1994). Traditions, Tales and Proverbs of the Bali-Nyonga. Archive Africanistischer Manuskripte: Harausgegeben Von Gudrun Meihe Band II. Rüdiger Köppe Verlag, Köln, Germany

Tadadjeu, M., E. Sadembouo (1984). The General Alphabet of Cameroon Languages. PROPELCA Series No. 1, Bilingual edition

Tadadjeu, M, E. Gfeller, G. Mba (1986). Introducing an official language into an initial Mother tongue education programme: the case of Cameroon. Annales de la Faculte des lettres et Sciences Humaines. Serie Science Humaines, Vol. 2.2. Université de Yaoundé.

Tadadjeu, M. et G. Mba (1981). 'Contenu et progrssion de l'enseignment experimental des langues maternelle Camerounaises à l'école primaires' dans Tadadjeu et al, (eds.) Proposition pour l'enseignement des langues au Cameroun. Travaux et document de l'ISH 28.

Tasama, J.N (2008) The Phonology of Mbembe. M.A. Thesis submitted to the department of Linguistics, University of Buea. , Cameroon

_____ (2013) Report on the Mungaka Rehabilitation Committee, submitted to the Bali Nyonga Development and Cultural Association - BANDECA.

_____ (2015). Mi' ŋwà'nì Mìŋgâkà ì mfi (The Mungaka revsied Alphabet). Bible Society of Cameroon, Unpublished Document

Titanji, V.P.K. et al.(1988). An Introduction to the study of Bali-Nyonga. A tribute to His Royal Highness Galega II, traditional ruler of Bali-Nyonga from 1949-1985, Stardust Printers, B.P 8361, Yaoundé

UNESCO (1953) The use of vernacular languages in Education. Monographs on fundamental education. Paris

Veilhauer, Adolf (1923). Nsun u, yi, I boṅ ntsa sun bu me'a (Your best Friend) Protestant Missions in the Cameroons.

_____ (1930) Ntsi Nikǫb bi ndzǫbdzǫb ni tsu Ba'ni Basel Mission, West Cameroon.

_____ (1932) Ndu'ti Nwa'ni Ba'ni. Basel Mission, West Cameroon

_____(1949) Nwa'ni Psalm ni tsu Ba'ni – 1949

_____(1953)Ke'fụn Ntsundab – 1953

_____(1967) Ntsi Nikọb bi ndzọbdzọb ni tsu Muṅgaka – 1967.

9

MUNGAKA IN PERSPECTIVE: PAST, PRESENT AND FUTURE TRENDS

Beatrice Kahboh Lebsia Lima Titanji

INTRODUCTION

Mungaka is the language of the people of Bali Nyonga; a Sub-Division in the North West Region of the Republic of Cameroon. It is a language that has enjoyed the generic usage by many people within the geographic landscape of the North West Region in the sense that it was used by the Basel missionaries like a language of evangelization and then as one for education before the dawn of independence. The quest for education and the interest to become as civilized as the white man (early missionaries) caused many men and women to follow the path of literacy in Mungaka. Mungaka was used in churches and taught in schools to enable Africans read and know the Bible. Evangelization by the Basel Mission spread in the North West Region and Mungaka fast became a *lingua franca* in all spheres of life between non-Bali natives as adult pupils could use and exchange pleasantries in a common language.

THE PAST

As a multilingual country with 286 languages (Ethnologue: 2009) that Cameroon is, the situation of using Mungaka as a lingua franca solved a major problem of communication between natives of the grass field in those days. As the missionaries made in-roads into the hinterlands, the use of Mungaka also spread raising its importance as a language for communication. The two world wars greatly mellowed the spread of Mungaka but it sprang up again just before independence and continued with its peak in the 1970s (Ndangam 1972) when the translated Bible was read in churches in the grassfield in Mungaka. The

popularity of Mungaka reduced from the 1970s onwards as pupils no longer needed Mungaka for studies. French and English were preferred at independence and used as the official languages in schools; with the incidence that native languages fell along the wayside. The Bible which had already been translated into Mungaka was used in the churches only and no longer in general education as before.

Mungaka is one of the early written national languages of Cameroon. Bali has a population of about 50,100 (1982 SIL). The language is named Bali, *Munga'ka, Nga'ka or Ngaaka*. Mungaka is the language of the Bali Nyonga people in the Bali Sub-Division in Mezam Division of the North West Region of Cameroon. Bali Nyonga constitutes one of the many groups of Chamba origin found mostly in the North West Region. All other groups (apart from Bali Nyonga) speak closely related varieties of a language known as Mubako', no relative to Mungaka. The word Mungaka literally means "I say." It is composed of the three elements: mu- `I', *nga*- `say', *ka*- vocative particle. The Bali Nyonga are one of the Chamba Fondoms of North West Cameroon who abandoned their original language, which was Mubako (Adamawa). In place of their mother-tongue they adopted the language of the Bati. This happened on their migratory tour and military campaigns during their temporary settlement among the Bati at Mom of the West Region of the Republic of Cameroon. The history of this almost total change of language has been expounded by Vincent Titanji and three other scholars in their book titled "Bali Nyonga", 1988. Johannes Stockle, (1992). This new Mungaka language Stockle (op. cit.) points out that it belongs to an entirely different language group of the Niger-Congo group. It is a bantoid language Malcolm Guthrie et al (1956) SIL (1982).

Although Mungaka is currently the language of only about 85.000 native speakers, it was up to recently understood and spoken far and wide by non-native speakers in the North West Region of Cameroon. The language was first written by German-Swiss missionaries of the Basel Mission who were welcomed and supported by Galega I. In 1889 he embraced Eugene Zintgraff when he arrived in Bali Nyonga without fear. Zintgraff's arrival spurred Galega to ask for schools to be opened by the Basel Mission. He died in 1900 and his son and successor Fonyonga II requested for the same thing i.e. schools. His chief aim was that schools should be opened and Fonyonga I himself was anxious to read and write. After the preaching of the first sermon in a market place, the Fon asked for the first school to be built. Fonyonga II told the missionaries that they could only leave after due promises that other missionaries would come to Bali without delay and start work in the schools. He sent one of his sons

with them to learn how to read and write. With this burning desire to learn, Schuler wrote: *"It is high time that we should advance to Bali. There are enormous prospects for a new working area which bears no comparison with the present one."* In 1906 when the schools had been built, the Fon gave 200 German Marks for slates for the learners in the new schools. This is how Bali became the Mission Station where other missionaries resided and then moved to other areas in the grass field with a translator who helped in naming villages and towns through which they sojourned in search of new outposts.

The orthography that was used to translate the first Mungaka Bible was based on the German alphabet and has continued to cause difficulties to many a native who have endeavoured to read or write it. Adolf Vielhauer in his tenure as missionary in the early twentieth century together with indigenes of Bali Nyonga translated the Bible using the German orthography. That translated version has stood the test of time and has been used to teach and evangelize the gospel. Inasmuch as the Bible was useful and served a purpose, it was not easy to read with the tones and stress patterns. Native Balis who speak Mungaka daily also find it difficult to read that first translated Bible. If we consider the rendition of the Lord's Prayer for example, we see the orthography in Mungaka which is not so easy to read. The presentation of texts in the various forms from its heydays (past and present) may better tell the story. A sample of it is in Box I below where I have presented the first copy of the Lord's Prayer.

> "Ba yu' yi u ku nindon a ti ndze bu ngomti lun tu; numfon u nto; ba-masi ndzu' ntu' bu ndzo ba- kunindon. Fa bu' bu' kedzu a ku'ni mbo bu' ndio a; ngwa' fannu bu', ndzo bu' se wa' mu nu, bon lo' mfan mbo bu' a; ku bim bu vu nku Satan bo; ndunu yu' ni nu mbukad; mbi' u mfon, ntun, mbon ntswe'ni nkanin a. Amen.

Box 1: Mungaka Bible translation (The Lord's Prayer) by Adolf Vielhauer et al 1958. (Culled from the Mungaka Bible)

This version is what is in use in our churches today but from observation, more needs to be done because of the difficulties discussed above. Thus, with the elaboration and adoption of a Cameroonian orthography, change is coming and another translation should be on the way to facilitate the reading and writing of Mungaka. Before that decision was taken, I had started writing Mungaka using the English alphabet with the hope of getting a wider readership of the

language and got the following translation as seen in Box 2

Ba yuh ku nindeng. Tih nje bu ngomti leng tu, nu mfon u nto. Bon masi njuh ntuh bu njo ba kunindeng. Fa buh keju a kuhni mbo buh ndio a, wah fannu buh njo buh se wah mu nu bon loh mfan mbo buh a. Lunghe yuh ni nu mbuked mbih u mfon ntun, mbong ntswehni nkanyin a. Amen

Box 2: Version of the Bible in the English alphabet (The Lord's Prayer)

This rendition when read does not sound like Mungaka to the native speaker and demands a closer translation that could sound real to the natives. As well as it helps the modern child to read the alphabet to which he-she is acquainted, it distorts the language completely reason why a new translation is necessary. Mungaka as a Bantoid language has tones that enable words of similar spelling give different meanings such as mbàŋ and mbáŋ.

THE PRESENT

After the glorious past of Mungaka, one would imagine that English and French killed the language. On the contrary, it has continued to enjoy some amount of prominence within the ranks of the church. Mungaka was still taught at the Presbyterian Seminary together with Douala and many pastors of the Presbyterian Church in Cameroon could utter words of greetings in Mungaka learned from the seminary. The challenge of the Bali Nyonga indigenes today remains in the preservation of Mungaka. Whereas, some Balis continue to speak the language to their children and household, others look low on the language and their children end up without any identity as a people. To ease the process of preservation, the new Cameroon orthography is being taught and learned in Bali by men, women and children who are interested to do so. Unfortunately, it is not compulsory reason why registration into the classes is rather timid. In one of my quests to find out the state of affairs at the Mungaka centre, I met two enthusiastic students (both male and female) who were picking up the alphabet rather swiftly. By the end of that session, they were able to read and sing a song in the new orthography.

The new orthography has greatly simplified the reading and writing of Mungaka since it is the same as the English alphabet but for a few typical

Mungaka vowels such as /ɨ/ and /ŋ/. This article is another way of encouraging Balis to take the opportunity to learn how to read, write and teach their children the language of their land which they have used since birth and to bequeath it to their own children's children. Language is culture and anyone who knows a language should knows the culture of the people. The Bali culture is so rich and varied and a knowledge of the language will only go a long way to enhance the culture of the great people of Bali Nyonga. The rendition in Box II could facilitate the reading of Mungaka to an extent since students presented with this spelling could read much easily than the former.

The new orthography for Cameroon writing has come up with yet another spelling guide to ease reading and writing of our languages. Thus, the Mungaka language now uses same to teach the reading and writing skills in Bali with the hope of gradually translating existing literature in Mungaka and writing new ones in the new orthography. The Mungaka alphabet has evolved to read as follows:

Aa	Bb	CH ch	Dd	Ee	ɛ	ə	Ff	Gg	GH gh
Ii	ɨ	Jj	Kk	Li	Mm	Nn	NY ny	ŋ	Oo
ɔ	Pp	Ss	Tt	Uu	ʉ	Vv	Ww	Yy	?

Box 3: The new Mungaka Alphabet

While the English alphabet which is used worldwide has twenty-six letters, Mungaka has thirty (30) sounds and not letters. This number is as a result of the following sounds that can only be found in the English phonetic chart and not used in writing everyday spellings such as the vowels /ə/, /ɔ/ /ɨ/ and nasal /ŋ/, /ny/ the /ɨ/ vowel is a typical bantoid sound and is not found in English. It is very dominant in Mungaka and can be heard in several words during running conversations.

The alphabet in Box III is now taught in Mungaka classes in Bali to any one who wishes to read and write the language initiated by Juliette Tasama and run by a special committee (Mungaka Rehabilitation Committee in 2010) formed by the Fon of Bali, Dr. Doh Ganyonga III. Today it is managed by Victor Tita-bai; an enthusiastic teacher I met in August 2015 but unfortunately with just two students in attendance. His spirits are quite high and he looks forward to having more pupils as the days go by especially during the long vacation period.

The existence of a readable orthography in Cameroonian languages paves

a bright future for Mungaka. The discussion above has shown clearly that there is need to translate existing Mungaka literature.

Ba yʉ' kʉ nindəŋ ti' nje bʉ ngomti lʉŋ tu u, numfon u nto. Bon masi nju' ntʉ' bu njə ba ku nindəŋ. Fa bʉ' keji yi a ku'ni mbo bʉ' ndio a, wa' fannu bʉ' njə bʉ' se wa' mʉ nu bon lɔ' mfan mbo bʉ' a, luŋʉ yɨ' ni nu mbʉked mbi' u mfon ntʉn, mboŋ, ntswe'ni nka nyin a. Amen

Box 4: The Lord's Prayer in the new orthography

THE FUTURE

Fig 6 Signboard leading to the Mungaka learning Centre

As this board indicates, the centre is supposed to be run by a network of cultural actors; but for the time I spent watching learners come and go, I could only see one actor in the person of Victor Titabai who looks really enthusiastic while dispensing knowledge in Mungaka. As a management centre, one can see a few outmoded computers in the room supposed to be used for translating Mungaka into English and vice versa. The computers are said to have been donated by the former Mayor of the Bali Council some years back and if the

centre has to function properly, newer ones should be purchased and put to use.

The Way Forward

After having looked at the evolution of Mungaka in the last 80+ years, the question is "what next?" As a pedagogue, I have taken up the task of encouraging my family members and especially the children I have raised together with my husband to expose them to the full use of the Mungaka language in our home. The password in our home is *"ngaaka."* I sometimes believe that even my dogs understand when I give them instructions in the language. Once one knows his/her mother tongue, the person dreams, plans, thinks and executes in the second and foreign languages that modern living has exposed us to. When one lives with the language of his/her birth, communication is made easy when one finds him/self back home. The raucous laughter one hears when the Ba's and Na's are in conversation makes one wish to be part of it all.

Fig 6.1 Building housing the Mungaka programme now in Bali in Titanji's Estate, Nted Quarter. Notice the overgrown grass in the surroundings of the house and the closed doors (sign of under usage).

Secondly, Nkumu Fed fed has just started a literacy centre (Women's Guild) at their Skills' Centre at the Gwan Multipurpose Centre where women learn to read and write and also do embroidery to enable them earn a little more money to improve their lot. This new disposition can change the future of Mungaka in that this new breed of learners could be introduced into the Mungaka literacy after their training at GMC. If properly organized, the transition could be for

the women to leave from one training centre into another.

Fig 6.3 Newly admitted members of the "Women's Guild" at GMC Bali (1st Batch). (Author is second from the right on the back row)

To be part of the Mungaka programme then is what I recommend in this write-up. Our CWF song says "It's never too late for a woman to start again." I say, "It's never too late for a people to start again." Many of us Balis have chosen to raise our offspring in the white man's language. True, we need English to cope with the exigencies of modern life but we also need an identity. When we discuss, work and show our prowess in another man's language, we should be able to also use our mother tongue similarly. Identity comes from the language one speaks; try to speak the language of a Bassa man for instance and notice the instant affiliation the person takes to you. Trust develops instantly and fear fades as well; that is the power of language. Polyglots (people who speak many languages) can testify to this phenomenon. Friendship develops when one can understand what one says and people become less aggressive when they speak the same language with you.

A few months ago, I boarded a taxi in Yaoundé with my sister to visit a sick friend at a rather difficult vicinity in Yaoundé. We had to stop somewhere and climb a steep hill to get to the home and the sun was at its zenith. As usual, we started speaking in our beloved Mungaka. The taxi driver followed most of what we said silently and said nothing; then a passenger asked to alight and guess what?

The lady's child was quite ill and my sister commented showing her sympathy
"Ei! mon le ni njaŋ ka! (Hey! That child is so ill)
And I added saying in Mungaka:
"Na i kwe?" ("Is its mother any better?)

Actually, the lady was looking very gaunt and sickly as well which called for the comment.

The comment in Mungaka had a different and more humorous connotation and the taxi man burst out laughing and it was only then that he asked to know what language we were speaking. He then said he had been trying to follow our conversation since it sounded like his own mother tongue. This short interaction in a public car drew the three of us closer and we saw this brother driving us up a hill we had earlier wondered how we would ascend. This is the power of language. Instances such as the one I just recounted occur daily in our country and only go to prove the point of what I have been trying to say in this write-up. A person's identity is important enough and can be shown through the language one uses to communicate with others in society. The interest of the people in the use of Mungaka can cause a real revolution in the usage and language gain popularity especially when the number of speakers is large.

One person who has shown interest in promoting Mungaka has been the paramount Fon of Bali Nyonga; his Royal Highness, Senator Ganyonga III. On his ascension to the throne after the demise of his father; his Royal Highness Galega II, he started literacy classes around the village and encouraged the use of Mungaka in homes and showed the example by speaking same in his palace with his family. This interest was punctuated by a foreword he wrote for a dictionary of Mungaka by Stockle and Tischhauser in 1992. The existence of a dictionary of Mungaka requires the active use of the language and consequently the development of literature and documentation of Nyonga cultures. Literary minds can start thinking of writing novels, documenting riddles, proverbs and stories that will further enhance the acquisition of Mungaka by the younger generation who are moving out of the village every day. This initiative having been spearheaded and supported by the Fon gives linguists a leeway in coming together to set up writing societies and training young learners in the process. All these motivations by the paramount Fon of Bali have been recently supported by the Government's action in her language policy which encourages tuition in the mother tongue. This policy has further strengthened the position of first languages and Mungaka should not miss out on this unique opportunity.

CONCLUSION

I started the preceding paragraph by quoting from a song by the CWF women - it's never too late to start... If for some reason anyone never had an opportunity to speak Mungaka, he/she can always start. The Mungaka rehabilitation centre is operational and receives students willing to learn how to speak and write in the language. During the long vacation, the teacher (name earlier mentioned) is always available and ready to teach for almost nothing. His readiness to teach the language can be seen in his broad smile and selfless attitude. I challenge Bali women and men who have hitherto neglected this cherished language to come back to the drawing board. Start speaking Mungaka in your home today and why not visit the Mungaka Rehabilitation Centre situated near the Fon's Dance Plaza (*ntan mfon*) or use the contact below. We all have little stories about the places we went to fetch water, harvest fruits etc. as children growing up in Bali. That will be one of the ways to document the rich culture of our people. What about the evening tales we told when we had no radio/ television? Can we retrieve and document them? Do you have any in your memory? Bring them out and share. Can you write them down in English for a start? Send them by email to be translated into Mungaka and acknowledged by including your name in any resultant publication. It has been a real pleasure for me to take time off the daily chores and reflect on the perspectives of Mungaka as I have seen it for the past 50 and more years of my life in the culture of the people of Bali Nyonga. Hope you find interest in this and join us in restoring the fine things that make a nation; language being an example.

References

Buea Archives Files, (1943). Bali language. File 38

Lima, A.S. (1974). The Mungaka Language with special reference to its pronouns. Unpublished MA. Dissertation. University of Leeds, England, UK

Ndangam, Augustine F. (1976) Linguistic Survey of the Northern Bantu borderland, Vol. I O.U.P London

Tischhauser, S.J. (1992) Mungaka (Bali) Dictionary Rudiger Koppe Verlag, Postfach 40 03 05 W- 5000 Koln 40, Germany.

Titanji, B. K. L. (2013) Literacy in Cameroon: The case of Mungaka in: Language Policy in Africa: Perspectives from Cameroon. Akumbu, P.W and Chiatoh, B.A. (eds). Miraclaire Academic Publications (MAP), USA

Titanji, V P K, et al. (1988). An introduction to the study of Bali-Nyonga. Stardust Printers, Yaoundé, Cameroon

10

ART AND CRAFT IN BALI NYONGA

Godfrey Forgha Njimanted

INTRODUCTION

Art is the marking of objects, images, music, etc, that are beautiful or those that express feelings while Craft refers to the skill and experience in relation in making objects. It also involves the activity of painting, drawing, and making of sculpture. It has to do with the ways of life of the people in question and in every community, Art and Craft has undergone series of re-transformation depending on the available row material that determine the mode of production and consumption in this particular community.

Although scientific sources have reviewed that Art and Craft began with the first human creation on earth, Arts and Crafts movement is often attributed to the building of William Morris' Red House in 1859, the true birth of the movement happened some 25 years earlier when a young architect named Augustus Pugin (1812-1852) publicly railed against a newly industrialized society that was increasingly separating designer from labourer.

The Industrial Revolution was based in part on an "innovative" concept called division of labour. The idea, which is the foundation of modern factory work, was simply that by dividing a job into its various tasks products could be made more quickly. Rather than depending on a small number of highly skilled craftsmen to do everything, individual skills could be taught to a variety of people who would perform that chore and pass the item to another person to perform the next task.

They may have been good for the bottom line, but from the humanist perspective, the division of labour robbed workers of the pleasure of seeing their work through from conception to completion as the traditional values of quality and beauty were being replaced by the new motto of economy and profit.

As the Industrial Revolution expanded in the 1830s, the life of simplicity and wholesomeness began to disappear. However much excitement this Revolution caused, with its time- and labour-saving machines, forward-thinking people saw its potential to change the English way of life forever. The devaluation of nature and the human touch in favour of progress and production especially worried Pugin, 1717-1822). He saw that in striving to master the future this new era was rapidly turning its back on the simple pleasures of traditional craftsmanship and artistry. Pugin was not necessarily anti-technology, but he wanted machines to perform the tedious and repetitive tasks they were designed for and not in the creation of second-rate, mass-produced decorative objects.

Pugin's philosophy struck a chord with a host of later artists/craftsmen/thinkers, most notably John Ruskin (1819-1900). During the late 1840s, Ruskin, an art history professor at Oxford University, began a campaign to return England to a simpler way of life in tune with nature. His vision called for the elimination of machine-made decoration and clean design free from foreign influence. The English, having borrowed heavily from the French in order to furnish their Victorian lifestyle, soon began to cast its collective eye inward for inspiration and there followed a revival of English Gothic and Medieval styles.

Ruskin also preached that work was meant to be joyous -- an idea that was lost on the growing multitude of factory workers who spent long hours toiling in poor conditions. This noble idea had its roots in the past when one's work was one's life and it was to become one of the Movement's basic tenets.

It is no coincidence that the Arts and Crafts movement's most important figure happened to be attending Oxford at the same time Ruskin was campaigning for reform. It is said that William Morris (1834-1896) was so moved by Ruskin's philosophy that in 1853 he dropped plans to become a minister in order to make his life's work the reformation of society through art. In 1859 he hired his friend and fellow architect Philip Webb to build Red House, which he painstakingly furnished with simple, custom-crafted furniture, wall paper, tiles and accessories specifically designed to fit the home. It was here that the ideas of Pugin and Ruskin were made physical and thus began the architectural and design style known as British Arts and Crafts. The grass fields of Cameroon have similar movement most of which are unrecorded. However, our concern in this write up is to examine crafts and arts in Bali Nyonga of the North West Region of Cameroon.

The Bali Nyonga is situated about 20 km from Bamenda and is known for its cool and pleasant climate. The Handicraft Centre is a well know tourist destination were the visitors can see how the beautiful crafts are being done by the

Bali crafts men. Besides a fully and modern equipped Joinery section, display are several workshops of the craftsmen in the form of produce carved stools, relief carvings, woven chairs and benches, bamboo items, calabash items and baskets.

It is observed that between the late 1950s and early 1960s a lot about Arts and Crafts in Cameroon were associated with witch craft. This was due to the ways they were practiced and their features upon displacement. It is possible that some visions were demonstrated by the presented Arts and Crafts but the interpretations by the public limited them to diabolic activities which limit their continuity. Therefore, the 1960s and the 1970s witnessed its retrogression. Although the people of the grass field have managed to sustain Arts and Craft as ways of life, it has undergone dynamics of metamorphosis. This is not different with the case of Arts and Crafts in Bali Nyonga. The Arts and Craft in Bali Nyonga could therefore be categorized into: The arts and crafts of building: the Arts and Crafts of greetings; the Arts and Crafts of eating; the Arts and Crafts of dancing; the Arts and Crafts of Marriage; The Arts and Crafts of mourning; the Arts and Crafts of burial; the Arts and Crafts of singing; the Arts and Crafts of worshiping; the Arts and Crafts of Farming; the Arts and Crafts of hunting; the Arts and Crafts of fishing; the Arts and Crafts of Inheritance; the Arts and Crafts of communication; among others.

On like the early man who lived in the caves as starting point for permanent settlement, the Bali Nyonga men and women Arts and Crafts of building have the historical trend that can be attributed to stages of internal and external developmental attributes. Bali with about 85,976 homes of residents as history holds it got its name from Princess Na'nyonga, who founded it in the early 19th century. Bali Nyonga is steeped in a rich history and possesses a strong cultural heritage which adds to its uniqueness within Cameroon. As the home of the earliest Basel Missionaries in the grass fields, Bali Nyonga hosts an array of architectural treasures such as the Presbyterian Church in Ntanfoang built by the Missionaries in 1902.

The Arts of Crafts of building in Bali Nyonga is similar to those of many villages in the grass field. It blends the traditional – Missionary old-fashioned styled with the modern method of building. The Basel mission school and the geometry constructed by the German missionaries which were the first buildings in the grass field regions of Cameroon consist of stones and cement. The building has been for over one and a half century. The roofs were made with special sink and dome form of brick styled roofs. Conspicuous examples are the Presbyterian Church building in Ntanfoang, some buildings of the Fon's Palace and the Missionary school buildings in Prescraft centre etc. This can be termed

149

the first category of buildings in Bali Nyonga.

The second category of building is the "bamboo" house. This consists of bamboos tied together (attached) vertically with pillars made up of big sticks that are embedded in the ground for about one meter deep in the ground. The roof is equally made up of bamboos (raffia sticks) which are covered in a special way with a special type of grass which are from the hilly slopes of the village. This grass are cleared and gathered during the dry season and are arranged in a special way to prevent rain from entering the buildings. The grass expires after 2 to 3 years and are carefully removed during the dry season and replaced with new grass. The grass is arranged in such a way that rain drops can only flow on them but cannot actually infiltrate and soak up to the last layer. Under this category, there is another category (minor category) that are constructed in the same way but in between the bamboo, the soil (mud) well mixed is embedded so as to form a strong wall. The roofs are constructed the same and sometimes modern method is used (zing or aluminium roof).

Another category is the sun-dried bricks buildings (local bricks). This consists of the earth ground, mixed with water and with the use of a particular tool called "brick-form" is used to make bricks which are hardened with the aid of the sun. The bricks are then used to build using mud, in between them to enable it stick together or using cement mixture (mixed with sand and water). The roof is done with the aid of planks and zinc or bamboos and grass (as seen above). Finally, there is the modern building using cement blocks (bricks) in which cement and sand are used to stick the blocks together with the roof being there. As at the current period, modern buildings are sported in very quarter in Bali Nyonga but dominated by bungalow for commercial or family use. While stories building are also available, they are very few to reflect the status of the subdivision and the income differential of the occupants of the subdivision.

The Art and Craft of Worshipping

The traditional belief and practices of the Bali people include traditional religion. The traditions are oral and rather than scriptural include belief in supreme creator, belief in spirits, and veneration of ancestors, use magic and traditional medicine. Rhythmic drumming and singing are used during prayers, during this drumming and singing the worshipers perform distinct ritual movements or dances which enhance their consciousness.

The Bali traditional worship pray to various spirits as well as to their ancestors. These secondary spirits serve as intermediaries between human and the Principal God. Bali traditional worship believe in a single creator God called

"Nyikob" of varies categories and the objects of interest. Some ranges from stones, sticks, trees, rocks, etc.

However, it is observed that Christianity is fast advancing in Bali but most still hold strong to their traditional worshiping of the traditional god simultaneously with the supreme God through consultation with lesser deities and ancestral spirits. The deities and spirits are honoured through libation, sacrifice of animals, cooked food, semi precious stone, palm wine etc.

The will of "the local Nyikob" is sought by the believers also through consultation of oracular deities or divination. Furthermore, the traditional worship morality is associated with obedience or disobedience to God regarding the way a person or a community lives. Some secret places or holy location for traditional religion as it was in the past include the Fon's Palace, road junctions, room in a house were libation are poured for ultimate respond by the god. Although the storey has changed, traces of these practices are still in existence.

Arts and Crafts: Cooking in Bali Nyonga

Cooking in Bali Nyonga is done on a hearth using wool for fuel. The cooking hearth is in the middle of the room or in one of the corners. Cooking is also done in a shed located next to the wife's house. Quite often the main cooking area may consist of three stones, arranged in a triangle which serves as a tripod to hold the pot. Fire wood is placed in the spaces between the stones and under the pot. The traditional kitchen has facilities to boil, fry, roast, grill, steam and bake.

Moreover, cooking in Bali Nyonga relies on and utilizes local materials very effectively. For example most people cook with palm oil and use pepper for seasoning. Most utensils used for cooking are made from materials collected from the immediate environment. For example, Fufu corn sticks carved from local bamboos are used to stir the corn flour, as well as the saucer used for serving the fufu corn and half calabash used for shaping the fufu corn are carved from local bamboos. The fufu corn is served in a tray made from raffia palms while the soup is served in a dish made from local clay. It is worth noting that; today cooking in Bali Nyonga utilizes utensils produced by Aluminium Company in Edea and not the local blacksmiths.

The staple diets of the Chamba in the Cameroon grass field consists primarily of corn fufu eaten with various vegetables (like huckleberry, bitter leafs, pumpkin leafs, cow peas, okra) as well as corn fufu eaten with mud fish soup, cricket soup *("targi")*, *"muchuk"* (found in sand) *"sinka"* (found on the hills) and *"nyam ngub"* (dug from the hill).

The Bali Nyonga cooking differs based on the occasion and depending on

the wealth status of the family. During important events like traditional wedding, "Lela festivals and the award of red feathers "Sugha" meal is served (it is a mixture of old corn flour and groundnuts). Likewise, chicken and goat are consulted as a delicacy consumed primarily by rich families during important events. Furthermore, during periods of war and when traders embark on a journey to neighbouring villages or countries for trade, the "jamine" another type of meal is served. It is a mixture of patched corn and ground nuts that have been ground. "Jamine" is also used as a snack when people sit to socialize.

When a child is born into a family as well as during a child's naming ceremony, the mother of the baby and her guests are served with fufu corn and "mpaa" (a mixture of okro and leaf). Sugwaa' is a staple food in Bali Nyonga mostly given to guests as a take home parcel.

Chamba people use the fingers of the right hand to eat their meals. This enables them to effectively extract all the pleasure from the food. Women and girls do most of the cooking for the family. Some men do cook, although they usually make light and simple dishes like "nkang" (corn beer). It is used during important ceremonies like Lela, burial rites etc. All "nkoms" (notables) are expected to provide two litres of corn beer to the palace during the Lela festival. It is worth noting that, drinking of corn beer (alcohol) by children is strictly prohibited.

In Bali Nyonga most families sit either on the floor or at table and eat with relatives. Men, women and children are segregated from each other during meals with each group occupying a separate section in the house or dining areas. Therefore, maintaining a balanced diet is quite difficult either because of existing taboos and or cultural and religious beliefs and practices of the people. While areas have also witness some degrees of transformation in the recent past, a mixture of cooking as Arts and Crafts are witness in Bali due to it transformation from a local to a modern community.

The Arts and Craft of Dancing

Among all the dances of the Bali people "lela" happens to be the leading dance of performed during the cultural manifestations at the end of the year when applicable. Other common traditional dance witness during most occasions and calibrations are the "Makongi dance, the Chibi dance, etc. Some of these dance require three major drums viz: a large drum (Makah) which is placed in the middle of the dancing arena, a smaller drum but of equal height with the large drum which is leaned on the large drum as the case may be and the third drum (bonkah) which is placed between the armpit or lab of the drummer(s)

and they produce melodious sounds for the entertainment of the dancers.

All the above are carved out of wood and covered with animal skin. Added to the above, the dancers use "Nchicheng" a local shaker which is made up of a calabash and thatched palm bamboos with cracked kernels inside including a well weaved broom stick which each dancer uses. There are my traditional dance in Bali to explain the cultural diversity of the people that writing on each of them requires a different forum beyond this. Modification are made in some of the that they have taken the tune of the nationwide so called "Makossa"

The Arts and Craft of Farming, Fishing and Hunting

Peasant agriculture is the main stay of the Bali people. The farmers work on their farm lands and rear animals. The Bali people are peace loving people and their crops vary following seasons and location. They farm crops like cocoyams – colocacia, Ibo cocoyams, and yams of different species, maize, beans, sweet potatoes, soya beans, rice, plantains, bananas and cassava amongst others. They also plant a variety of fruits like pears, mango, plum, guava, palm nuts, etc. They also have cash crops like coffee and palms for oil. Coffee is not much planted again since the price in the market has fallen; instead some people have started planting cocoa.

Their farming is mostly according to laws and customs laid down by their ancestors long ago. The time of preparing the plot, planting and harvesting is by customs and tradition. The farming process is shared between men and women. The men clear the land which is owned only by men. The women then do the hoeing and planting, weeding and harvesting. They use the *"gonfah"* system where the grass is gathered in follows and are covered with soil for planting. The " chary" system is also practice although not encouraged , dry grass are heaped and some soil are used to cover them and only some sections are allowed uncovered where fire will be used to burn the dry grass in the soil. The clearing of the farm takes place between December and January. The hoeing is done in February because the rains are expected to pour down by the 15th of March. Planting is normally done from late March to early April. With the present climate change the farmers are somehow confused.

This *"kuhvi"* farming is done mostly June when the land most have been allowed to fallow for some years and another piece of land will be exploited. When it is harvesting time which starts from late September, the first harvest in the past were taken to the palace but the situation has change. Today it is the gesture of the harvester to do so. Secondly, the women use to give some to the Quarter Heads or second class chiefs etc. In forest areas in Bali, the land is

still cleared by the men. Some come together and form a 'njangi' group, which work on the different plots on appointed dates. When the group is coming to one plot, he or she prepare for and drink for them. They work in groups because they use crude tools and so the work becomes very cumbersome and tedious for an individual.

When the grass is dry it is burned by the women who clean the plot well and plant with or without making beds. They plant upland with plantain and deeper down the forest they plant groundnuts, cocoyams and colocacia, cassava etc.

Talking of hunting, the men do it. They have spears, den guns and dogs in the upland they go for rat moles and grass cuter. Down the forest they hunt monkeys, chimpanzees and baboons which come to eat their corn and groundnuts. When they go hunting they will dress like women and pretend to farm while the other men with the dogs will hide. When the monkey comes it will see only a woman and so will come down from the tree into the farm. The men will then come out of their hiding with the dogs and capture it. For the rate mole, the entrance into the hole and the exit will be identified. One of the dogs will be with those digging and others waiting for the moles at the exit. When the mole is stubborn and will not come out either way, the hunters will look for dry grass and burn it with pepper and push it through the entrance. The smoke and pepper will choke the mole so that it will be forced to rush out for air and it will be caught.

When a big animal is caught, like a lion or tiger it will be taken to the palace and those responsible for its killing will be decorated with a red feather or the hair of a porcupine depending on what is caught and how the palace sees it. After an ordinary hunting spree with no event the booty will be shared as follows, the elders, the men, women and children then come later.

Fishing is a source of protein in Bali. They have steams which harbour fishes such as mud fish. Since some of the streams are flowing fast, what the men do is that they get baskets made out of bamboos in the shape of a cylinder "lack". One end of the basket is blocked. The man now looks for an area of the stream that has low currents and the basket is stocked in between stones, mud. The other side of the basket without grass is left open as an entrance for the fish. Very early in the morning at about 5:30 AM the man then comes without making noise and just quickly carries the basket out of the water and then gets the fish that has been trapped inside. This fish is a delicacy in the North West. Some of the fishing is done using hooks.

Women also fish for tadpoles using the same method. Another method is with a hook. The fisherman attaches an earthworm to a hook that is tied on a

black twine. This twine is in turn tied on the long bamboo or stick. He then lowers the earthworm into water while holding the stick in his hand. He needs to be very steady so that the fish will not suspect the presence of the fish hunter. When he feels that the stick is being pulled from his hand he quickly raises it out of the water and grabs the fish.

Most of the fish is used for home consumption and the excess sold for money to make up for other demands of the household. Hunters in Bali also use the trap setting method for animals and birds. The traps are of different types. Those for animals are big and strong. When he is hunting for a big animal he ties the trap to a tree or stone. He uses urine as bait for the grass cutter or big rate moles and others. The trap is then set where he expects the animal to pass. To hide the trap he places a live leaf on it and sprinkles ground lightly on it, but exposing whatever bait he has used. When the animal is trying to go for the bait or smells the urine, it will move to it and once it steps on the leaf the hook of the trap is released.

For birds a black magic rope is issued and the bait is mostly corn. A snoop is made where the corn is placed and when the bird tries to get the corn the snoop tightens in and hangs it on the neck, the stick to which the thread is tied will pull up the bird at the speed of light since this stick is bent in a concave shape. The hunter inspects his traps every morning and evening to avoid losing a catch.

The Arts Craft of Marriage: Individual marriage in Bali respects the customs of the Bali people. It is usually preceded by the payment of bride price. Before a girl is given out for marriage, the family of the suitor pays a bride price to the family of the bride-to-be. On the first visit, the suitor and his family take along palm wine. The family of the bride-to-be assembles in the family house and the eldest member of the suitor's family presents the reason for their visit. After listening to him, the family of the bride-to-be receives the palm wine, pays a token for it and informs them to return later (at least one month) for a response to their request. Within this period, the family of the bride-to-be carries out a thorough investigation to ensure that there is no biological relation between the two families or other impediments that could hinder the union. On the second visit, the suitor and his family take along palm wine, salt, palm oil, etc. This is done after receiving tips from an informant about a possible positive response. However, before this visit, the suitor's family sends words to the would-be in-laws of their visit. If no answer is given, the suitor's family keeps on waiting. The bride price brought by the suitor and his family is first kept in the house of the eldest in-law-to-be. The family members of the bride-to-be and that of the suitor gather in the family hall. The family head inquires from

the guest in the presence of the bride-to-be the reason(s) for their visit. Once a positive response is given to their request, the suitor's family is then requested to hand to the bride-to-be family what they have brought. A jug of palm wine is presented and the suitor is requested to open it (usually a token in cash is given to the family head before it is opened). Then, the bride-to-be is asked to serve the palm wine in the family cup. She drinks first, gives to the family head and then to the suitor. This is an indication that they have accepted the request of the suitor. The other family members can then partake in drinking the palm wine. At this moment other jugs of palm wine can be brought into the family hall. The bride-price paid varies from one family to the other and depends on how much was paid to the mother of the bride and in the education of the bride. At the end of the occasion, the family of the suitor is requested to present themselves to the biological parents of the bride (considered as 'baby-sitters').

Once all requirements have been fulfilled, the bride it accompanied on the eve of the wedding day (usually in the night) to the suitor by a group of women usually aunties. They take along cooked food and other gifts to the suitor's family. As soon as they arrive, the bride is handed to the suitor's family. She is bathed and rubbed with camwood by elderly women of the suitor's family. The suitor's family fees their in-laws very well and give some token in compensation for the gifts brought to them.

On the wedding day, the bride is presented to the public by a traditional dance from the family. During the presentation the suitor's family presents more gifts to the in-laws. In the evening, the in-laws return and submit a verbal report to the family head. This is partially on the average what was obtainable in the past. Presently the story has change. While there is "cam we stay" as some common method of marriage among youth today, the ultimate truth is that a lot have been modified in the Art and Craft of marriages in different families in Bali Nyonga

The Art and Craft of Healing

Traditional healing in Bali is the process of using herbs from the environment to treat various types of illnesses carried out by local traditional practitioners (usually called "traditional doctors").

The traditional healers can broadly be placed into two categories according to the type of treatment they handle and also the mode of treatment being administered to the patients.

The simple traditional headers: This group of healers uses simple herbs around the environment to treat simple or mild illnesses. Here, only herbs are

involved and the categories of patients are those whose illnesses have 'natural origin'. By natural origin, we mean any illness that is not associated to witchcraft and in some cases illnesses associated to witchcraft but not very complicated (usually the young traditional healers answered present).

The secondary traditional headers: This group also deals with simple cases 'natural illnesses' and also with very complicated cases highly associated to witchcraft. In this situation herbs and other traditional devices including the metaphysical powers of the healers are involved. The base line in traditional healing is that, the healer must have the ability to detect the type of grasses and other objects used in treating the patients and in some cases, they can detect the type of illness using visible symptoms and explanation or complains given by the patient in the form of consultation.

Unlike in the hospitals where consultation is done by the medical doctors and the patient referred to the lab for medical diagnosis, with traditional healing, the laboratory consists of objects of cowries, broom, etc called "ngambe". which the healer uses to find out what is wrong with the patient (consultation fees are also paid which is separate from the treatment cost).

Concerning the type of illness, we can see that generally there exist the simple and the complex cases. For the simple illness, not related to witchcraft, the treatment is usually done just around the place where the consultation takes place. On the other hand, if the case is a complicated one, then the patient might need to be taken to some particular places where higher spiritual forces can intervene, e.g. the patient may be taken to a river, in some particular area in the bush etc. Hence the environment of treatment will depend on the type of illness, on the severity and also on the cause of the illness.

The cost of treatment depends also on the cause of the illness. Simple treatment is administered immediately and the patient is discharged but for complicated cases, the patient will have to stay at the premises of the healer for some time. Just like with modern medicine when patients could be transferred to a specialist in another hospital, traditional healers also refer patients to specialists with higher metaphysical powers.

Conclusion

As a way of life Arts and Craft is not limited to the physical objects that satisfied utility but the innovative components of human actions, thought and feeling which he or she unique from the other. If this holds for an individual, then it does for a group. It is on this ground that we identify as presented above the

Art and Craft of the people of Bali Nyonga. Like the say's law "all supply creates its own demand" the uniqueness of the Bali people are the Art and Craft that can be mined in them either in agreement with other communities or otherwise.

11

TRADITIONAL MEDICINE IN BALI NYONGA

Charles Fokunang

INTRODUCTION

Traditional medicine in Bali Nyonga Fondom has stood the test of time from the health care mobilization of our ancestor and currently characterized by a wide variety of diverging practices which lack a solid legal and medical framework that could prevent deviations and abuse along with their potentially dangerous consequences for patients. However, traditional health practices in Bali still remains the primary health care provider for the populations. Traditional practitioners or trade-practitioners of the health systems are largely available and provide easily accessible, culturally acceptable and low cost care to the local patient population in Bali and its environs. It is a standard practice that modern medicine is practiced under defined international regulations and ethical regulatory guidelines as inspired by the Nuremburg Code, and Helsinki Declaration (Fokunang et al., 2014). The African Traditional Medicine (ATM) research seems to fall short of such scrutiny as it is still a grey area of research in Bali Nyonga and the national territory of Cameroon at large (Fokunang et al., 2011a).

The history of traditional medicine practice in Bali dates back to the 1800s when the ancestors of the Bali Nyonga fondom started their journey to the today *promise land* like the Israelites did while leaving Egypt. This was a very long journey that started from Nigeria, cutting through Northern Cameroon, the Tikar plain, descending the hills and valleys of the Noun plateau until they arrived their promise land Bali Nyonga, under the leadership of their powerful dynamic Princess Nahnyonga. The current settlement was strategic as it is the most fertile land in the Mezam Division and a land which rich cultural and flora biodiversity, making Bali the Garden of Eden in the North West region

of Cameroon, and also one of the oldest subdivisions in Cameroon. To succeed in the long pilgrimage the Bali tribe needed survival strategies to adopt to the changing environment and landscape encountered on the way. With the climatic oscillation that came with vulnerability to all kinds of diseases, the Bali tribe produced great traditional medicine practitioners. These great doctors discovered herbs to send away evil spirits, assist in child birth, enhance fertility, cure sexually transmitted diseases and cure different forms of fever. There has been claims that some of our ancestors and even some current Bali tradi-practitioners in Bali Nyonga have herbs that can prevent the Balis to be visible by enemies in times of war, send thunderstorm to destroy evil citizens, suspend heavy rains during high profile funerals and important ceremonies like the Lela festival. This is the reason why Bali Nyonga is known as a fondom that has preserved its traditions.

I can vividly recall during my early childhood days my late father Ba Foku-nang Ngwe Meshack who was one of the super tradi-practitioners of his time in Bali Nyonga. He used to place a spear in front of the house during very heavy rains and will tell us he was sending a thunder. He claimed to suspend rain from falling, neutralize any form of poison, and had a community consultation that saw many patients flooding the compound as early as 6 AM in the mornings. This made him a highly influential member of the Bali Nyonga community during his life time. His practice has been passed on to his children who were in charge of going to the forest to harvest the herbs. He taught them how to prepare and administer those herbs to outpatients and also when the patient population was too large for him to handle alone. The trade has been handed to the next generation who continue to practice in traditional medicine at a professional research platform.

The TM practice in Bali took a more aggressive form in the late 80s when Cameroon witnessed a drastic slump in her economy. This created a long period or hardship in the country, more felt at the level of the community. The population with low liquidity, unemployment, devaluation of currency resorted to alternative treatment of their diseases. This brought about the rebirth of traditional medicine practice in Bali Nyonga. Since then traditional medicine practice became very popular almost competing with faith healing (upspring of pentecostal churches). These churches have brought another dimension in spiritual healing causing more indigenes of Bali to abandon both the modern medicine and traditional healing for Faith healing.

The big problem created by the Faith healing in the community is the fact that the patient healing cannot be quantified. Apart from the testimony that the patients gives after postulating to be healed it is difficult to ascertain the

effectiveness of Faith Healing, especially as these same patient still visit tradi-practitioners and/or take modern treatment as a last resort when their health situation continue to deteriorate. It is certain that there are more people dying than before in Bali despite the Faith healing and the traditional medicine practice. This is a great problem that needs to be addressed about the health situation in the Bali Nyonga community.

Despite the historical records of traditional medicine practice in the Bali Nyonga fondom, the actors are still working in isolation and there are very few of the tradi-practitioners who can be counted in Bali as professional actors, living solely on the practice of the profession. Most of the actors are amateurs or operate at artisanal level, with a few herbs passed on to them by their ancestors that are seldom used in times of need for treatment of identified diseases. Other tradi-practitioners in the village acts as suppliers of herbs to the city tradi-practitioners who visit the village to replenish their stock of herbs. The herbs are prepared by drying, or powder preparations and sold at give away prices to city tradi-practices. At the city the products are repackaged, bottled, allocated for large commercial sale in their modern clinics. Some of the city tradi-practioners are sales agents or what we call charlatans. Unfortunately, those charlatan in the cities are very popular, monopolize the media and communication sector and therefore render our tradi-practitioners in the villages dependent on them for milk and honey. In short the charlatans are the paymaster to the village tradi-practitioners. Some city tradi-practitioners own traditional modern clinics with consultation service, herbs formulated into galenic forms (tablets, capsules etc) and some are street vendors or sell in transport buses. Some tradi-practitioners in Bali and in the city carry dual functions. They are both herbalist and man of God. They start their sale by preaching the word of God. When the customers are filled with God's message then they launch into their real business, which is to sell their concoctions.

Traditional health practices are the primary health care providers for the inhabitants of Bali and surrounding villages, and in some of them, or in the remote and rural areas, they even represent the sole provider. In such enclaved places, practitioners of traditional health systems are largely available and provide easily accessible, culturally acceptable, low cost and largely holistic care to the needy community.

The TM care has not yet been proven to be efficient for treating diseases such as HIV and AIDS, malaria and other parasitic conditions, and chronic and lifestyle diseases in the Bali Fondom or at the national level. On the other hand, traditional health practices have the potential to harm when they are applied in

an inadequate or uncontrolled manner, or when they claim to cure these incurable diseases (Boli, et al., 2006). This is for example the case of herbal medicine that the potency is generally underestimated and insufficiently known, or of practices that are exclusively turned to without consideration of their limitations. Traditional herbal medicines are naturally occurring; plant-derived substances with minimal or no industrial processing that have been used to treat illness within local or regional healing practices (Miller et al., 2004; Jiofack et al., 2009).

As attention and public funding for international traditional herbal medicine research collaborations grows, the Bali fondom is still to have an organization, harmonization and regulation of the TM sector, in order to address in more detailed analysis of ethical issues in this sector. Limited literature has addressed selected issues such as informed consent and independent review related to traditional herbal medicine research. Considering the extremely large proportion of practitioners active around the national territory of Cameroon and the even larger population calling on their knowledge, traditional health care raises fundamental questions and requires specific reflection to deal with its ethical implications. Traditional health practices in Bali pose the challenge of finding a way to integrate cultural diversity and respect for individual cultures with medical obligations and universally accepted fundamentally binding ethical principles such as consent, equality or dignity, as a result of *free for all and survival of the fittest* attitude in TM practice.

There is the need for example to identify the stage at which beliefs and traditions could endanger or harm the patient and create conditions of vulnerability. In Bali Fondom, there are cases where an ailment is regarded as a supernatural occurrence by tradi-practitioners that must be solely diagnosed and treated by supernatural means, the patient is directly deprived of his/her chance to receive appropriate health care: he/she cannot reject the culturally framed answer to his/her pain without violating taboos or threatening his/her social or religious identity and status. Here, the principles of autonomy and individual responsibility of a patient, which is part of the Universal Declaration on Human Rights are not fully respected.

RE-BIRTH OF HERBAL MEDICINE IN BALI NYONGA FONDOM

Herbal medicine is making a dramatic comeback in Bali since the onset of economic down turn in Cameroon in the late 1980s. There is more indication of increasing awareness about herbal medicine among the general population in the region. The majority of the people living in rural part of Bali are dependent

on medicinal plants for curing common diseases. Several factors are responsible for the comeback of herbal medicine. Drug resistance seems to be the prime cause, cost-effectiveness is another factor where herbal drugs score over synthetic drugs. There is the general saying that 'herbal drugs are safe and can be consumed over a period of time without side-effects without any scientific proof. Herbal-synthetic drug interactions are major challenge for practitioners in Bali. Studies on hepatotoxicity and nephrotoxicity associated with certain medicinal herbs also pose a major health problem that needs serious investigation in the Bali community on those using TM as main source of therapy. It can also be said that there is rise as well as fall in popularity of herbal medicines in recent times. In our view, there is an obvious difference between rigorously researched product and cheaply/unethically promoted product.

HERBAL CLINICAL PRACTICE IN BALI

The herbal system of medicine in Bali in the past and in the present state is alternatively known as medical herbalism or botanical medicine. Recently TM has been used as a popular alternative for plant-based formulations. In older days, knowledge of herbalism was based on experience from our ancestors exploring vegetation around their environment for food source. Hardly any work was done on documentation of plant-based remedies until the mid-70s when Dr Dan Lantum (now Professor Emeritus), and a team of Bali Nyonga traditional doctors assisting him on medicinal plant research namely Mallam Adam Usumanu Fokunang (Alias Papa Bamenda) of Njenka Kundu, Ba Fomantum of Naka, Ba *Ta Kappa*, Ba Takah, and Ni Ambrose and Dr Baaboh Fokunang of Paila quarters, to name but a few visited the Fon of Bali, His Royal Highness Late Galega II. This maiden visit was for Dr Lantum and his delegation to receive the blessing of the fon to embark on the census of tradi-practitioners in Bali Nyonga and its environs, collect herbs to develop a monograph of the potential herbal plants of pharmaceutical importance in use in Bali subdivision and finally set up a research collaboration partnership with the counted herbalist in operation in the fondom. This project ended up with the publication of a book by Dr Lantum, who eventually became a Professor. From going down memory lane by interviewing some of the collaborators of Dr Lantum I was chanced to meet there was all indications that they were exploited in that project for the following reasons. First they were never properly acknowledged nor remunerated for their time and intense work they did on the book project. The initiative by Professor Lantum was the last attempt to create a data base on

traditional medicine practice in Bali and any census of the tradi-practitioners operating in the fondom.

The TM practice currently in Bali is done in isolation and there has been no association of traditional medicine practitioner in the fondom. This sector is not organized and regulated to fall in line with the strategic primary health care plan in Cameroon. Practical classes has been the major weapon of acquiring knowledge on herbalism in Bali from ancestors. With a passage of time, the need for documentation was felt but there has not been any advocacy or united front to develop written text on TM in Bali and the region as a whole. Herbal clinical practice is largely based on experience of an herbalist or natural medicine physician. Herbalists tend to prepare their own medicines, therefore, in the majority of cases, the patient does not know about the nature of the drug.

MAJOR CHALLENGES OF TRADITIONAL HERBAL MEDICINE PRACTICES

In the last millennium, TM has been in major use in Bali Nyonga, However, as TM practices are adopted by new populations there are challenges. Traditional medicine practices have been adopted in our Bali cultures and regions without the parallel advancement of international standards and methods for assessment.

National policy and regulation

There is no validated national policy document for traditional medicine regulation and practice. Regulating TM products, practices and practitioners is difficult due to variations in definitions and categorizations of traditional medicine therapies. In the Bali Nyonga fondom, a single herbal product could be defined as a food, a dietary supplement or a medicinal plant. This disparity in regulations at the rural level has implications for international access and distribution of products (Fokunang et al, 2011b).

Safety, efficacies and quality

Scientific-based evidence from tests done to evaluate the safety and effectiveness of TM products and practices is limited. While evidence shows that acupuncture, some herbal medicines and some physiotherapy are effective for specific conditions; further studies on products and practices is still needed in Bali Fondom (Fokunang et al., 2015). Requirements and methods for research and evaluation are complex. For instance, it can be difficult to assess the quality of finished herbal products. The safety, effectiveness and quality of finished herbal medicine products depend on the quality of their source materials (which can

include several natural constituents), and how elements are handled through the production processes or pipelines.

Knowledge and sustainability

Herbal materials for products are collected from wild plant populations or cultivated medicinal plants around Bali or introduced from outside the subdivision. The expanding herbal product market could drive over-harvesting of plants and threaten biodiversity. Poorly managed collection and cultivation practices could lead to the extinction of endangered plant species and the destruction of natural fauna resources. Efforts to preserve both plant populations and knowledge on how to use them for medicinal purposes is needed to sustain traditional medicine in Bali Nyonga fondom

Patient safety and use

Many people believe in Bali that because medicines are herbal (natural) or traditional, they are safe (or carry no risk for harm). However, traditional medicines and practices can cause harmful, adverse reactions if the product or therapy is of poor quality, or it is taken inappropriately or in conjunction with other medicines. Increased patient awareness about safe usage is important, as well as more training, collaboration and communication among providers of traditional and other medicines.

Protection of Herbal Patrimony and Biodiversity

There is the need for the creation of protected areas in Bali and environs to conserve the biodiversity of the rich cocktail of medicinal plants. So far, the medicinal plants are overexploited by *city tradi-practitioners* who visit the village to collect primary raw materials for their herbal clinics in the city. Since their request is high in demand, the village tradi-practitioners are under pressure to supply their city clients with the highly sought after herbal products thereby destroying the medicinal plant biodiversity in the community at a meteoric rate.

World Health Organization promotion on TM

WHO and its Member States cooperate to promote the use of traditional medicine for health care. The collaboration aims at supporting and integrating traditional medicine into the national health systems, in combination with national policy and regulation for products, practices and providers, to ensure safety and quality; ensure the use of safe, effective and quality products and practices, based on available evidence; to acknowledge traditional medicine as

part of primary health care, to increase access to care and preserve knowledge and resources; and to ensure patient safety by upgrading the skills and knowledge of traditional medicine providers (WHO, 2010). The World Health Organization (WHO) recently announced a new project that could bring greater respect and more widespread recognition to TM systems across the world (WHO 2010). With the goal of easing and encouraging the use of traditional medicine in clinical, epidemiological, and statistical settings, WHO's International Classification of Traditional Medicine (ICTM) is aimed at providing a harmonized traditional medicine evidence base with stated terminologies and classifications for diagnoses and interventions (WHO 2010).

TRADITIONAL MEDICINE PRACTICE AND REGULATORY POLICY SITUATION

Law 81/12 of 27 November 1981 approved the Fifth Five-Year Social, Economic, and Political Development Plan (1981-1986) of Cameroon, Section 16-1.3.1.5 states the following:

During the Fifth Plan, measures will be taken to lay down a joint strategy and method to effectively integrate traditional medicine into the national health plan by implementing a program on traditional medicine in conjunction with some of our neighbouring countries (Fokunang et al., 2011b). Under this plan, Cameroon created the Traditional Medicine Service within the Unit of Community Medicine in the Yaoundé Central Hospital and set up the Office of Traditional Medicine in the Ministry of Public Health. A number of research projects on traditional medicine and training programmes for traditional medicine practitioners have also taken place. Local officials are allowed to authorize the practice of traditional medicine in their administrative and/or health subdivisions, and some traditional medicine practitioners are involved in Cameroon's primary health care programme (Jiofack et al., 2011).

Another problem encompasses counterfeit, poor quality, and contaminated herbal products. These represent substantial and serious patient safety threats at the international level.

However, even though natural plants are of benefit for the populations and widely used in other circumstances (e.g. for nutritional purposes), the Ethics Review Committees shall consider that there is no reason to validate an herbal treatment without applying of international standards and methods for evaluation. Therefore, traditional medicine research needs development, and statements like "this product is from herbal and therefore carry no risk for harm" shall be

avoided. In drug development process, traditional medicines, ameliorated herbal products or finished herbal products that contain parts of plants or other plant materials as active ingredients need to undergo rigorous chemical trials before they are released to the population (Nyika, 2006).

Intellectual property rights vis-à-vis TM

The right to ownership of a TM product in Bali and Cameroon generally is still at its infancy. This is partly due to few defined funded projects that have undergone any new chemical entities discovery and development process from herbal plants, as is the case in most developed nations. This process requires a lot of funding and in most cases the government has not got developed new drug product from plant high on its priority budget agenda. Consequently, as part of the international and national regulation, research protocols on herbal products shall be developed and submitted for review to the competent ethics review committee. The protocol shall be approved prior to its implementation. Herbal product shall obtain authorization for market prior to its use by potential patients (WHO, 2010).

Ethical Review proposal on studies implicating TM or alternative therapies

African Ethics Review Committees (AERCs) shall review research protocols involving herbal products within the framework of the standard operating procedures applicable to the requirements for the review of scientific clinical research. Any application for research involving herbal products must include:

a. A duly signed explanatory cover letter
b. The study protocol and any supporting documents.
c. CVs of all investigators on the study.

Ethics Review Committees shall review and approve a research protocol for each study involving herbal products prior to its implementation. Therefore, ERCs shall apply national and international ethical guidelines to independently review both the scientific and ethical aspects of research protocols involving herbal products and human beings, and make a determination and the best possible objective recommendations, based on the merits and validity of the research proposals (Kaptue et al., 2013).

ERCs shall therefore make an assessment of the following:

a. The study personnel comprises of at least one clinician and one toxicologist.
b. The plans for preserving indigenous knowledge of the community or

any traditional health practitioners consulted.

c. The agreement(s) on intellectual property rights.
d. The evidence that the herbal product has been subjected to rigorous toxicological testing.
e. The safety profile of the herbal product/therapy not just full reliance on anecdotal observations.
f. The plans for benefit sharing in the event of the production of commercial product, process or patent in the form of technology transfer, medical benefits or a share in the intellectual property rights.
g. The Data Safety and Monitoring plan.
h. The process for obtaining and documenting informed consent.
i. Provision for confidentiality.

WHAT IS THE ETHICAL FRAMEWORK ON TM?

Generally, international research on TM should be subject to the same ethical requirements as all research related to human subjects. An ethical framework previously outlined by Emmanuel et al 2004 and revised for international research offers a useful starting point for thinking about the ethics of international traditional herbal medicine research. This framework includes eight ethical requirements for clinical research (Emmanuel et al., 2004). These ethical requirements are universal and comprehensive but has to be adapted to the particular social context in which the research is implemented. Among the requirements, fair subject selection, independent review, informed consent, and respect for enrolled subjects are of important consideration. However, social value, scientific validity, and favourable risk–benefit ratio raise specific challenges in international herbal medicine research (Fokunang et al., 2013).

Social value

All research should hold the potential to achieve social value. Different entities may view the social value of traditional medicine research differently. Public-health officials are often eager to define the safety and effectiveness of herbal medicines for conditions such as malaria. On the other hand, harm can arise with the poor use of herbs (Nyika, 2006). While some claim that some medicinal herbs have "stood the test of time", they nonetheless pose serious challenges to investigators and regulators from developed countries, in which standards of proof are closely linked to proven efficacy in clinical trials. While public-health entities may be concerned with defining the risks and benefits

of herbal medicines already in use, entrepreneurs and corporations hope herbal medicines may yield immediate returns from herbal medicine sales, or yield clues to promising chemical compounds for future pharmaceutical development. They test individual herbs, or their components, analysed in state-of-the-art high-throughput screening systems, hoping to isolate therapeutic phytochemicals or biologically active functional components. Nongovernmental organizations may be primarily interested in preserving indigenous medical knowledge. One such organization, the Association for the Promotion of Traditional Medicine (PROMETRA), based in Dakar, Senegal and Cameroon, is dedicated to preserving and restoring African traditional medicine and indigenous science (Adelaja, 2006).

Scientific validity

Part of ensuring the social value of research includes devising and implementing sound science. Although international collaborative research on herbal medicine is no exception, discussing scientific validity as an ethical requirement raises some specific challenges, including the meaning of scientific validity, establishing inclusion and exclusion criteria, using appropriate outcome measures, and determining appropriate study designs and sample size for clinical trial studies (Munyaradzi, 2011).

Balancing internal and external validity

Building a solid knowledge in herbal medicine will require balancing two aspects of scientific validity: internal and external validity. Internal validity means the research must reliably test hypothesized relationships between an intervention and an outcome under controlled conditions. Internally valid research will typically try to answer a focused research question that is important within the vocabulary and methods of the scientific community at the time the research is conducted. External validity refers to the applicability of the research results to a target population outside the experimental conditions of the research study. External validity must always be weighed against the need for rigorous internally valid research (Sheng et al., 2012).

Perspective and consideration in the issues of inclusion and exclusion criteria

To ensure that research results are externally valid, the inclusion and exclusion criteria for research participation should fit with existing diagnostic categories in the target population specified by the research question (Schnyer et al., 2005).

169

Valid outcome measures

International herbal medicine research must use outcome measures that accurately incorporate the effects conferred by herbal medicines. Therefore to accurately measure a traditional complementary medicine (TCM) herb's effects on quality of life, some investigators have constructed and validated analogous measures that effectively detect the effects of TCM interventions that make sense within that healing tradition. Ideally, when new measures are introduced, they should overlap with existing outcome measures, so that the research can adequately contribute to the existing body of knowledge (Linde and Jonas, 1999).

Determination of research design

While it is generally agreed that all human subjects research must maintain valid study designs, questions arise about the characteristics of a valid research design. Two extreme positions are often defended. At one extreme, some research-ers trained in biomedical methods of clinical investigation argue that the *only* valid source of knowledge regarding clinical efficacy must come from one type of research design: the randomized double blind, placebo-controlled trial. They argue that any deviations from this gold standard of scientific validity amount to worthless science (Linde and Jonas, 1999; Gagnier et al., 2006).

At the other end, critics of biomedical research conducted on traditional medicines argue that attempts to evaluate traditional therapies with biomedi-cal methodologies may fail to generate true knowledge, since that knowledge itself depends on a scientific vocabulary that only makes sense from within the concepts of phytomedicine. They worry that "standard notions of experimental design criteria represent an imperialistic 'western' mode of thinking".

In recent years, growing attention has been paid to a group of additional important ethical issues surrounding publication bias, financial conflicts of interest, and clinical trial registries. In the arena of traditional herbal medicine, these same issues apply, and when cross-cultural differences exist in the defini-tions of valid science, as is the case in traditional herbal medicine research, these questions compound.

Favourable risk–benefit ratio

In advanced herbal medicine research, several practical challenges arise in making accurate risk–benefit determinations. Typically, in the US pharmaceutical development, a defined process of drug testing occurs – a compound is isolated, tested in tissue cultures and animals, and then investigated in phase 1, 2 and 3 clinical trials. However, herbal medicines are already in widespread use, are often

used in combination, and are drawn from plant sources with their own variability in species, growing conditions and biologically active constituents. They often come into use by a process of trial and error, or over centuries. Accordingly, in clinical herbal medicine research there is rarely a strong preclinical basis for dosing, and there are significant unanswered questions about product purity, quality, chemical stability and active constituents at the time herbal medicine trials are proposed (Miller et al., 2004).

Attempts in implementing large-scale research trials in such circumstances raises questions about whether the risks and benefits of research participation can be accurately determined. Those reviewing protocols should factor in the uncertainty associated with product variability in determining whether a herbal medicine trial has a favourable risk–benefit ratio. However, protocol reviewers (i.e. institutional review boards) should not presume that because they are personally unfamiliar with a herbal preparation that there is no credible or valuable background evidence regarding safety and potential efficacy. While researchers should provide such information in research protocols, reviewers must remain aware of the role their own lack of familiarity may play in their ultimate judgements of risks and benefits of the research (Fabrega, 2002).

Cultural factors also may influence judgements of the risks and benefits in herbal medicine research. For instance, a cultural familiarity with many traditional Chinese herbal medicines in China may promote a familiarity bias, accepting a widespread cultural assumption of safety, based on the historical use of herbal medicines. There may also be a cultural difference in emphasis placed on standardized adverse events reporting in China (Chong, 2006). These cultural differences make achieving agreed-upon standards of favourable risk–benefit ratio more difficult. In order for international collaborative herbal medicine research to achieve its objectives, it will be important to establish standards of evidence for demonstration of safety before conducting large-scale clinical trials evaluating the efficacy of herbal medicines.

COLLABORATIVE PARTNERSHIP IN TRADITIONAL MEDICINE RESEARCH

Collaborative partnership, the first requirement for international research ethics, provides both the rationale and the context for achieving appropriate application of the other ethical requirements. Partners in these collaborations must share vocabulary for all the requirements, especially for social value, scientific validity, and favourable risk–benefit ratio. To achieve collaborative partnership, parties can engage in structured methods of democratic deliberation to devise

shared language and concepts for research. These methods have been used to bring different parties together in a safe and collegial process of decision-making (Kaptue et al., 2014).

CONCLUSION

With increasing number of patients consulting herbal medicine practitioners, herbal clinical practice will be of more relevance in future in Bali Nyonga Fondom. There is therefore a pressing need to put in place an umbrella for the organization of TM and develop an inventory and monographs of medicinal plants of pharmaceutical importance in Bali. There is also the need to integrate research in traditional herbal products with herbal practitioners collaborators in Bali. Herbal product claims, supported by scientific evidence should be used in clinical practice with confidence. This will enhance the physician-patient compliance and provide the much needed support to herbal clinical practice. The creation of awareness and concretization of research in TM and the emphasis placed on the importance of ethically guided research in traditional medicine will be welcome not only in Bali Fondom but in the entire North west region as a whole. The TM practice is still isolated in Bali with no union to regulate and harmonize traditional medicine practice in the fondom. There is also the need for the regulation of the alternative healing approach termed Faith or spiritual healing headed by leaders called chief evangelist, popes, prophets and prophetesses, bishops and what have you. This sector have taken more patients out of the hospitals and TM as an alternative solution to their health problems. The question is are they delivering the goods to these loyal believers who are in need of health attention?

The Way Forward For TM in Bali.

There is a need to create an organization of Bali Nyonga Tradi-practitioners Association develop a working platform to promote training in basic hygiene and sanitation, good herbal preparation practice, collaboration with researchers and clinicians for research partnership for phytochemical screening and preclinical testing of potential lead compounds from plants of potential pharmaceutical importance, advocacy group to promote the practice of ethics and deontology in the traditional medicine trade in Bali and the entire regions of Cameroon and Develop a monographs of locally used herbal medicines in Bali.

Wider education on the use of TM in Bali Nyonga by community health groups and other non-governmental organization in the community is plausible.

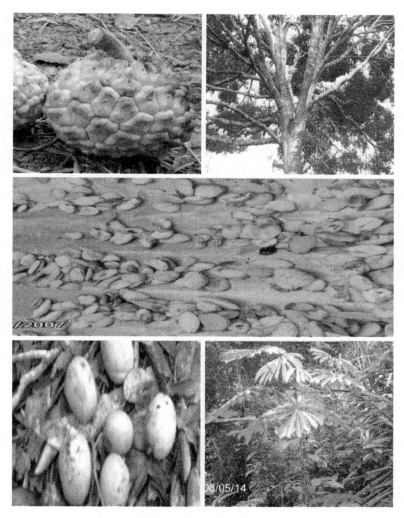

Fig 7 Top left, Myrianthus arboreus (Cecropiaceae) fruits, use to treat sterility; bark of tress are boiled, fruits eaten when ripe; Top right, Irvingia gabonensis (Irvingiaceae); Bottom left, Bush mango Plant to treat diabetes, Centre: dried fruits of bush mango; Bottom right: Myrianthus arboreus plant.

Fig 7.1 Top left: Cissus quadrangularis (Vitaceae) Plant to treat hypertension; Top right: Lantana camara (Verbenaceae) For treatment of hypertension; Bottom right : Vernonia guineensis (Asteraceae). Ginseng for treatment of malaria; Bottom left: Spathodea campanulata (Bignoniaceae) For malaria treatment

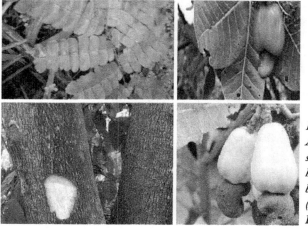

Fig 7.2 Top left and bottom; Albizia adianthifolia (Caesalpiniaceae), for treatment of hypertension; Top right and bottom; Anacardium occidentale (Anacardiaceae) for treatment of Diabetes.

References

Adelaja A. (2006). Nigeria boosts research into traditional medicine. Science and Development Network; Available from: http://www.scidev.net/en/news/nigeria-boosts-research-into-traditional-medicine.html [accessed on 3 April 2015].

Boli Z, Shuren L, Junping Z, Hongwu W. (2000). Manifestation of symptoms in patients with SARS and analysis of the curative effect of treatment with integrated Traditional Chinese Medicine and Western medicine. In: SARS: clinical trials on treatment using a combination of Traditional Chinese Medicine and Western medicine. Geneva: WHO; 2003. pp. 53-61.

Chong W. (2006). China launches traditional medicine safety research. Science and Development Network; Available from: http://www.scidev.net/en/news/china-launches-traditional-medicine-safety-researc.html [accessed on 25 May 2012].

Emanuel EJ, Wendler D, Killen J, Grady C. (2004). What makes clinical research in developing countries ethical? The benchmarks of ethical research. J Infect Dis; 189: 930-937

Fabrega H. (2002). Medical validity in eastern and western traditions. Perspect Biol Med; 45: 395-415.

Fokunang CN, Tembe-Fokunang EA , Sando S, Djuidje MN, Atogho-Tieudeu B, Kechia,FA, Ateudjieu J, Ndikum V, Langsi R, Fomnboh DJ, Fokam J, Gwum L, Abena OMT, Asongani T, Titanji VKP & Kaptue L (2015). The Public Health perspective on Migratory Health Displaced Populations in Global Disease Epidemics Intech Publishers

Fokunang CN, Tembe-Fokunang EA, Awah P, Djuidje NM, Chi P, Ateudjieu J , Kaptue L,, Abena OMT .(2012): The role of ethics in public health clinical research.: In Alfonso J Rodriguez-Morsels (eds): Current Topics in Public Health. Intech Publishers: ISNB.978-953-1121-14 Intech May 2013 Chapter 27. Pp. 662-683.

Fokunang CN, B. Ngameni, N.M. Guedje, R.T. Jiofack, J. Ngoupayo, O.Y. Tabi, E.A. Tembe-Fokunang, B. Salwa, P. Tomkins, E.A. Asongalem, B.T. Ngadjui.(2011). Development of antimalaria, antibacterial, anticancer and antitumour drugs from new chemical entities from plant sources Journal of Applied Science and Technology (JAST), Vol. 16, Nos. 1 & 2, pp. 15 - 23.

Fokunang CN, Ndikum V , Tabi OY , Jiofack, R.B, Ngameni B, Guedje N.M , Tembe-Fokunang, E.A , Tomkins P, Barkwan S, Kechia, F , Asongalem E, Ngoupayou J, Torimiro, NJ, Gonsu KH1, Sielinou V, Ngadjui BT, Angwafor III F, Nkongmeneck A , Abena OM, Ngogang J, Asonganyi T, , Colizzi V., Lohoue J , Kamsu-Kom (2011). Traditional medicine: past, present and future research and development prospects and integration in the national health system of Cameroon. . African Journal of Traditional Complementary and Alternative Medicine, 8(3):284-295 284.

Gagnier JJ, Boon H, Rochon P, Moher D, Barnes J, 2006. Bombardier for the CONSORT Group. Reporting randomized controlled trials of herbal interventions: an elaborated CONSORT statement. Ann Intern Med; 144: 364-7.

Jiofack RN, Fokunang CN, Guedje NC. 2011. Les plantes exotiques d'Afrique Tropicale humide: Guide Scientifique d'illustration des plantes introduites au Cameroun et en Afrique Tropicale. Editions Universitaires Europeenes. ISBN: 978-6-1315-5680-7. AMAZON publishers. Distribution GmbH, Leipig, Berlin, USA, United Kingdom, 299pp.

Jiofack T, Jiofack T, Ayissi I, Fokunang C, Guedje N and Kemeuze V. 2009. Ethnobotany and phytomedicine of the upper Nyong valley forest in Cameroo. African Journal of Pharmacy and Pharmacology 3 (4): 144-150

Kaptue L, Djuidje MN, Fokunang CN. 2014. Traditional Medicine Research: Ethical Implications in the Conduct of African Traditional Medicine Research. Research Ethics in Africa: A Resource for Research Ethics committees Research Ethics in Africa: A Resource for Research Ethics Committees Sun Media publishers Stellenbosch.

Munyaradzi M., 2011. Ethical quandaries in spiritual healing and herbal medicine: a critical analysis of the morality of traditional medicine advertising in southern African urban societies. Pan Afr Med J; 10:6.

Nyika A. 2006. Ethical and regulatory issues surrounding African traditional medicine in the context of HIV/AIDS. Developing World Bioeth. Available from: http://www.blackwell-synergy.com/toc/dewb/0/0. [Accessed on 5 April 2012].

Schaffner KF.2002. Assessments of efficacy in biomedicine: the turn toward methodological pluralism. In: Callahan D, ed. The role of complementary and alternative medicine: accommodating pluralism. Washington, DC: Georgetown University Press;. p. 7.

Schnyer RN, Conboy LA, Jacobson E, McKnight P, Goddard T, Moscatelli F, et al., 2005. Development of a Chinese medicine assessment measure: an interdisciplinary approach using the Delphi method. J Altern Complement Med; 11: 1005-13

WHO. 2010. The WHO Family of International Classifications. World Health Organization website. Available at: www.who.int/classifications/en/. Accessed Jan 2012.

Part III
BALI NYONGA IN PERSPECTIVE

12

THE BALI SOCIAL MAN

George Nyamndi

When Zintgraff enters the grassfields, he samples a variety of social habits. He's German, and his natural inclination is towards cultures that place a premium on self-worth. Germans have a fine eye, a knack as it were, for value, and will stop at nothing to cash in on it. His first meeting with Galega I somewhere in the early days of 1889 alerts him to a unique opportunity; not least because the order of etiquette, what the French call la préséance, has been ruffled, subverted. Curiosity, the driving force of all adventure, has abandoned the adventurer and located a new command site in the object of the adventure. Come to think of it, until his arrival in the Bamenda grassfields, the German white man – not just any kind of white man – knows that the initiative to make things happen belongs to him solely. But now he is confronted with a different reality, one that rocks his worldview to the core.

The Galega/Zintgraff metaphor provides a fitting canvass on which to profile the Bali man, socially speaking. Bali history may be – and is – replete with narratives of war, victory and domination; but also of loss and heartbreak. If one limited one's reading of these narratives to the surface plane of war in the service of territorial acquisition, one would miss the nobler intentions that sustain them. That metaphor invites the man interested in Bali history to evolve away from the beaten track and to look more deeply into the core of the Bali consciousness. If he does that, he will see in the encounter between those two figures an illustration of the strategic importance of sociability in any human enterprise. The first thing this metaphor reveals is that the Fon of Bali does not wait for the white man to come to him. He is not reactive; he is proactive. He takes the fight to his opponent. In this case, he dispatches his emissaries to Bamessong to see and size up this curiosity.

Nowhere else in the records of cultural encounter are we treated to such felicitous, utterly gainful conduct by an African leader. Zintgraff and the Fon of Bali epitomize two contending worldviews, each with its own specific ego. Under such circumstances, anything short of rivalry born of mutual respect will be unwelcome. The failure by succeeding generations of African leaders to maintain a relationship of rivalry with western culture rather than puerile subservience has been the root cause of the continent's current predicament. There is therefore a sense in which the Bali Monarch's visionary strategy can be said to position him in the vanguard of Africa's true leaders. This much Zintgraff underwrites: he does not scoff at the invitation; he respects it. Accounts of his meeting with the Fon tell of a moment of deep wonder and deference, in which there is no shortage of mutual esteem.

Only a man with his ears to the ground can pick up echoes of distant feet and see windows of opportunity. Like the people he incarnates, this Fon is proactive, free-minded and positively inquisitive. He has his eyes permanently on opportunities to bring good things to his people. No doubt he and his German guest see eye to eye almost instantaneously. In the days of feudal authority, when the Germanic race was structured into a comitatus or social unit grouped around a chieftain, the bond between lord and subjects was marked indelibly by the former's ability to show generosity to the latter. The German visitor easily detects this quality in his host, mainly through the groundswell that his arrival provokes, and in the texture and strength of the attendant social bonds.

This very spirit inhabits the Bali consciousness and informs its motives. Social groups in the fondom and out of it have only one direction in which they look and one goal for which they labour: the welfare of their village. The Bali man identifies with and shows off his village in ways that whip up envy in other peoples. It is common to hear others grumble: "Dis Bali people, dea own don too much!" Irritating as that show-off may be, one has to be in the skin of the Bali man to know how it feels to be part of that enchanting village.

When Galega's emissaries return with positive impressions of Zintgraff, the Fon seizes on the opportunity and invites the white man to his palace. If this is not shrewdness at its best, then we do not know what else it is. Here's a leader who knows what it takes to keep his people's interests permanently on the front burner. Zintgraff becomes for him a proud trophy of diplomatic foresight. The Bali consciousness thrives on the rewards of an innate gift in keeping human beings together; at times at tremendous odds; very often in inextricable circumstances. Galega invites Zintgraff. To invite is to extend a hand of friendship. To invite is to be positively disposed. To invite is to dispel animosity. To

invite, especially, is to broaden and intensify the web of human intercourse. In this, the Bali woman, cherished and sought after by the other, continues to be the elected magnet in the Bali man's burning hunger for friendliness. There is something in Bali women that everybody, the outsider even a lot more so than the Bali man himself, finds irresistible. They are in such high demand! One is yet to see a village that has "lost" more of its daughters to the outside. But in losing a daughter the village gains a son, so that in the final analysis the exercise becomes nothing but a celebration of friendship, with the women as the conduit. I have eavesdropped here and there, gone places, and come away each time elated that my sisters and daughters are so very highly cherished. Here is the occasion to thank those 'moyos' whose justified infatuation with our women and girls brings so much radiance to the aesthetics of the Bali community. Above all, here too is the opportunity to felicitate those gender emissaries, those girls and women on love errands, who by their attributes bring attention and distinction to their people.

The Bali man is gregarious. He readily opens his house to the outsider. One is always struck at the place the stranger takes in Bali events. In fact, it is the feeling among the Bali that an occasion is not successful until a few strangers have dropped in and partaken especially of the feasting. Occasions, good or bad, always provide the Bali man with the chance to foreground his generosity. That is why he comes across very easily as sociable. And he is. Spend a weekend in Bali and you will be treated to a rich ballet of food and drink zipping and zapping on bikes and heads, and in opulent boots. These stuffs are the insignia of Bali sociability and the mark of a culture that lays great store by generosity. And since these occasions are interminable, a villager who organizes himself/herself well can live comfortably on them at no cost to his/her pocket. In Bali invitations are redundant. It is enough to appear at an occasion, invited or not, to be immediately intrinsic to it. Dance and dirges, jubilation and wailing, ecstasy and gloom, these moments interweave into a broad and fascinating canvass of action. Just being there in that village is in itself celebration!

But who are the engines of that celebration, indeed the essence of the Bali character? The women. Incomparable organizers, gifted from birth with exquisite taste. Distinguished, like the foo-foo corn they stir, and which no other women anywhere else have ever been able to replicate. The Bali woman is not beautiful. She does not need to be. She is charming. And that's a winning consciousness. Beauty is unsolicited; charm is willed – and outshines beauty. The Bali woman plies even the most unseemly trade still with distinction, with a difference! That distinction is the flagship of Bali distinctiveness; that difference the measure

of Bali uniqueness.

But for all that it is outgoing, the Bali character is nonetheless circumspect: it looks before it leaps! That is what history and experience have taught it to do. Its sociability is therefore no indication of naivety. Rather, it is an expression of informed alertness. You don't lose anything by always looking over your shoulder, especially in an environment where your past and immediate present teach you to sleep with one eye open. For this reason, some find the Bali man to be proud. And he is. Who isn't? But the pride others fault him on needs to be appraised. Anyone familiar with the Bali royal progeny also understands why this high sense of one's self – what others call pride – is so suitable in characterizing the Bali bearing. There is, in Buea, a descendant of Galega II. He is a warder, it would appear. Now, when this young man walks past you, he seems to take your gaze with him. You turn, forgetting where you were headed, and watch him stride away. This young man encapsulates the Bali spirit. He is majestic, graceful and witty. These traits are not class-determined. They are native to all Bali people.

Like all social beings, the Bali man has his flip side. What this side is made of can only be conjectured or lived out in context. Whatever the case, he is one creature with whom bonding has mainly dividends.

13

BALI NYONGA MUSICIANS AT HOME AND ABROAD

Kehbuma Langmia

INTRODUCTION

Music is the lightning rod that imposes its feelings (good/bad) on human beings in any given situation. Even on a very sad day when the Heavens seem to have broken loose on anyone on earth, music seems to serve as a panacea i.e a spacio-temporary state of relaxation on the human psyche regardless of culture, custom or tradition. The Bali Nyonga people of the North West Region of Cameroon are not immune to that effect. They have used music as an instrument of war to subdue their enemies through the loud throbbing sounds of their war drums in the various battle fields during their migratory journey from Northern Nigeria to their present site in the North West region of Cameroon. The Lela musical dance festival (Fardon, 2006) remains the highest, most attended event in Bali Nyonga since 1891. It is celebrated intermittently once a year at the Fon's Palace Plaza in Bali Nyonga in the month of December. The other songs and dances are performed during birth/ death celebrations, special events (National/Youth Day celebrations), crop planting season celebrations, etc. It is not uncommon to find the various Chamba Leko groups represented during these important ceremonies in the village by their songs and dances that brought them glory, safety and courage to their present site today. This is true of the Kufat, Ti, Kundem, Lolo, Tikali, Buti, Baku, Mudum, Ngeam, Sangam, Won, Set, Ngot, Sang, Fuleng and Munyam (Ndangam, 2014). The songs and dances by these groups represented in the village would not be the focus of this paper. Rather, it will be an analysis of individual musical achievements by the kith and kin from the entire Bali Nyonga fondom.

This paper dwells primarily on the various musicians at home and abroad today that have used traditional lyrics with western instruments thereby creating

a unique genre of their own. They have transliterated traditional lyrics using instruments that synchronize local messages with modern western realities of life today at home and abroad. Their music has achieved a somewhat different significance in the lives of Bali citizens from the purely traditional renditions of Lela or those of the various aforementioned groups/ neighbourhoods from Chamba Leko represented today in Bali. Some of their songs still maintain the original lyrics and languages that were used under their leaders like Gawolbe, Nyongpasi, and Nahyonga during the migration epoch. And since death has wreaked havoc on those elders that mastered the lyrics of some of those songs, the younger generations have developed a unique genre of blending those traditional songs with western ones due to the influence of westernization.

Apart from the Lela song and dance festival that has survived the throes of colonial incursions and the Basel/Catholic Missionary activities in Cameroon, most of the neighbourhood/groups music and dance in Bali have witnessed low socio-psychological significance. The younger population now prefers to listen, sing and dance to these new folks' songs that are played with western-made instruments and disseminated through CDs and iTunes. By focusing on these newer versions of Bali music as opposed to the traditional ones played using traditionally made instruments of wood and gongs, I am not by any means demeaning their roles. On the contrary, I simply want to match according to the times by examining the role of folk music from Bali Nyonga with an eye to the future.

TRADITIONAL MODERN MUSIC IN BALI NYONGA

I grew up watching young 'westernized' Bali citizens who had been to the city play and dance to record LPM turn-table music in Bali in the late 1960s. At death celebrations, some youths clad in western attires would seclude themselves in a room listening and dancing to this kind of music. We were not allowed to get inside. We could only watch from the windows to see young boys and girls clad in western clothing swinging to and fro to the sweet modern melodies. This was similar to the ballroom dances at the Community Hall in Bali town central. We watched these modern western influenced youths swing and dance to the tune of 'Makossa', 'Salsa', 'Merengie' and 'Highlife' under flickering deemed blue and red lights. It was also there that we heard the songs of Bali Modern Jazz Musicians like Doctor Moses. These were our first introduction to non-Bali Nyonga traditionally made music with African instruments. Sometimes in the early and late 1970s, these kinds of music started gaining steam not only in the

village but all across Cameroon. The neighbouring West African countries like Nigeria, Congo, Gabon, Benin and Cote d'Ivoire also had their music played on Cameroon National Radio stations and bars, hotels and many other drinking spots in the cities. It was under these kinds of influences that "Makossa" rose in Cameroon. This genre of music from the Littoral Region of Cameroon became so popular that many young musicians in the Eastern, Western and Northern parts of Cameroon were inspired to produce similar kinds of lyrics. The influence of Makossa in the entire country, notably with artists like Manu Dibango, Ekambi Bryant, Toko Asanti, Toto Guillaume, Nkotti Francoise, Misse Ngoh Francoise, Francis Bebey etc could be seen in the style and format of the younger generations. Even though the influence of Makossa was so strong and visible during the 1970s in Cameroon, some artists opted to utilize a blend that would not completely neutralize the tradition songs. These artists were called folk singers. They used western made musical instruments like guitar, piano, and traditionally made drums and rattles to produce their music. Granted, they edited and mixed their songs using computers but they maintained their traditional rhythms. The content of their songs is what sets them apart from the regular pop culture stars that I mentioned earlier. These artists are resident at home in Cameroon and in the Diaspora. Those at home include, but not limited to the late Dr. Moses of the Bali Modern Jazz, Bobgala Didier, Stavo Le Meilleur, Titatang Ernest and those in the Diaspora are Austin Doh, John Njinjoh, Pa Bali and Walah Eric.

METHODOLOGY

Africology is a methodology that privileges the African ontology, epistemology and axiology when examining issues rooted in the African context. According to Asante (2015) "Africology is sustained by commitment to studying the life narratives, cultures, values, and possibilities of the African people transnationally and trans-continentally" (p. 15). The lives of the Artists at home and abroad would be examined from multiple perspectives that holistically capture their musical philosophy. This is done through archival data analysis of selected songs for those at home and abroad. Data interpretations are informed by the African worldview. Even though these artists have used western instruments to produced their music, they have equally, and rightly so, included traditional ones to spice the tunes. Secondly, the messages in their selected songs for this analysis are transmitted in Mungaka, the language of the Bali Nyonga people of the Bamenda grassland of Cameroon. The contents of their music are examined through an Africological lens with a backdrop of Bali Nyonga culture, values,

ethics and worldview in mind. Since I grew up listening, watching and dancing to these genres, the interpretation of the themes that are enunciated from the music will be conveniently carried out based on my views of Bali Nyonga history, culture, customs and traditions. The artists resident in Cameroon will have the content of their music examined through the Africological lens whereby themes emanating from their music will be analysed and interpreted. Adopting such a stance is in line with most Afrocentric scholars that examining materials from Africa by Africans must have Afrocentric theoretical and methodological grounding. The Bali Nyonga people of Cameroon are primarily Africanist with their religious, political and economic world view firmly entrenched in their historical experience. Before the arrival of the missionaries from the Basel Mission in Switzerland in the early 1900s, they were polygamists. Before the influence of industrial revolution gripped Africans, they were agriculturalists using traditionally made tools for food crops. Their value systems of upholding the man as the head of the household still holds true today. Their matrimonial rites, kinship, widowhood (Nwana & Nwana, 2011; Ndangam, 2014), their divination rites (Mutia & Mecaly, 2011), Mungaka language (Fielding, 2011) are all present in their musical renditions. Doctor Moses and Bobgala Didier resident in Cameroon and Austin Doh, John Njinjoh, Pa Bali and Walah Eric will have their selected music analysed spiced with some telephone interviews.

BALI NYONGA MUSICIANS AT HOME

Moses Ndasi Fokong (Alias Dr. Moses)

According to Ngong Nico writing in Cameroon Life, August 1990[1], Dr. Moses formed the Bali Modern Jazz group in 1956 and they only had "two guitars, a pair of drums, a horn and bottles". As can be seen from the instruments, they constituted western and traditional forms. The traditional equivalent of guitar in Bali Nyonga is called "lung". Lung is not as acoustic as guitars and not connected to electricity. Doctor Moses and his group faded from the music stage around 1988 and in 1996 he died. The popular songs for this group include "Na Mammun O", " Bon Bon" and " Sekele". The content of "Na Mammun Oh" has as main theme "identity crisis". In that song he is lamenting the fact that as a child his mother has never understood him. This does not necessarily mean his biological mother. The Bali Nyonga woman is not imprisoned by biological

[1] The entire article can be seen on www.tedjohnson.us/ted/drmoses/camlife.php

definition of birthright to be seen as the mother of a child. As the society accepted polygamy as a form of marriage, the child of one biological mother is the child of the rest of the co-wives of the man. When she prepares food, she invites all the children of the compound and that still holds true today. In the song he says whenever he does what he considers the right thing, he is punished by the mother, when he does something wrong, he again is punished by the mother. So when is his identity going to be understood? In other words, when is he going to be on the right side for the mother? This is symptomatic of children raised in Bali Nyonga. You remain a child to simply obey and not challenge your elders. This is very evident in Dr. Moses song. His other song "Bon Bon" is especially symbolic. The theme of the song is adult responsibility. This song is the yearning cry of baby beckoning the elder brother for candy, what we now call today sweet from the city. It was understood in our days when an elder travels to Bamenda, the nearby city, he will bring goodies to the kids in the compound. This song echoes that loving cry. It should be recalled that these delicacies are shared to every child that the elder comes across. His third song "Sekele" represents an instrument that was used in Bali to filter corn powder to prepare corn fufu. The grain is sifted from the chaff before it can be cooked. This song is a tribute to that instrument made locally in Cameroon. There is no one household in Bali that does not have "Sekele". That is probably why this music resonates more to Bali Nyonga people because Fufu corn is the staple food in the village.

Bobgala Didier

He is a Bali Nyonga artist residing in Douala, Cameroon. He started his music career in school when they were called upon to organize inter-school cultural contest. During these events, Bobgala Didier would compose a song and play to the delight of his peers and school officials. He played in English, French and Mungaka. But of late he has vastly adopted Mungaka as the language of preference in his numerous albums some of which have become hits at home in Cameroon and the United States. Speaking about the impact of his music to the Bali Nyonga folks he said in his interview with me that

> A lot of people have called me at home and abroad about what my music has done to them. Especially in the United States, some parents have told me that my music has made their children to "now" speak Mungaka. So according to me my music acts like a therapy" (Bobgala Didier, October 10, 2015).

This is what the young generation of Bali Musician resident in Cameroon has now come to witness. As a result of rapid media globalization, music can travel faster through the multifarious social media channels like YouTube, Whatsapp, Viber, and Facebook. In fact, the songs of Bobgala Didier have all been loaded on YouTube. He is one the few Bali Nyonga musicians that presently have a YouTube presence. This is to show that distance is no longer a hindrance to music dissemination in the age of media globalization. He uses a blend of traditional and modern western instrument (Guitar, Piano, Lung and drums) in songs like the recent " Big Mammy" (Sweet mother), "Keban" (Hatred), "Nahsala"(lover) and "Bah Lah Las"(We will live forever). In "Nahsala", the central theme is love. He longs for the charming presence of Nahsala to the extent that he is sad because he slept with an open door because she promised to spend the night with him but never showed up. This again reechoes the Africological insinuation of traditional African love that is vastly different from that of the West. In the West, lovers are seen moving hand in glove and sharing the master bedroom. In monogamous and polygamous Bali Nyonga, lovers are not often seen together in public, let alone kissing. At night, they sneak in without notice. The fact that she did not show up as promised, he attributes it to ill fortune as he laments in the lyrics: "you sleep peacefully in the bedroom at night but prejudice and hatred are buried outside your house". This is to say that someone must have supernaturally blocked Nahsala from coming to see him. He continues in the music to ask a painful rhetorical question "Who knows tomorrow?" This is actually part of the culture and traditions of Bali Nyonga people. They believe that no one can foretell the future including the Fortune Tellers. They can only approximate. Bobgala Didier's other song "Ba Lah Las" echoes a similar theme to Nahsala.

BALI NYONGA MUSICIANS ABROAD

Austin Doh

He has been credited by many young Bali Nyonga rising stars as the producer of the most successfully "Makongi" marketed CD. He started playing music at the age of 13 while growing up in Bali Nyonga. But the parents did not encourage his music talent. In fact, he told me his dad "broke his guitar" in an attempt to allow him focus more on school work. When he eventually travelled out to the United States and enrolled at Howard University, his friend, John Njinjoh inspired him. He then decided to re-kindle his long forgotten talent in 1992. He said he was particularly interested in Makongi and so when he returned

home to bury his brother a group of original Makongi singers and dancers came to grace his late brother's funeral and he decided to invite them to a studio in Bamenda to record the music using western instruments. Those who accepted his invitation were, Chico Chikaya, Late Peter Ayim (of the Bali Modern Jazz) and Bobgala Didier who actually played one of the guitars. He told me in the interview that both traditional and modern instruments were used during that recording in Bamenda. The traditional instruments were "*Lung*" and "*gong*"while the modern ones were Guitars and drums. With regards to impact, his music is being played at most small, medium and large scale events at home and abroad and since most people grew up listening to Makongi, it is not uncommon to find the dancers lip singing each of the musical collections. One of the most popular is "Bo mfa Njika". The theme of this music is "Giving Thanks". The Bali Nyonga people are known to be humble, grateful indigenes of the North West Region of Cameroon. That word "Njika" means thanks and they cannot utter two to three sentences during any given discourse without uttering the word "Njika". The other hit in the collection is "A lah be", meaning "Hope for the future". The rhetorical question that is raised repeatedly in that collection is when will hope be materialized? But hope cannot be realized because there are lots of traitors in our midst, those who cause the destruction of the village through spying and gossip. So, this song is a warning to those who sell state secrets to neighbouring tribes. As Austin Doh said in the interview, this kind of message resonates with the villagers thereby making the music popular.

John Njinjoh

John Njinjoh grew up listening to music from Congo and other African countries from Radio Buea. As he imitated the artists by singing like them, his mother rewarded him with 10frs FCFA (2 US cents). That was the spark that lightened him up and couple with the fact that when he went to secondary school in GSS Nyasoso, his mother bought him a guitar in form one and in form five his Dad bought him the complete musical set. With all these, He knew that he was destined to become a musician one day. In fact, in his interview with me, he said, he requested one student's guitar to play but that student would not give him instead putting as condition that he has to give him his 'meat'[2]. When he narrated this story to his mother that pushed her to buy him a guitar. When he migrated to the United States, he was already in love with Bali Nyonga music

[2] He was in the boarding school where accommodation is provided by the school.

188

because his parents used to take him to Bali meeting in Buea and he would admire the players with 'lung' and 'njang'. But for the main reason that he was not raised in Bali Nyonga village itself, only visiting it during holidays, he did not have a firm grip of the language, the more reason he was drawn more to Makossa and his music in the Diaspora reflect that pattern. In his most popular album titled "Lela", he has seven songs, four of them are titled in "Mungaka" and three are in English. Those in Mungaka are: "Bi Sam Mbongket" (Do not waver or be firm), "Kongni" (love), "Mbi'h Nu Nfomvi" (Future mishaps) and "Lela". In Bi Sam Mbonket, he sings in three languages, Mungaka, Pidgin and English asking for brothers and sisters to love one another and stay in unity. The music is a call for responsible love and care. The instruments, beatings and rhythm are all western and mostly in the style of Makossa. The same is true of the other three songs titled in Mungaka.

Fidelis Koyila (Alias Pa Bali)

Pa Bali is resident in Maryland, USA. He is one of the Bali Nyonga music stars in the Diaspora. His music is played at home in Cameroon, Europe and The United States. To demonstrate the impact of traditional Bali Nyonga tradition, custom, rituals and culture that he embodies, he decided to transplant the traditional rhythms of celebratory, mourning, dirges, ululations and joyous songs into modern instruments. This experiment he told me in an interview that it has paid off:

> I grew up playing the traditional xylophones in Bali Nyonga. But when I came across the piano, I quickly realized that they were arranged in similar pattern like the traditional xylophone in Bali. It was then easy for me to compose the Bali Nyonga songs on them."(Fidelis Koyila, interview, October 10, 2015)

Apart from the Piano, he also uses the guitar as part of the modern instruments and edit on modern musical software. But more important for him is the traditional drums as well. With respect to language, he said the Mungaka language was not only a language of communication, it was symbolic and so transporting Mungaka through musical rhythm to the United States to him has been a huge success.

> I feel the sense of pride for my culture, my language, Mungaka and Bali Nyonga, my village. The impact of my music has been felt at home in

Cameroon and the United States. People have called me. People have reached out to me, even those I do not know have reached out to me to show how my music has entertained them and taught them valuable lessons. The fact that I did not make a Douala Makossa copy cat music has made my music special" (Fidelis Koyila, interview, October 10, 2015).

Some of the songs of Pa Bali are "No Take me for Court", "Ya Nah", "Kon-ikon" and "Samba". "No Take me for court" mirrors the lives of Bali Nyonga people from the legal perspectives. At first Bali Nyonga people settled family disputes in the Fon's Palace before the arrival of colonialism. The litigants will present their cases before the traditional jury made up of elders carefully selected by the traditional council. Today, western court systems have overtaken the traditional courts. Family and non-family cases are now adjudicated in law courts. Since repercussions for culprits are often severe compared to what used to take place at the traditional courts, people are now careful with creating conflict with one another. That is why Pa Bali is recommending dialogue in the place of law courts. The yearning theme of peace and love echoes all through his entire album and again this goes to reinforce the African sentiment of living in harmony with one another. "Konikon and "Samba" are direct replicas of traditional rhythms in Bali. He fills the entire songs with traditional proverbs mostly inspired from his father who was a, trader, singer and traditional orator. In one of the songs he repeats the common proverbs and sayings in the village like "I sit with them but they deny me drinks", "I was walking with them only for me to see them returning with their harvest", " There is oil in the bottle but I am licking the body of the bottle because I cannot drink from the mouth". All these sayings and proverbs are rooted from the sociocultural lives of Bali Nyonga people before imperialism. An idiomatic interpretation of "Ngwed Ntsong" is that carnal love cannot be satisfied, can never end.

Walah Eric

Walah is young rising Bali Nyonga musical star living in the United States. He and his family migrated recently to the States and he has attributed that to the work of Yahweh. The theme of religion is the overriding message in all his music. Unlike the others he uses mainly western instruments in his music to play traditional/western songs. One of the songs where this is exemplified is titled "*Meu Yi Gala*". This is a direct translation from the refrain of "Lela" classical song. It is so intriguing to find him playing the exact rhythm that is played using hand-made traditional flutes and drums in western-made guitars, saxophone

and drums. He said in an interview with me that God inspired him to use Bali Nyonga rhythm and beatings to play the kind of music he is playing. It should be emphasized that Bali Nyonga people were religious, not within Christianity and Islam but with the African ancestors, gods and God. When the missionaries settled in Cameroon, they used Bali Nyonga as one of their bases and established the Basel mission college and presbytery there. That launched the dual religious beliefs of the citizens and that has affected progenies like Walah Eric who now worship God in specific churches. It should be mentioned that those who were sceptical of the mission of the German, Swiss and British missionaries opted to remain entrenched in African religion, but were torn between obeying the tenets of the Christian Bible and traditional Priests. And so in Walah Eric music he glorifies the Christian God but does not disparage African tradition. In fact, he sees them as complementary. This is what he said:

> God does not discriminate. God likes goodness and provides wisdom and talent to the artist like him. So the artist has to be recognized. Tradition goes closer to God and God also goes closer to tradition. Things are changing" (Walah Eric, interview, October 7, 2015)

Of course things are changing as can be seen even the themes of his music. The main album that pushed him to the global diaspora stage was "Fine fine driver". In this album, he glorifies the almighty God through the messages he transmit to the listeners and dancers. The theme of this entire album is about everyone renewing their relationship with God almighty. "I am contributing to make people examine their relationship with God" (Walah Eric, Interview, October 7, 2015). It should be noted that with the arrival of the Presbyterian, the Catholic and the Baptist religion in Bali Nyonga, it was not uncommon to find people going to church regularly on Sundays and the union between Christian religion and African tradition comes during the annual visit of the Christian church administrators and their congregation to the Fon's Palace in Bali Nyonga. Today, it is very common for the Fon of Bali Nyonga and his entourage to worship with Christians in the village either at home or abroad. So that theme that Eric echoes in his music is manifested through actions. Another music that resonates with most people in Walah Eric album is the song titled "Money". In this song he reiterates the theme of frustration that everyone has with this charmer and destroyer called "Money". He says, what is mysterious about money is that once you get a certain amount that you have requested, your problem doubles making you to ask for more and so with or without money,

man is always broke.

CONCLUSION

These papers set out to document and analyse the Bali Nyonga Musicians at home and abroad. It has been ascertained that though all of them set the theme of their music in Bali Nyonga village, they all have different approaches with respect to instruments, rhythm, beatings and style. There are those that have embraced the traditional format with occasional twists to fit in modern demands, but there are others that have embraced the western instruments, format and style. But what is more important to note is that they have contributed to promote Bali Nyonga folk music beyond the frontiers of the village. One major point of concern echoed by John Njinjoh in his interview with me is worthy of consideration:

> Bali People have not supported our music. During conventions here in the United States, they don't allow us to sing. They will say to us they like our music but to buy it they will not" (John Njinjoh, Interview, October 19, 2015)

If we can encourage them by not just by words but by deeds, it will go a long way to promote Bali Nyonga music for the world at large and for the next generation.

References

Asante, M. K. (2015). African pyramids of knowledge: Kemet, Afrocentricity and Africology. Broklyn, NY: Universal Right Publications

Fardon, R. (2006). Lela in Bali: History through ceremony in Cameroon. Oxford, UK: Berghan books

Fielding, P. (2011). Language use in a multicultural online community. In J. Fokwang & K. Langmia (Eds.) Society and change in Bali Nyonga. Bamenda, Cameroon. Langaa RPCIG, 109-130

Mecaly, B. & Mutia, B. (2011).Marriage and widowhood rites in Bali Nyonga. In J. Fokwang & K. Langmia (Eds.) Society and change in Bali Nyonga. Bamenda, Cameroon. Langaa RPCIG, 37-58

Ndangam, G. (2014). Cultural encounters: Society, culture and language in Bali Nyonga from the 19th century. United States of America: Instant Publishers.

Nwana, E. M. & Nwana, V. L. (2011). Marriage and widowhood rites in Bali Nyonga.

In J. Fokwang & K. Langmia (Eds.) Society and change in Bali Nyonga. Bamenda, Cameroon. Langaa RPCIG, 109-130

THE LELA FESTIVAL

Gwannua Ndangam

Ere the gleam of dawn,
Faint, like the night war alert
Drum signals from the palace plaza,
The sacrifice offered by a few for many.
There will be sunny faces
At the river shrine before sundown.
The ancestors will accept our sacrifice
And nod their approval and blessing.

Our fluttering standards in the dry-season sun,
Emblematic of a prosperous year
Will telegraph the news of
The white ram that slept on the good side
Breathing its last.

The boat astir on the river –
Is loaded with calabashes of corn beer
The Priestly *Tutuwan* bowing before the throne,
Whispers his secret readings.
And the Fon, gorgeous and radiant,
Beams a royal smile.

We will return from the shrine triumphant,
The smell of gun-powder and dry-season dust,
The sounds of the trumpet and the *gakwan*,
And the vibrating mirth at each door,
Have drowned the brawling street
And the storm from the bedroom last night.

There is praise on the street:
Praise for our fluttering banners,
Praise of our gallant ancestors,
And praise of their living embodiment:
The Fon, seated on the white horse.
There is praise at the plaza
From the dazzling faces of women:
And thou Mount Buea
Most stately of all,
Where is he, bearing a mortal frame,
(Or where on earth, that measure of splendour)
That dares to compare
Thy grandeur and majesty,
Or these impair?

Sundown, and clean- hearted,
We will squad side by side
At the Royal plaza,
Drink the sacred corn beer
In awe-filled silence.
We have embarked:
Rowing backwards into the future,
Renewing ancient allegiance.
Solemn, each drum beat, the Royal trumpets
Calling on the ancestors in the silence of the sacred night,
Signals each renewal of allegiance
As we steer the boat down the river.

We will row backwards into the future,
Glimpsing familiar landmarks past
Where drums of war were heard,
And sounds of guns roared:
The brawl of Wolbe and Sama,
Gawolbe and war-wearied Bafufundong,
Evacuation at Dunkirk,
War blasted Ypres,
Ladysmith, Manila Bay, New Orleans,
Constantinople, and Syracuse,

Satan and the rebel angels.
The roaring guns and mortars were heard and
Men mourned their slain.

We will row backwards down the river
And each pledge at the plaza
Will be a promise written on the sands of time.
Each drum beat, Ay, each trumpet sound
Calling the ancestors in the sacred night.

We will dance and wallow at the plaza.
We came out of the past,
Abide the present,
And foretaste the future.

We will dance and wallow,
Women with dazzling faces
Dancing with steps of leisure.
Men with flowing gowns
Dancing with steps of pleasure.

The young and the old agree:
This is a worthy festival,
Bequeathed by ancestors.
We cherish the past.
We dream the future.
We live our lives today.

Dance over,
We will come home under the rising moon,
Clutching love colanuts and "*bitter- cola*" in one hand,
In our palms, they rub side by side
Like pleasure and guilt under the quilt.

Between pleasure and guilt,
One lingers and the other evaporates
Like smoke in the wind.
Between the empty hand reaching out,

And everything else it fears to grip or grab,
Space, that is empty,
Expectation, that is momentary.
Between evening and morning,
The sacred night.
In the darkness, the light of stars
(Light-years in coming).
So rowing backwards into the future,
We take in the past, our past.
Between today's dance and tomorrow's,
Our repose - a transient respite.
We surrender the silent night to the silver moon,
Full, bright and low on the horizon,
We have calabashes of dreams on the boat
Now anchored in the harbour,
Where the winds are still,
No breakers roar, no surges rave.
The turbulence is over.

Beyond the harbour,
Summoned by ethereal drum signals,
Like the night one at the Plaza shrine
The Lela dance animates the dawn,
The bright morning rays
Wraps the dawn in fresh and refreshing beauty.
The festival has begun.
The rest is rest.
Actum est.!
Clark's Summit PA, the USA, Thurs. 16 Feb. 2012

Contributors, Listed in Alphabetical Order

Prof Jerry K. Domatob Rev. Babila Fochang Prof Charles Fokunang

Prof Mathew B. Gwanfogbe Prof Kehbuma Langmia Ba Nkom Gwannua Ndangam

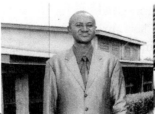

Prof George Nyamndi Mr. Robert B. Sikod Ms Juliett N. Tasama

Prof Vincent P. K. Titanji Dr Beatrice Lima Titanji

APPENDIX I

In history, (precolonial and colonial eras, through political independence) administration, politics and popular usage, the terms "Bali" and "Bali-Nyonga" have always been used variously and interchangeably to refer to one and the same geographical/geo-political entity, which, in its evolution, became an administrative unit, first a District and then the Bali Sub-Division that it is today.

That is how my great grandfather, Galega 1, who received the first white man into the then Grassfields was "Mfobani" (King of Bali), his son and successor was (M)Fonyonga II, (King of Nyonga) and my late father, V.S. Galega II, (active in the politics that culminated in our country's Independence and Re-unification), went in official delegation to London (Lancaster House,1957) as Fon of Bali, a historical fact recognized by academia.

When, in recent history, other Balis (in present day NWR) evolved and came into the limelight, it became often necessary to add "Nyonga" to better distinguish and identify.

However, the indisputable fact remains that "Bali", "Bali-Nyonga" and "Mezam III - Bali" (which adds political flavor) all refer to the same geographical/political entity, Bali Sub-Division, in Mezam Division of the present day North-West Region in the Republic of Cameroon.

His Majesty Dr. Ganyonga III

SENATOR

APPENDIX II

Na Na'nyonga was a bold and courageous daughter of Gawolbe II and founder of the Bali Nyonga dynasty

Fonyonga I (Nyongpasi) son of princess Nahyonga established the Bali Nyonga Dynasty and ruled from about 1830 to 1857. He died and was succeeded by his son Galega I.

Galega I ruled from 1857 to 1901. He welcomed the first European explorer, Dr. Eugene Zingraff from Germany and established the present palace. He concluded a treaty with the Germans in 1891. He died and was succeeded by his son Fonyonga II.

Fonyonga II ruled from 1901 to 1940. The Native Authority (NA) was created during his reign. First NA school and first Native Court in the grass field were constructed during his reign. The construction of Bali/Bamenda earth road and the translation of the Holy Bible into Mungaka were also done during his reign. He died and was succeeded by his son Galega II in 1940.

Galega II ruled from 1940 to 1985. He struggled for political independence and unification of Cameroon. the health and hygiene system were improved. He encouraged community.

Dr. Doh Ganyonga III ruling since 1985. Bali Nyonga has witnessed lots of improvements and new development projects since his installation especially in the domain of health, education and infrastructure etc.

- Renovation, extension and modernization of the Fon's Palace
- Opening and running of Nted Mungaka Nursery School
- Creation of a Development Association – Bali Nyonga Development and Cultural Association (BANDECA) to replace BACCUDA and BASCUDAF
- Creation of seven new nursery and primary schools at Boh Etoma
- Creation of a Bilingual Secondary School in Bawock
- Construction of the Bali District Hospital and Health Centres with internal and external assistance from Bali Cultural Association USA, friends of Cameroon in Frankfurt Germany and Nkumu Fed Fed Cameroon.
- Posting of permanent Doctors to the Bali District Hospital and the Catholic Health Centre, construction of modern libraries at GHS and CPC Bali
- Construction of the Bamenda/Bali/Batibo Trans-African Highway
- Construction of a modern grandstand and modernization of the Bali Community Hall

- Construction and improvement of farm to market earth roads
- Construction and installation of MC2 Bali Micro Community Bank to produce economic activities in Bali
- Creation of a Palace Arts and Crafts Centre (PACC) in the Fon's Palace
- Improved expanded Immunisation program in Bali
- The construction of water by gravity to replace the expensive water supply by electricity
- Provision of land for the creation of a Christian University of Bali to foster Education in Bali and Cameroon in general
- Transformation of SAR/SM into Government Technical College.

INDEX

CPSIA information can be obtained
at www.ICGtesting.com
Printed in the USA
LVOW03s0044141017
552413LV00021B/1226/P

9 781942 876168